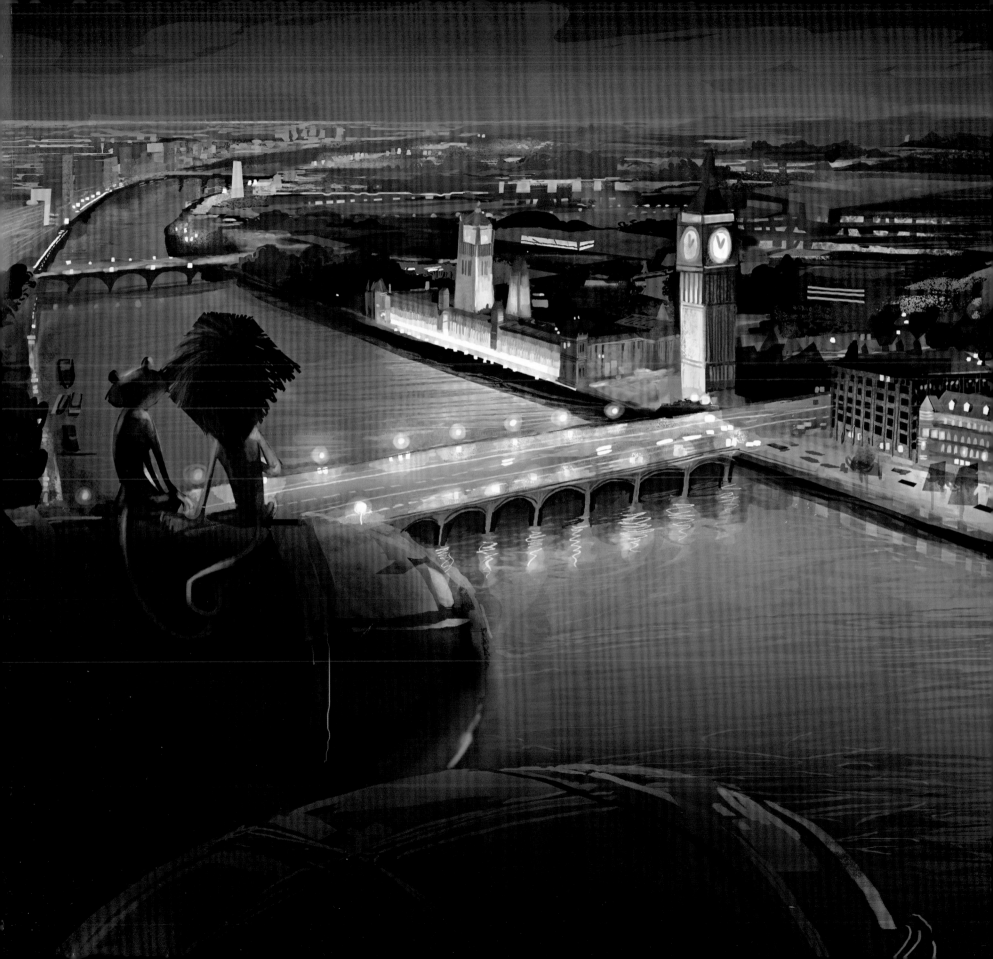

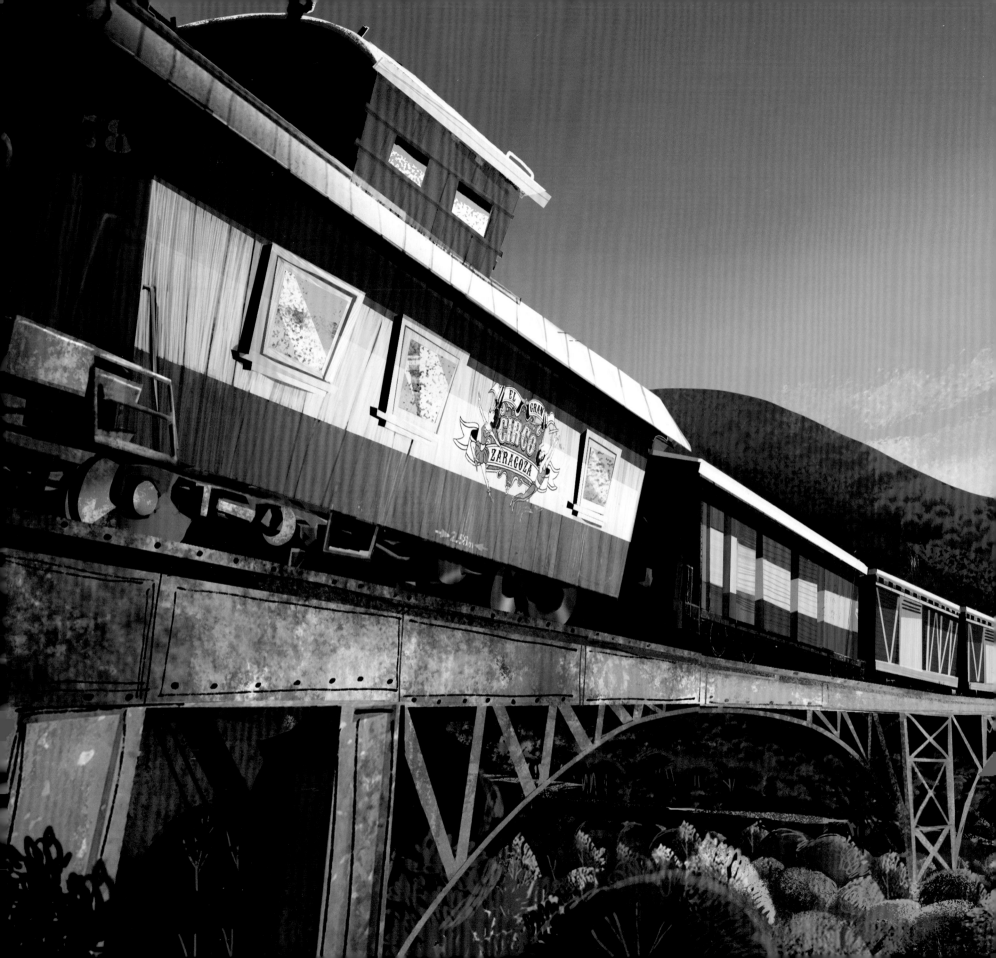

THE ART OF DREAMWORKS MADAGASCAR 3
EUROPE'S MOST WANTED

FOREWORD BY **CHRIS ROCK**

WRITTEN BY **BARBARA ROBERTSON**

INSIGHT EDITIONS

San Rafael, California

(CASE) New York Circus • Ken Pak
(PAGE 1) London Romance • Lindsey Olivares
(PAGES 2-3) Connecticut Countryside • Lindsey Olivares
(RIGHT) Stowaways Circus Animals • Goro Fujita
(PAGE 6) Old Circus Countryside • Shannon Jefferies

INSIGHT EDITIONS

PO Box 3088, San Rafael, CA 94912
www.insighteditions.com

*Madagascar, Madagascar: Escape to Africa; Madagascar 3: Europe's
Most Wanted* © 2012 DreamWorks Animation, L.L.C.

Library of Congress Cataloging-in-Publication Data available.

ISBN: 978-1-60887-075-2

REPLANTED PAPER Insight Editions, in association with Roots of
Peace, will plant two trees for each tree used in
the manufacturing of this book. Roots of Peace is an internationally renowned humanitarian
organization dedicated to eradicating land mines worldwide and converting war-torn
lands into productive farms and wildlife habitats. Together, we will plant two million
fruit and nut trees in Afghanistan and provide farmers there with the skills and support
necessary for sustainable land use.

MANUFACTURED IN CHINA BY INSIGHT EDITIONS

10 9 8 7 6 5 4 3 2 1

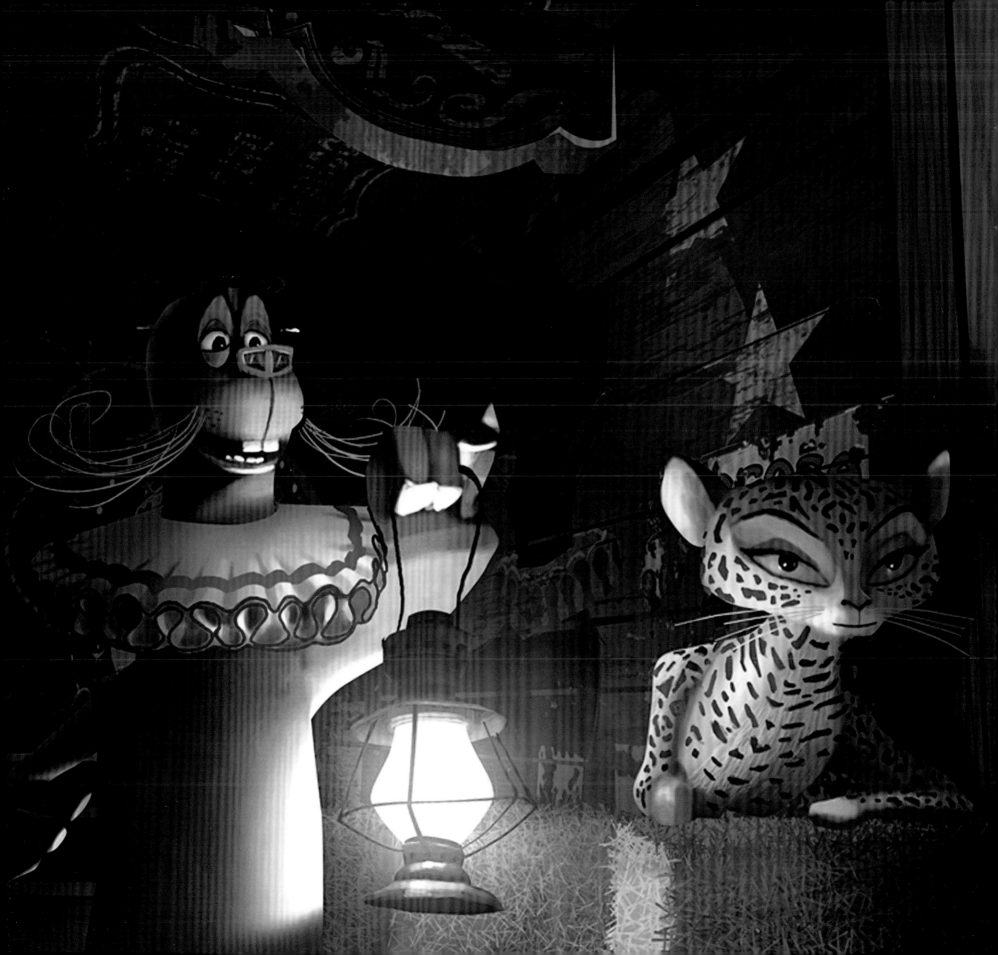

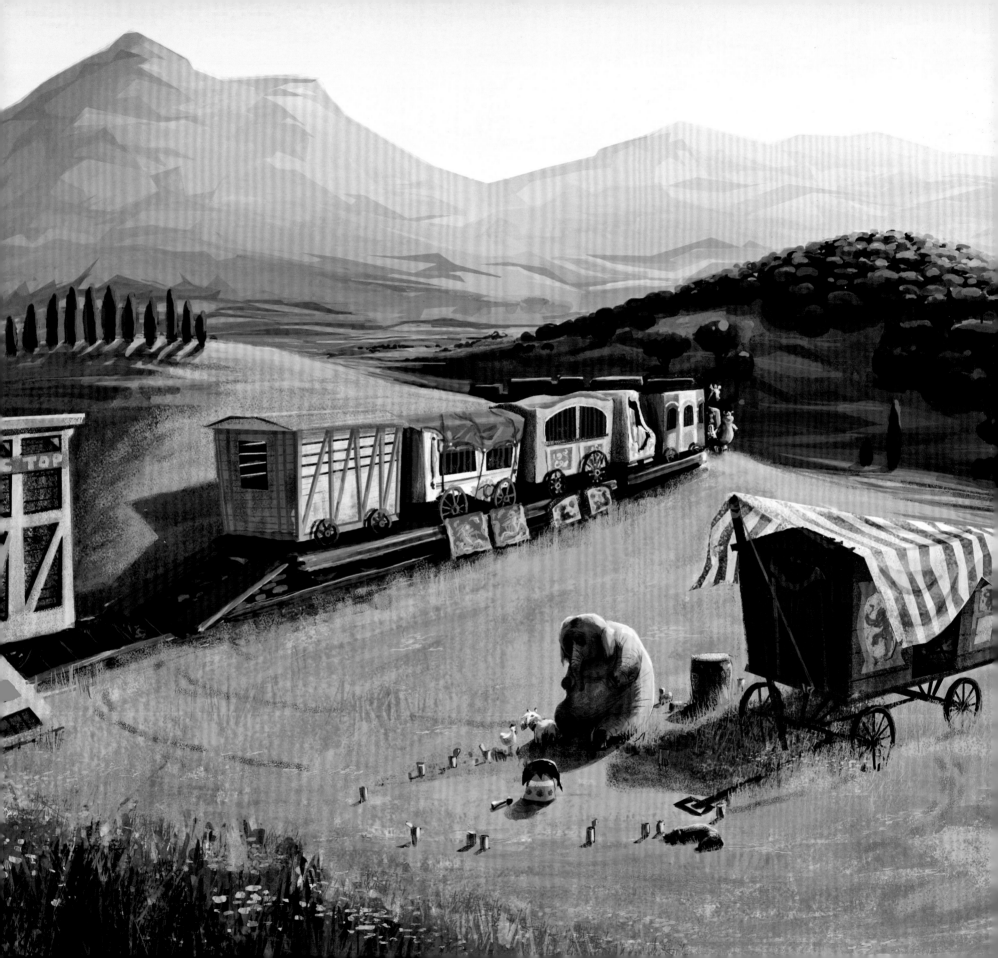

❦ CONTENTS ❦

FOREWORD

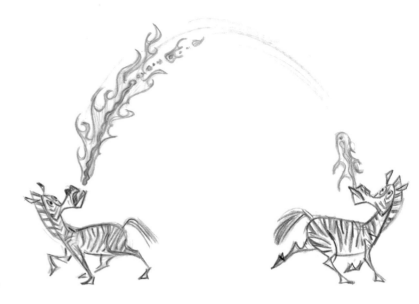

I'm from Brooklyn. Almost everywhere you go in the world, you seem to be able to find someone who is from Brooklyn. Even in Madagascar.

I loved playing Marty the zebra. The eternal question: Was Marty a white zebra with black stripes or a black zebra with white stripes? I'll give you my answer in a second. But first, with apologies to my friend Ben Stiller, *Madagascar* is Marty's story. If *Madagascar* is about anything, it's about wanting to know what else is out there, experiencing it, and coming full circle. Marty gets to see that although the world can be exotic, strange, and wonderful, there's nothing like New York. I love Marty. He's a dreamer.

If you, like Marty, have curiosity about the world, or just how *Madagascar 3* was made, you'll have it satisfied here in this book.

In these pages, you'll get to meet the real Marty and Alex and Gloria and Melman and King Julien and Penguins: the animators and artisans who bring dreams to life. I love craftsmen. My dad was a blue-collar worker who would fix things around the house and put in storm windows. These animators work with green screens. Same thing. That's why a book like this is important. In *Madagascar 3* we walked a tightrope, and here you'll see how a similar precision, patience, and teamwork turn out scenes like that. During the filming process, we actors get to see the animation in early stages. It's like seeing your wife without makeup. But then she puts the whole look together, and it's like "Wow, will you marry me again?" Putting together a movie like *Madagascar 3* is like putting together a fine Ferrari FF. The voices of the characters is the last detail, the cherry on top. By the time the movie reaches me, I'm just the guy who pops on the hubcaps. So sit back, pop the hood, and check out the work of people who richly deserve recognition.

By the way, here's the answer to the eternal Marty question: Marty is black . . . with very straight measles.

Thank you, Jeffrey Katzenberg, for taking a guy from Brooklyn around the world and back.

—*Chris Rock*

(ABOVE RIGHT) Flaming Spit • Geefwee Boedoe
(OPPOSITE, TOP LEFT) Marty and Triplets • Erwin Madrid
(OPPOSITE, TOP MIDDLE) Alex and Marty • Stevie Lewis
(OPPOSITE, TOP RIGHT) Rainbow Marty • Stevie Lewis
(OPPOSITE, BOTTOM) Marty Flying • Erwin Madrid

INTRODUCTION AN URBAN ADVENTURE

(ABOVE) Atomic Reactor • Alex Puvilland
(BELOW) New York Arrival • Lindsey Olivares

Through two films and two continents, four friends who left the Central Park Zoo—Alex the lion, Melman the giraffe, Marty the zebra, and Gloria the hippopotamus—have been trying to go back. The zoo is home. Unlike the wild countries they've been visiting, the zoo is safe and familiar.

But when *Madagascar 3* opens, the four New Yorkers are still in Africa. It is Alex's birthday and his Zooster friends have surprised him by building a huge model of New York City out of mud. Alex blows out the candles on his birthday cake and makes a wish: He wants to go home. When the Zoosters agree, they all travel to Monaco to find the Penguins, certain that the inventive birds will fly them home in their monkey-powered superplane. And with that decision, the third film in the *Madagascar* story takes off.

All three *Madagascar* films center on the Zoosters' journeys, which are both emotional and physical. In their first film, Alex, Marty, Melman, and Gloria accidentally fall off a Penguin-skippered ship and wash ashore on the island of Madagascar, where they learn something about their true natures. In the second, they try to fly home in the Penguins' monkey-powered superplane but

crash-land in Africa, where Alex meets his parents, Melman and Gloria get to know each other in new ways, and Marty learns that running with the herd isn't all he hoped it would be.

The third film sends the Zoosters back into an urban environment and on an unexpected journey through Europe—this time in 3D. During this journey, the animals discover unusual talents and unrealized potentials and, at the end, understand where they want to be in the world.

"We couldn't leave them in Africa," says producer Mireille Soria. "That's not really where they belong. So, we had to ask, 'Where do they belong?'"

In Monaco, the Zoosters find the Penguins and Chimps in Monte Carlo's famous casino. While there, they attract the attention of Chantal Dubois, the head of Animal Control for Monaco. All her life, she has wanted to hunt big game, and now she has a lion, giraffe, zebra, and hippopotamus in her sights. Obsessed, she becomes Alex's nemesis throughout the film. He wants to go home. Dubois wants to capture him. She doesn't give up.

After a harrowing and hilarious car chase through the streets of Monaco—in which the Zoosters drive a Penguin-modified Luxury Assault Recreational Vehicle and Dubois and her animal control officers ride scooters—the Monkey-powered plane comes to the animals' rescue. But, once again, the plane crashes—this time in a train yard somewhere in the French countryside.

This unexpected development puts the Zoosters in a muddle. The plane is beyond repair, and they are without a way home. Moreover, they are four big animals in a human world. How can they blend in? They hear police sirens. They dash deeper into the train yard, frantically looking for a place to hide. And then Melman sees a circus train. The Zoosters hop on the train, join the show, and travel through Europe with a host of new animal characters.

(TOP RIGHT) New Circus Vis Dev • **Geefwee Boedoe**
(ABOVE RIGHT) Zoosters and Vitaly • **Erwin Madrid**
(ABOVE) Rooftop Run • **James Wilson**

(ABOVE) Stefano in Diving Gear Vis Dev • Geefwee Boedoe
(BELOW) Alex's Speech • Alex Puvilland

"In the last two films, we spent most of our time in the jungles of Madagascar and on the savannas of the African mainland," says director Eric Darnell. "So it was very exciting to have the opportunity to apply the same artistic style to the iconic cities of Europe and to the magical world of the circus. It gave us the opportunity to deviate a little from reality and even go almost surreal."

The circus stretches the Zoosters' imaginations and abilities, and so, too, stretched the imaginations and abilities of the artists at DreamWorks Animation, many of whom had worked together on all three films. "Working on a film is always collaborative," says Soria. "But this one felt like a reunion. Everyone wanted to come back. And then we added wonderful people. It was a very happy group." New to the series were writer Noah Baumbach and director Conrad Vernon.

In addition to Darnell and Soria, returning crew members included producer Mark Swift, production designer Kendal Cronkhite, head of character animation Rex Grignon, head of story Rob Koo, head of layout Nol Meyer, and Tom McGrath, director of the first *Madagascar* movie,

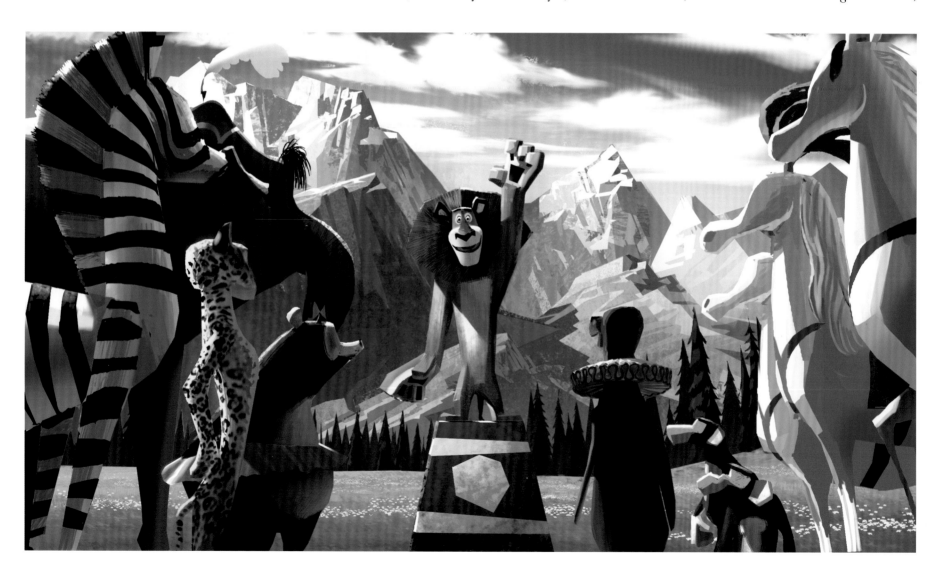

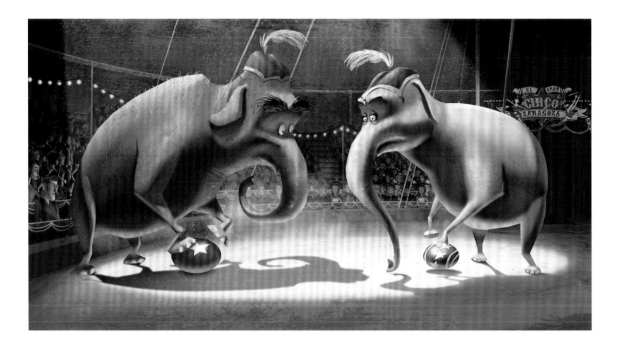

who served as a consultant. And visual effects supervisor Mahesh Ramasubramanian, who had worked on *Madagascar* as an effects artist, rejoined the crew for *Madagascar 3* in his new role.

The reunion wasn't a trip into the past for the crew, though. To meet the film's artistic and technical challenges, the design and production crew set their sights on the future.

Madagascar 3 has a huge cast with more major characters than either of the previous two films. It stars a complex lead human character, Monte Carlo's chief Animal Control Officer Chantal Dubois. And diverse crowds of people populate the urban environments of Monte Carlo, Rome, London, and New York. As for the animals, in addition to the Zoosters, three circus animals join the main cast: Vitaly, a Russian tiger who has lost his passion; Gia, a beautiful and sensible jaguar; and Stefano, a joyful Italian sea lion.

To bring all these moving parts together into a cohesive and exciting story, the production crew had to develop a host of new techniques and technologies. New lighting tools helped Cronkhite realize the illustrative vision she had for the film, and more sophisticated layout programs helped the directors previsualize the action, even with lighting and atmospheric effects, in stereo 3D.

"Because the look of *Madagascar* is so stylized, we have a lot of flexibility in how we use our production design to support the story," Darnell says. "We can push our colors, exaggerate our textures. We can do fun stuff with the shadows and bring in color in unexpected ways without kicking the audience out of the movie. It gives us a great deal of flexibility. We never derive the components of the *Madagascar* world from photographs. Artists design everything, including all the textures that go into this world, which gives it a rich, lush, and unique look. Kendal [Cronkhite] and her team have done an amazing job bringing the *Madagascar* style into the human world. This movie is beautiful."

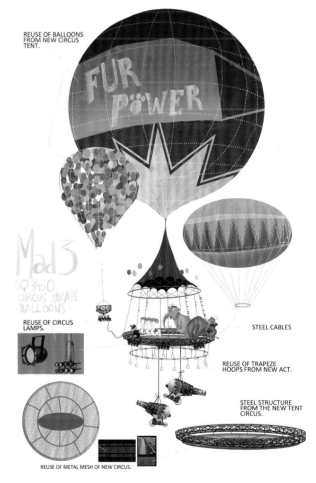

(TOP LEFT) Bad Circus Elephants • Travis Koller
(ABOVE) Balloon Rig • Alex Puvilland

CHARACTERS

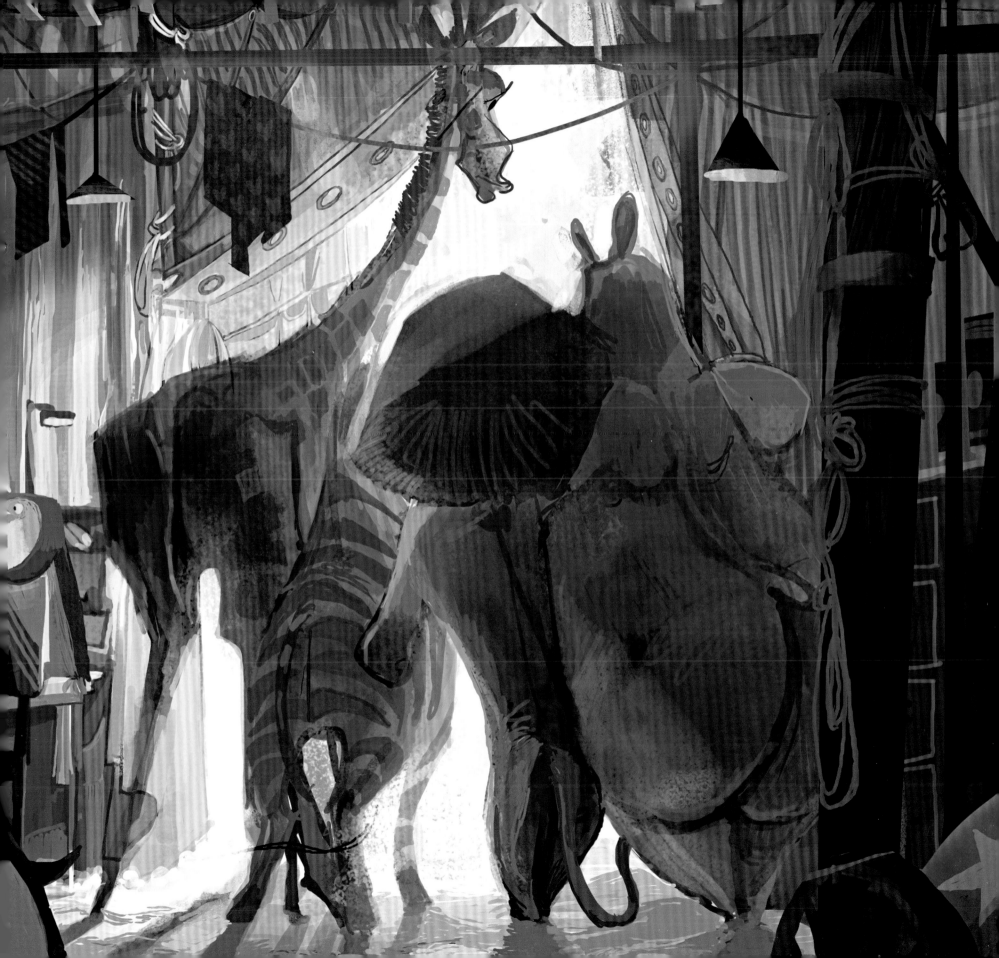

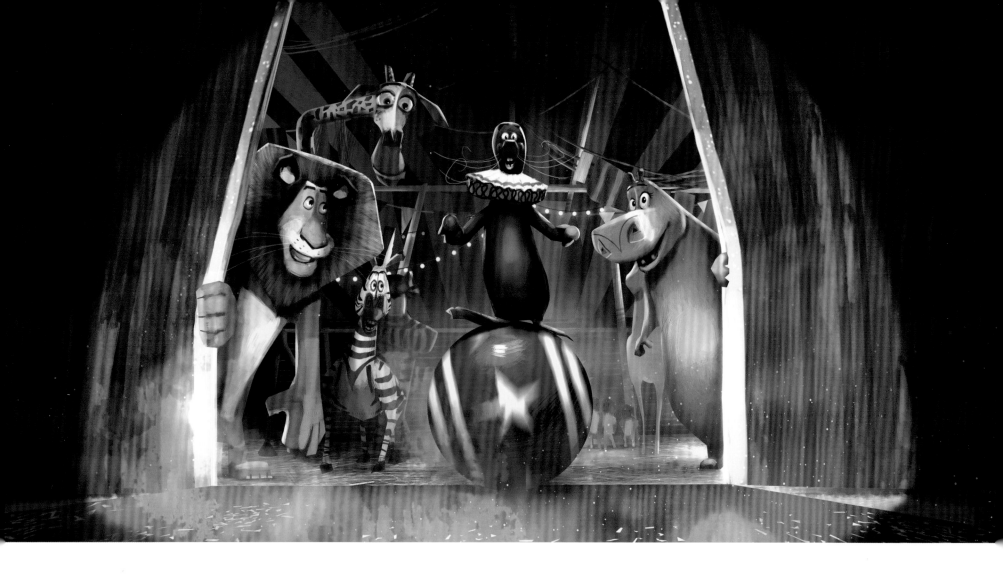

ANIMALS IN A HUMAN WORLD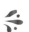

(PREVIOUS SPREAD) Backstage Early Circus • Lindsey Olivares
(TOP) Circus Animals' Entrance • Goro Fujita
(ABOVE) Hands Meet • Erwin Madrid
(OPPOSITE, LEFT) Run Away • Travis Koller
(OPPOSITE, RIGHT) Elephants Hanging • Lindsey Olivares

In the first *Madagascar* film, the Zoosters began their journey as sophisticated New Yorkers living in a human world. Misadventure led them to the island of Madagascar and eventually mainland Africa, where they spent time predominantly with wild animals. For the third film, they return to the urban environment of Monaco, a civilized place full of people—but not always welcoming people. Almost as soon as the Zoosters snorkel into the Monaco harbor, they find themselves on Animal Control Officer Chantal Dubois' WANTED list. When the Penguins' monkey-powered superplane fails to provide their ticket home, they escape Dubois by joining a New York–bound circus, hoping this new enterprise will take them back to America.

"The circus provides the perfect cover for our African animals and allows them to move freely through Europe," says director Eric Darnell. "The nature of the circus also gives us the opportunity to keep our animation fun, broad, and comedic."

We see all the familiar *Madagascar* characters early in the film, when they meet in Monaco: the Zoosters—Alex, Marty, Melman, and Gloria—and the Penguins, Chimps, and Lemurs. These animals haven't changed physically since the previous films, but they grow substantially in *Madagascar 3*. They develop emotionally as they interact with their new circus friends and face difficult challenges together. They push their bodies to new limits while performing astounding circus acts. They race from city to city in a cross-continental chase driven by Dubois' relentless pursuit.

"The challenge of this movie, more so than any of our other movies, is the character density," says Nol Meyer, head of layout. "That's something we had to work on with animation and production. How do we keep all these characters moving through the movie?"

Craig Kellman, who created the original character designs, returned to help develop the new characters, which include the villain Dubois, the animal control officers she commands, and the numerous circus animals the Zoosters befriend. "We have a visual language that we try to stick to," he says. "It's based on graphic, two-dimensional artwork—straights against curves. We use varied shapes: small, medium, large. And we push the proportions. When we did the first film, people weren't sure it would work in 3D. We learned that we can't keep the designs as pure as 2D drawings, but if we can sculpt something, it will work in 3D."

The inspiration for the style came from 1950s and '60s graphic art. "There was a great wave of simple, direct graphic art, which came from cubism and other styles of modern art," Kellman says. "It was exciting, and animation was a great form for it. With the advent of television, artists created a graphic style with bold lines and simple shapes so people could read the animated characters visually on the small screen. *The Rocky and Bullwinkle Show, The Flintstones, The Yogi Bear Show*—they all used straights against curves. We looked at that style for *Madagascar*."

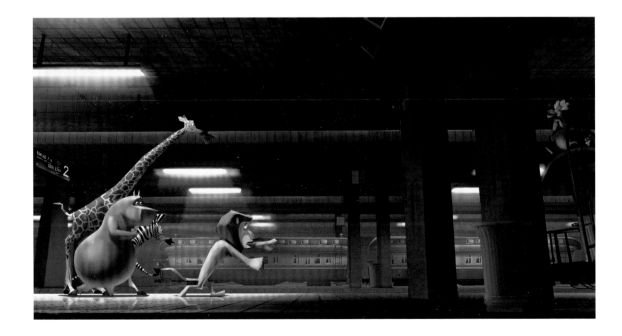

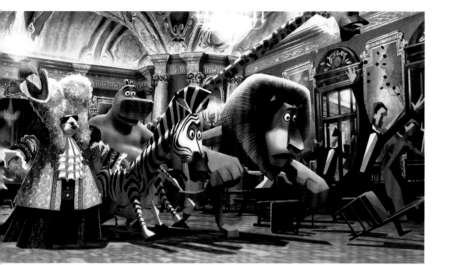

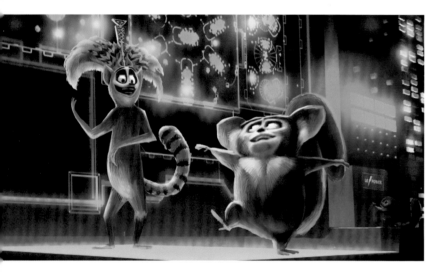

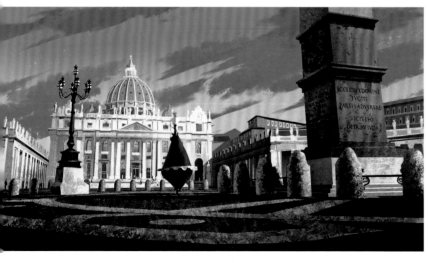

“ **We wanted this third film to be the next chapter in . . . the story we've told. The lessons that our characters learn and the ways they grow are related to not just what happens in this movie but also what happens across their entire journey.** ”

—Eric Darnell, director

Kellman provides a "straights against curves" example: an arm with a straight line down the back and a curved bicep in front rather than stiff parallel lines or the parallel curved lines seen in rubber-hose animation.

"The more graphic you are, the more curved and straight the lines, the more they are in opposition, and the more tension and excitement you create for the eye," Kellman says. "It isn't just simplifying; you can be abstract. The characters become stylized, less real, and more representational."

Representing that style in 3D, however, is a persistent challenge for the rigging department, which engineers the controls animators use to move a character. The rig causes belly folds when a character sits, and muscle bulges when a character moves. "When a character flexes a muscle, we want to keep the silhouette simple and graphic without too many bumps, and that is not as easy as you'd think," says visual effects supervisor Mahesh Ramasubramanian. "We typically build characters with muscles that react realistically. So on this film, the rigging department had to constantly tell the rig not to behave as it would in a *Shrek* movie."

Getting art, rigging, and animation to work in concert with one another was paramount for the *Madagascar* series of films, since all the characters, even the human ones, have varied shapes and pushed proportions. For example, Alex is an inverted triangle with enormous paws, Gloria is an especially wide rectangle, and Dubois has a huge bust on a blocky body atop skinny legs. "If she or any of the humans looked too real, the animals would look like cartoon animals in a real world," Kellman says. "And that would take audiences out of the *Madagascar* world. When everything is cartoon-y, you accept that Alex is a real lion."

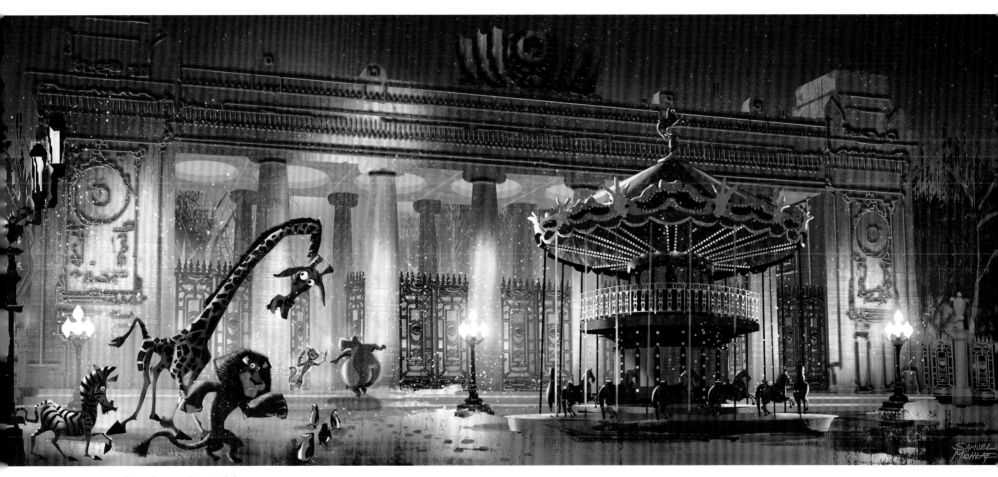

(OPPOSITE, TOP) Fleeing Casino • Erwin Madrid
(OPPOSITE, MIDDLE) Lights On • Erwin Madrid
(OPPOSITE, BOTTOM) St. Peter's Square • Stevie Lewis
(ABOVE) Gorky Park Gate • Sam Michlap

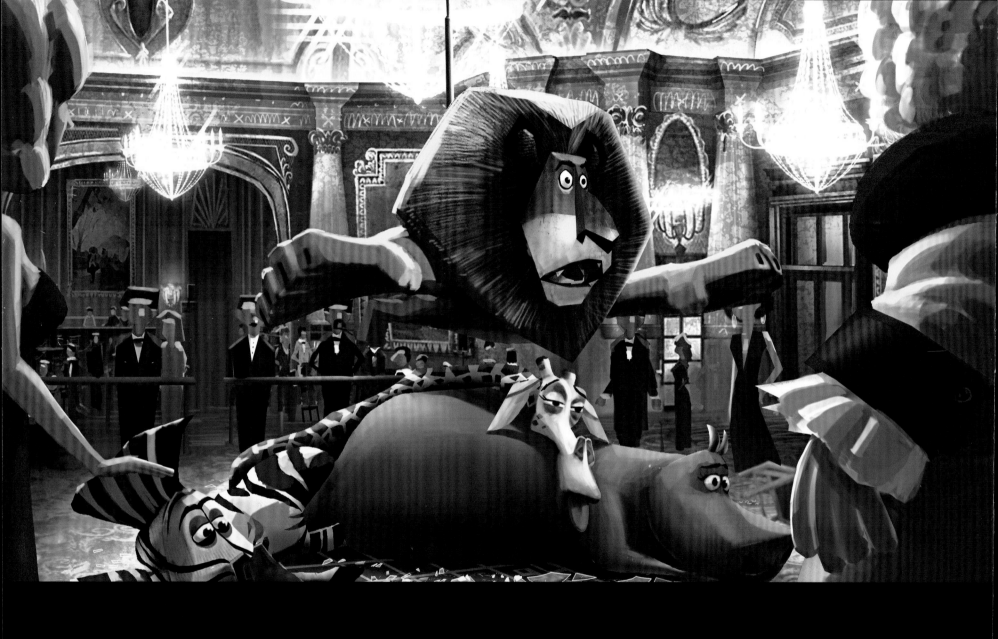

THE ZOOSTERS

The Zoosters have been together since Alex, Melman, and Gloria followed Marty out of the Central Park Zoo in *Madagascar* and into trouble, defining themselves through their various adventures as a group that stays together. Even when they found their identities in different ways in the second movie, the Zoosters remained united by a common desire: They want to go home—especially Alex. "He's always defined himself as a New Yorker and the star of the zoo," says producer Mireille Soria.

Thus, in *Madagascar 3* the Zoosters join the traveling circus not just to hide from Dubois, but because they learn an American promoter might send the circus to New York. They soon discover, though, that the circus, which they actually bought, is no good.

> **"We've lived with these characters so long, we kind of think of them as people. We know their tics and how they're going to react, and it's very strange. They are so familiar they're like someone in your family."**
>
> —Mark Swift, producer

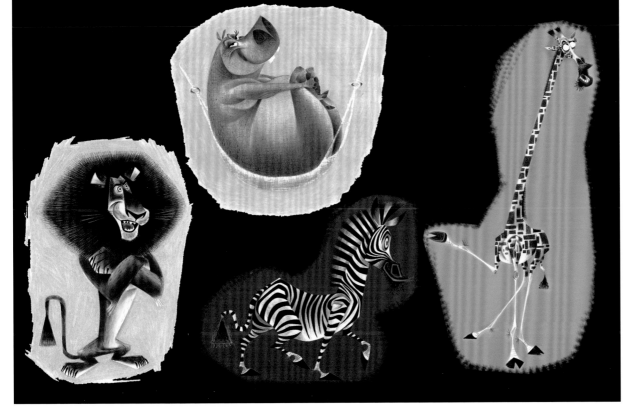

(OPPOSITE) Lion • Chin Ko
(LEFT) Zoosters Color • Craig Kellman
(BELOW) Zoosters Water Lookout • Erwin Madrid

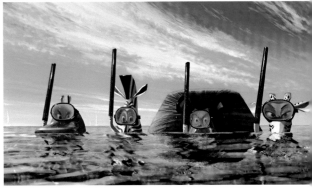

The circus animals are uninspired. The crowd in Rome boos. Clearly, the circus needs help, too. That's when Alex steps into his new role.

"The circus used to be fantastic, but time has whittled away at the circus animals' passion for what they do," says director Eric Darnell. "Alex takes the lead in trying to make the circus great again. His motives are selfish at first—it's all about getting back to New York—but when he sees the circus' transformation, he finds passions in himself that he didn't know he had. And he realizes that there may be more to life than just being 'The King of New York City.'"

In fact, all the Zoosters fall in love with the circus. And then something magical happens: The Zoosters and the circus animals reinvent the circus. They create a spectacular show in which the new characters—the circus animals—fulfill long-dormant dreams. Gia the jaguar becomes a trapeze artist with Alex's unwitting help, Stefano the sea lion cannonballs over the crowds, and Vitaly braves the little hoops once again.

The Zoosters undergo similar transformations of spirit. After watching Stefano, Marty shoots himself from a cannon, too, and realizes he has always wanted to fly. Melman and Gloria dance on a tightrope. And Alex invents "Trapeze Americano."

"In this film, the Zoosters find their passion in life," Darnell says. "They take risks, try new things, and are OK with the fact that they don't have complete control over what happens to them, because they know that's when the unexpected happens. And that's where the greatness can come from."

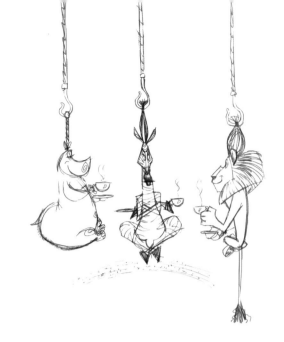

(BELOW) Marty and Clouds • Erwin Madrid
(ABOVE RIGHT) Hanging • Kendal Cronkhite
(RIGHT) Alex New Circus Vis Dev • Ken Pak
(OPPOSITE) New Circus Clown Act Vis Dev • Lindsey Olivares

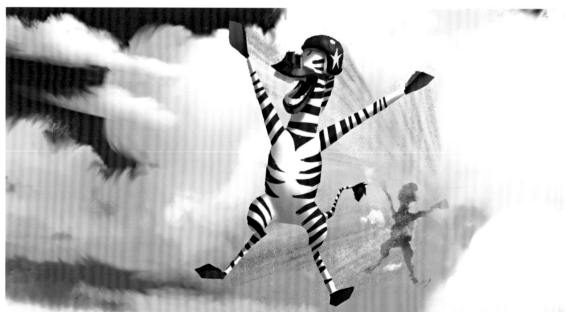

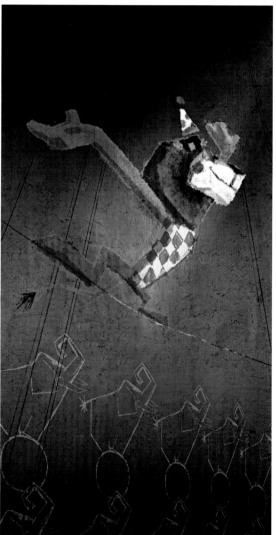

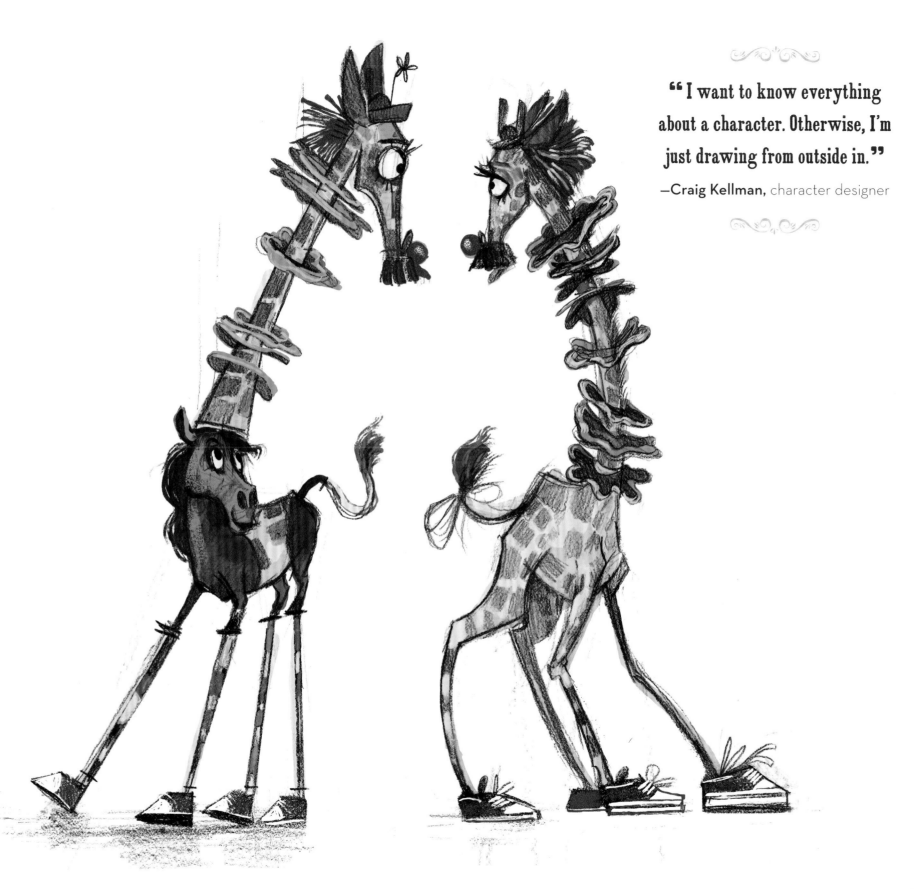

"I want to know everything about a character. Otherwise, I'm just drawing from outside in."

—Craig Kellman, character designer

CHIMPS

The Chimps power the superplane that flies the Penguins to Monaco, and in Monaco, they fly the plane long enough to lift the Zoosters out of danger. But the Chimps aren't all brawn. When the Penguins and Zoosters need a human to help with some monkey business, the Chimps fill the role. Phil sits on Mason's shoulders, they wrap themselves in a robe, don a wig, and suddenly they have become the tall King of Versailles. Under the robe, the Chimps run a sports book operation.

"In the first *Madagascar*, we had stacked the Chimps and put them in an overcoat to buy a train ticket," says production designer Kendal Cronkhite. "For this film, we needed a gambler in the casino that the Penguins could control, so we decided to make a similar character. Because we were in a French environment, and we wanted him to be outrageous, we gave him the ruffled shirt, long robe, and big curled wig with the white face and beauty mark of Louis XIV. Even though he's in disguise and stands out like a sore thumb, no one notices. Craig [Kellman] nailed the design right out of the box."

(RIGHT) King of Versailles Drawing • Craig Kellman
(FAR RIGHT) King of Versailles Color • Craig Kellman

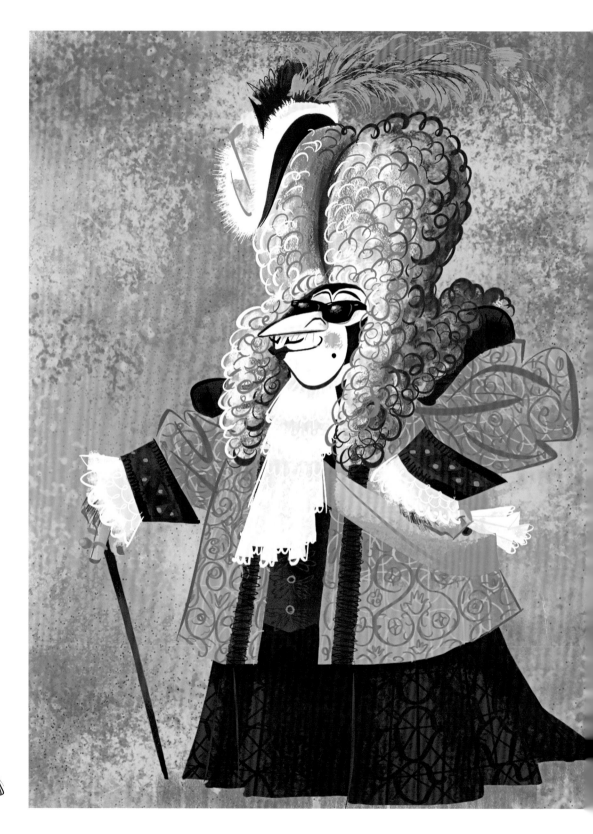

PENGUINS

As in the two previous films, the Penguins—Skipper, Kowalski, Rico, and Private—are a driving force in the story—literally. Believing the Penguins can fly them home in the monkey-powered superplane, the Zoosters track them down in Monte Carlo, where Skipper is enjoying a gambling honeymoon. "The Penguins are running a mission in the casino," says Rex Grignon, head of character animation.

When the Zoosters get into trouble, the Penguins help them escape in a modified, super-charged Luxury Assault Recreational Vehicle (LARV). "They basically get everybody out of trouble and into *more* trouble," Grignon says. "They have this wonderful way of doing both at the same time."

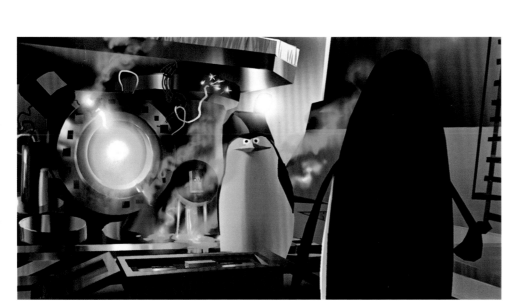

(TOP RIGHT) Penguins Color • Craig Kellman
(RIGHT) Penguin Expressions • Craig Kellman
(ABOVE) Penguins with Nuclear Reactor • Alex Puvilland

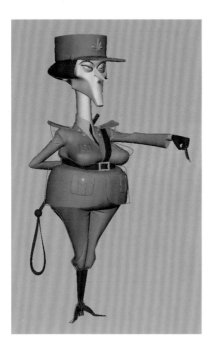

DUBOIS

Chantal Dubois has spent her entire career as an animal control officer pursuing stray wildlife in Monte Carlo's concrete jungle while nurturing an ambition to be a big game hunter. So when she sees the Zoosters, she becomes obsessed. "She's a great villain because her view of animals is the exact opposite of what we've been doing up to now," says director Conrad Vernon. "She believes animals belong in cages."

Early designs for Dubois gave her a soft, piggy face and a square, buxom body. "She was a tiny character," Kellman says. "But that was too close to Granny (from *Madagascar 2*). So we made her bigger. And we redesigned her head to make her prettier."

Dubois' final design, in which supervising animator Carlos Puertolas played a key role, features a face with hints of Marlene Dietrich atop a long neck that gives her a sense of authority. She's still buxom, with a blocky body that sits on thin legs.

"She's an odd-looking woman," says production designer Kendal Cronkhite. "Severely beautiful. We've given our villain a visual point of view that is very film noir. Her face is often shadowed. Her color is red. When something happens to her, she repaints her red lipstick; it's her reset button."

(TOP LEFT) Dubois Vis Dev Model • Minyu Chang
(TOP RIGHT AND BOTTOM LEFT) Dubois Expressions • Craig Kellman
(LEFT) Dubois Color • Craig Kellman
(OPPOSITE) Dubois Color • Craig Kellman

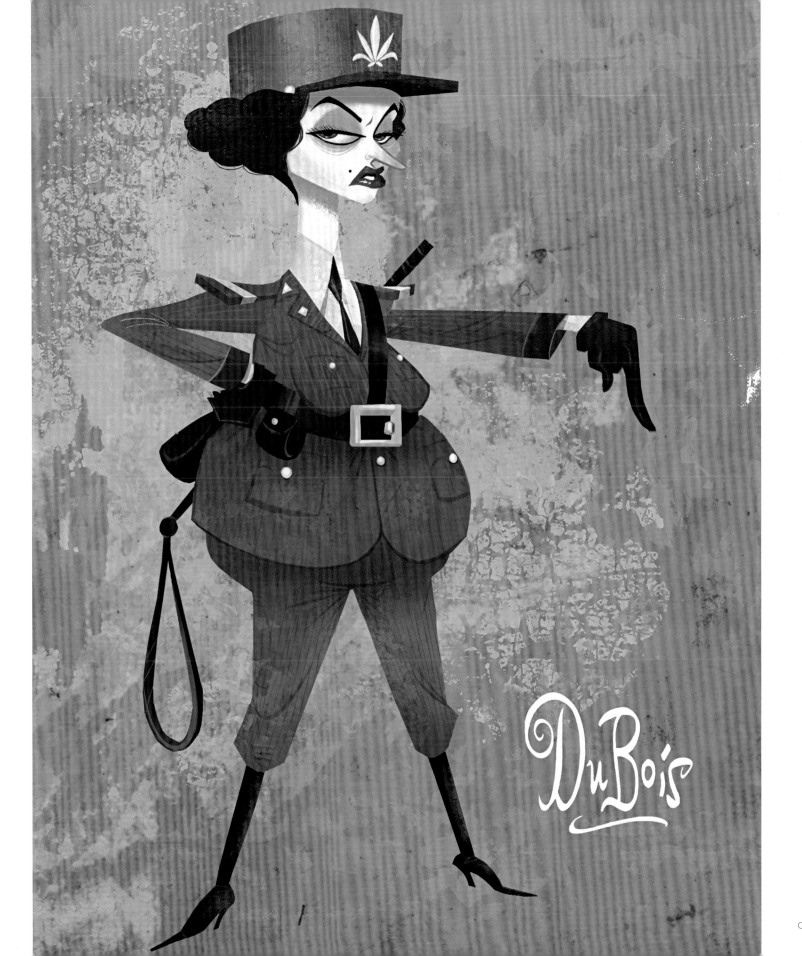

DuBois

“ The approach with Dubois was to make sure
we could keep the same sense of broad caricature
with her performance as with the animals.”

—Craig Kellman, character designer

(THIS PAGE) Dubois Expressions • Craig Kellman

❧ SEEING SCENTS ❧

After the Zoosters escape with the circus animals, Dubois moves through the plane-crash site, tracking them. "If she needs the skills of an animal, she keys into that animal's traits, physically and in her thinking," says head of character animation Rex Grignon. When tracking, Dubois sniffs the ground. She laps up water from a paw puddle. When she picks up a scent, we see what she smells from a character-specific point of view the filmmakers dubbed "Seeing Scents."

"It's what you imagine goes on inside a hound dog's brain," Grignon says. "The smell triggers almost a ghostly vision. It tells them someone walked this way. She does that. And that's what puts her on the trail for the chase."

(TOP) Smells Exploration • **Ruben Perez**
(ABOVE) Smells Sequence 500 "Meet Dubois" • **Ruben Perez**

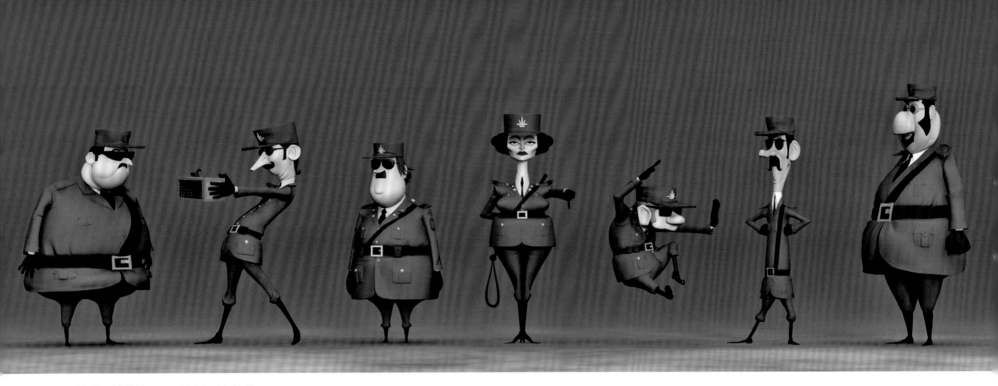

(ABOVE) Modeling ACON Line-up • Modelers: Min Yu Chang,
Kull Shin, Sean Choi, Phil Zucco; Surfacer: Hayyim Sanchez
(BELOW) ACON Drawings • Craig Kellman
(OPPOSITE) ACON Expressions • Craig Kellman

ANIMAL CONTROL OFFICERS

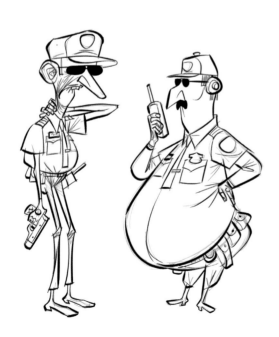

The four animal control officers (ACONs) would follow Dubois anywhere. "These crazy ninja animal control officers are in love with Dubois," character designer Craig Kellman says. "They love that she's domineering." They ride behind her on their scooters, until the Penguins dump oily fish from the Luxury Assault Recreational Vehicle and send two sliding into a car. The other two swerve into the sea.

"The ACONs were designed to have some of the qualities of Inspector Clouseau," says production designer Kendal Cronkhite. "We wanted them to be French and slightly bumbling. To make them feel institutional, we dressed them in older French military coats with belts and pants tucked into high boots. Then we desaturated their color and used dark sunglasses to cover any expression in their eyes."

Although they are secondary characters, the ACONs have the same pushed proportions and sophisticated animation controls as the main cast. "They're very different from each other, and all the proportions are exaggerated," Cronkhite says. "One is a big round guy with little hands and feet. He's similar to Gloria in how his proportions work. Another is a little old guy with a hump on his back. The tall, thin one has a head as thin as his hips. He's a line, a stick. And we have a pear-shaped guy. They were originally going to have bigger roles in the film, so we wanted to give them real personalities. They work more as a unit now, but they're still so much fun to look at."

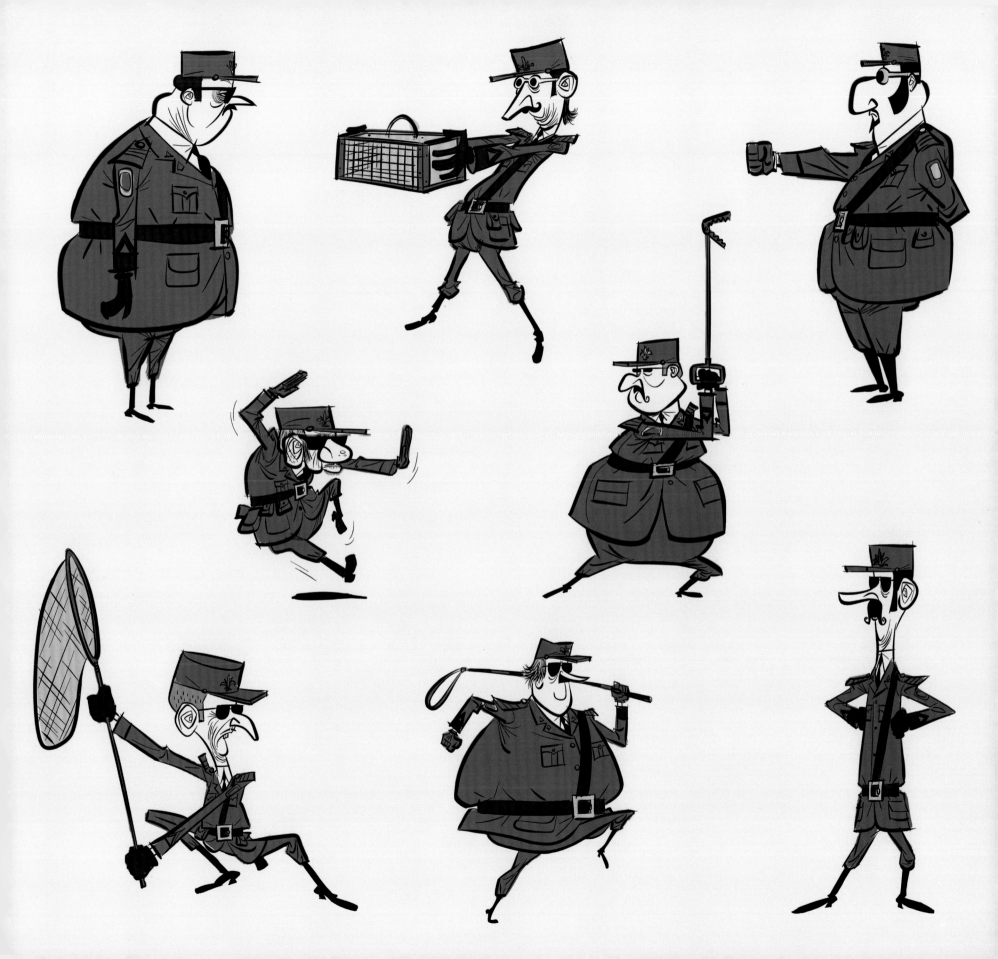

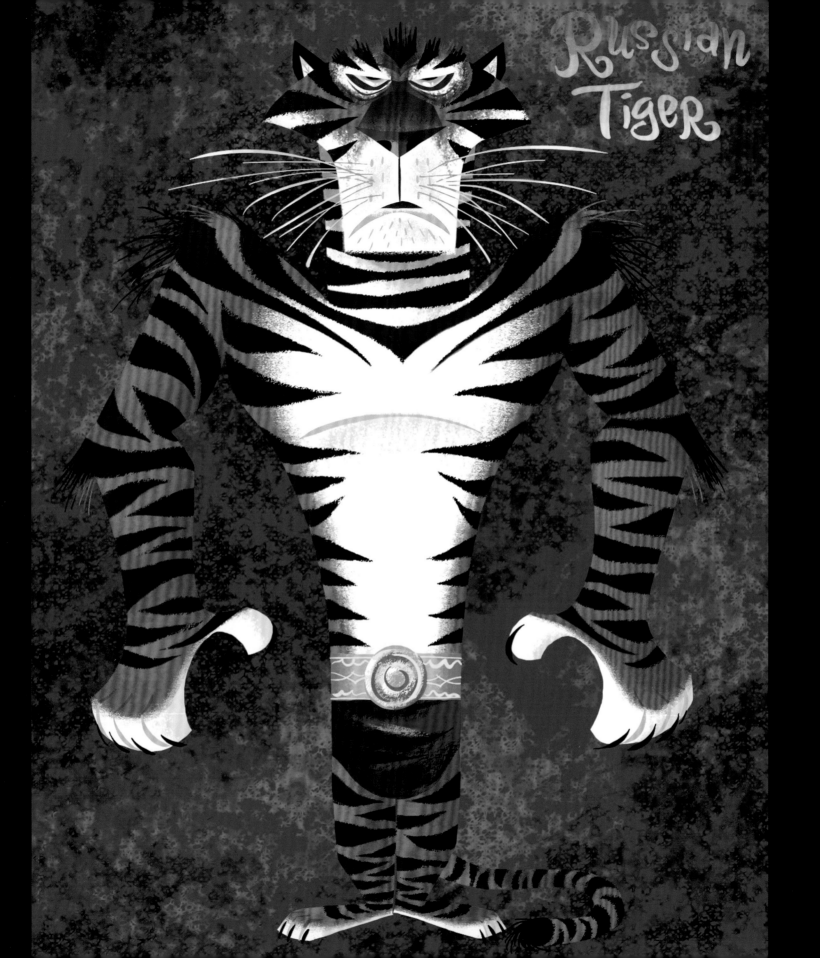

VITALY

When the Zoosters first approach the circus train to hide from the animal control officers, a hulking Russian tiger named Vitaly opens the door to the train car and confronts them. At first he resists allowing the Zoosters onto the train, but he relents when they lie and say they are circus animals. "Vitaly is very conservative," says director Eric Darnell. "He wasn't always this way. In fact, he became famous for pushing his act where no other circus animal would go. But after a dramatic failure on stage, he pulled back, stopped taking risks, and became very resistant to anything new."

Deep down, Vitaly is afraid to perform his impressive, death-defying circus act. He won't even try until Alex inspires him to think about the circus not as the sum of the acts the animals perform, but as a passion that resides within all of them.

When character designer Craig Kellman began sketching Vitaly, he worked from a preliminary description that called the tiger "proud, agile, and strong." "I was really graphic with him," Kellman says. "My first drawings were flat, front-on graphic drawings. He's a big dude. I lifted him off the ground into a big, broad chest and kept his shoulders and arms very stoic."

(OPPOSITE) Vitaly Color • Craig Kellman
(ABOVE) Vitaly Expressions • Craig Kellman

(TOP ROW) Vitaly Flashback Color Keys • Ruben Perez and Goro Fujita
(FAR LEFT) Baby Vitaly • Bryan Lashelle
(LEFT) Vitaly Poster • Bryan Lashelle
(ABOVE) Circus Magazine Covers • Bryan Lashelle
(BELOW LEFT) Olive Oil Bottles • Goro Fujita
(BELOW RIGHT) Borscht • Alex Puvilland
(RIGHT) Vitaly News Clipping • Bryan Lashelle
(FAR RIGHT) Vitaly Hero Poster • Bryan Lashelle

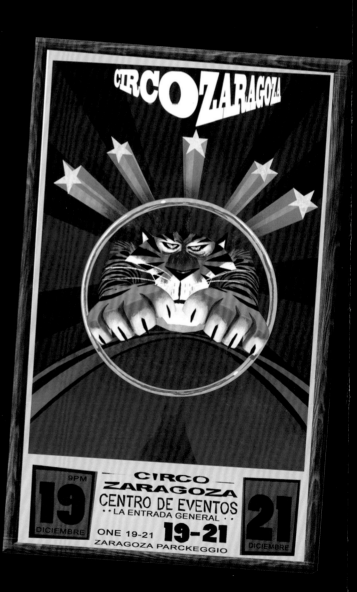

⚜ VITALY'S BACKSTORY ⚜

I n a scene that takes place in the circus master's luxurious train car, Stefano tells Alex Vitaly's sad story. Vitaly was once the star of the circus. He was fearless. He was an inspiration for the other circus animals. He did an act in which he would jump through a hoop as if he could fly. With each performance, the hoop got smaller and smaller, until the huge tiger had to grease himself to slide through. One day, to make the act more fantastic, Vitaly decided to light the tiniest hoop on fire. It was a mistake. When he tried to squeeze through, he stuck and the oil on his fur caught fire. He never jumped again.

"Because this is a flashback sequence, and it's the story of something that is physically impossible, it didn't have to be rooted in reality," says head of layout Nol Meyer. "We wanted to make it magical. As Vitaly becomes famous and more grandiose, we could detach him from the crowd and have him spinning faster than possible with the background behaving normally. Or, when he's doing something normal, we could have the background doing something different. We transition from black and white to color to show the passage of time. And there are few normal transitions. When Vitaly pours oil on his body to get through the hoop, rather than using a cut or dissolve, previs artist Scott McGinley created a transition that has the image of Vitaly coming down like oil from the top of the screen."

Stefano ends his story by revealing that Vitaly not only lost his fur and his fame, but his dignity, too. And when the big tiger lost his pride and passion, so did all the other circus animals. To put Vitaly's tragic performance on the screen, the production effects artists needed to create digital fur, wet it with oil, and set it on fire—three of the most difficult effects to accomplish in computer graphics.

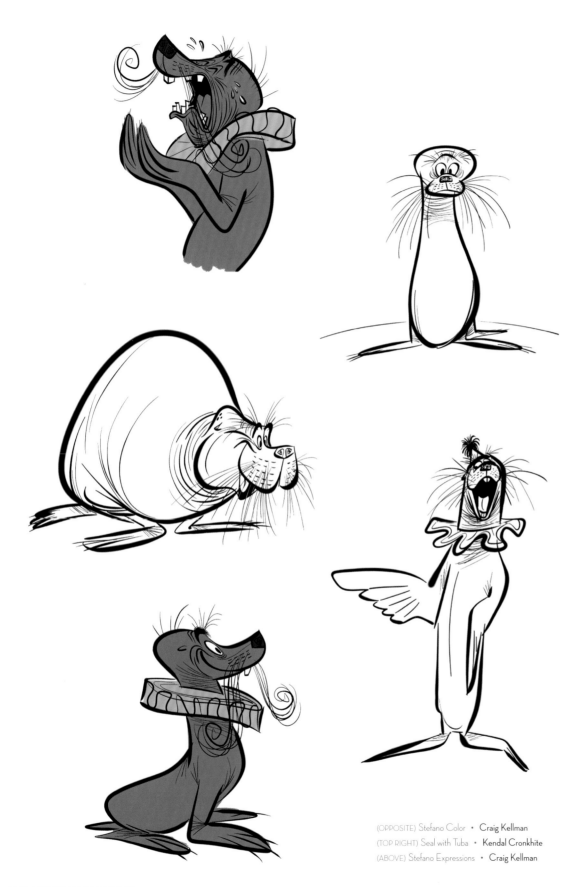

One of the three main circus animals, Stefano the Italian sea lion has always wanted to shoot himself out of a cannon. And in the reinvented circus, he does. "He'd probably win the prize as the most fun new character," says head of character animation Rex Grignon.

"All the characters are fantastic," adds director Conrad Vernon. "Their personalities are strong, and the animators have given them great traits. But the funnest character has been Stefano the seal. He's innocent, a fun idiot. His design is hilarious. And he's voiced by Martin Short. So we could go nuts with the animation. For every sentence, he has six other thoughts."

Character designer Craig Kellman played with various proportions to nail Stefano's size. "We had a fat, elephant seal version," he says. "But we didn't want to go with a really big guy. He ended up a little more agile. He's Italian and he talks with his hands, so his shoulders were important. The most important thing was making sure his eyes and mouth were expressive. So I put my face on him. I have a goofy face with huge teeth and eyes, so I thought, I can't lose. I looked in the mirror and drew me."

(OPPOSITE) Stefano Color • Craig Kellman
(TOP RIGHT) Seal with Tuba • Kendal Cronkhite
(ABOVE) Stefano Expressions • Craig Kellman

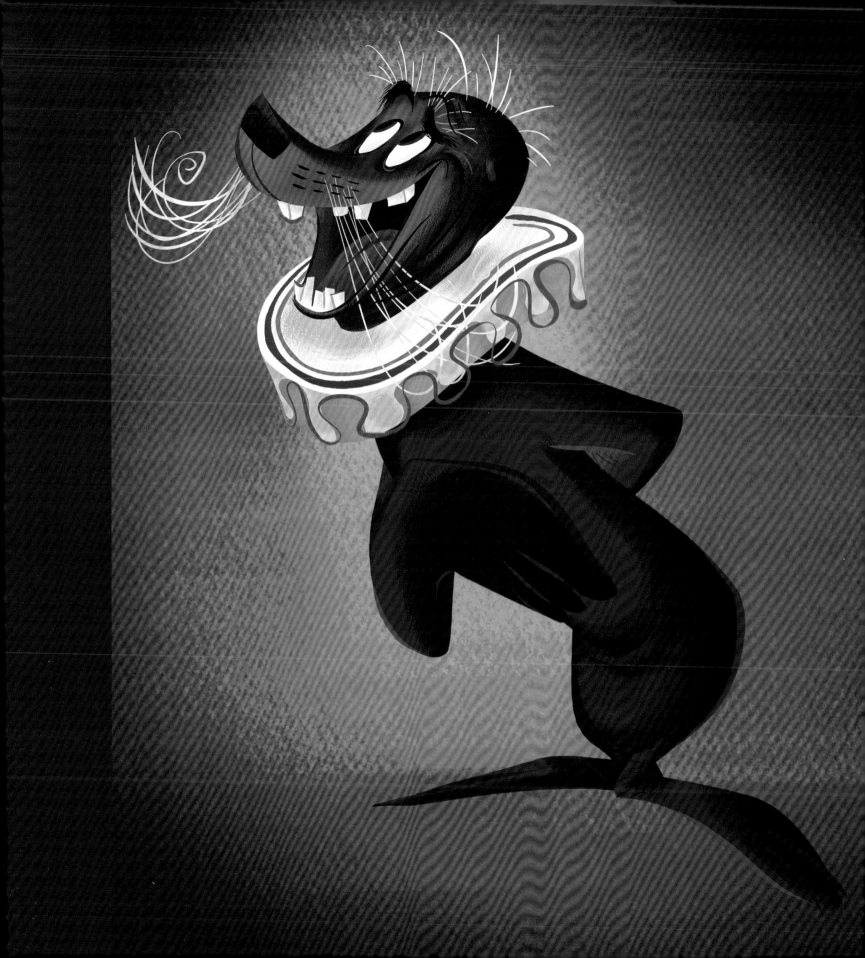

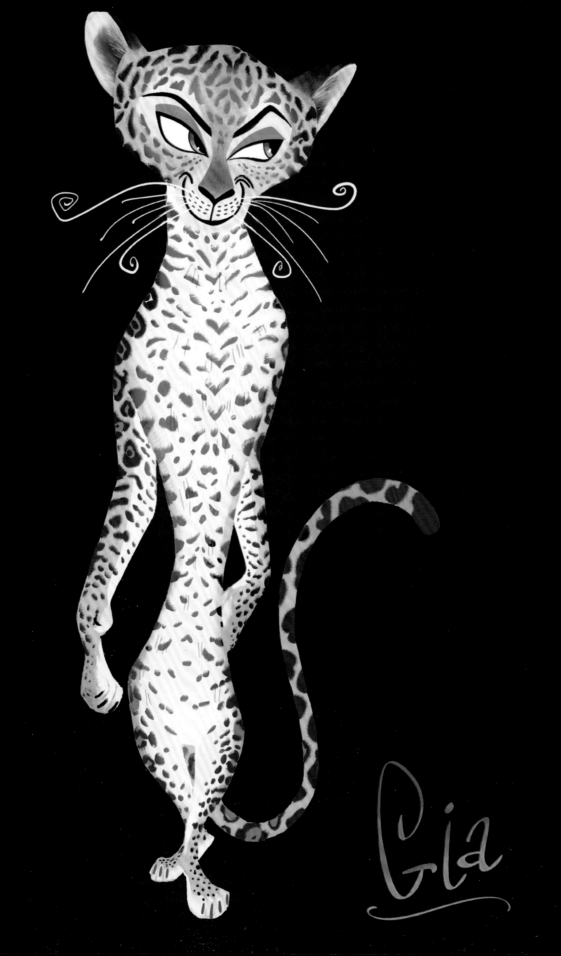

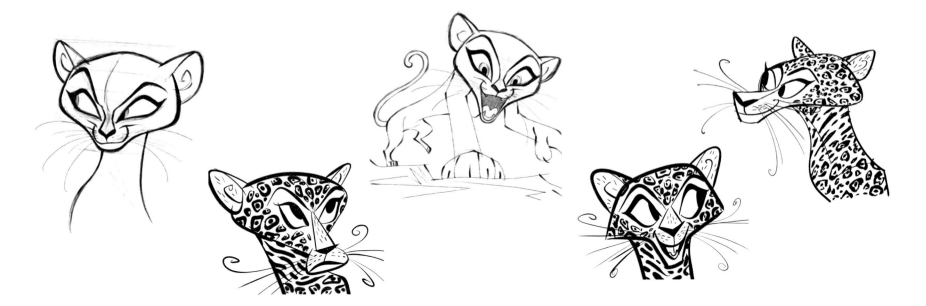

The jaguar Gia is the moral compass for the circus and a pragmatist who makes sure everyone is happy. "She can see that the circus is suffering," says director Conrad Vernon. "So when Alex comes in with new ideas for reinventing the circus, she doesn't say 'Hey, let's do it,' like Stefano or 'Let's forget it because it's too risky emotionally,' like Vitaly. She is the balancing force between those two."

From the beginning, Gia was always a possible love interest for Alex. "Originally, she was Italian—an albino jaguar kept in a gilded cage in the Monte Carlo casino," says production designer Kendal Cronkhite. "But the directors decided it would be better for the story if Alex met her in the circus. Her design is similar to the female lions in Africa in the last film. She has a long, thin body; long waist; short legs; and long arms. Like Alex, she has a large head on a thin body, but she's softer. She doesn't have Alex's hard edges. She's rounded and fuller with more hip. We made her face more exotic, with almond-shaped eyes, upturned at the corners, to give her a catlike quality. We based her a little on Sophia Loren. Her color is now like a regular jaguar, but her spots have a subtle flower pattern."

In the reinvented circus, the animals perform acts usually done by humans. Gia has always wanted to become a trapeze artist and convinces Alex, who has previously talked about his prowess as an aerialist, to teach her. "Alex has claimed to be a circus star. Now he's trapped," says director Eric Darnell. "He has to get up on the trapeze to teach Gia. He has no idea what he's doing, so he makes it up as he goes along. He falls into the net and smashes into posts, and she thinks that's all part of it. 'Wow,' she says, 'Trapeze Americano is a very different style.'"

(OPPOSITE) Gia Color • Craig Kellman
(THIS PAGE) Gia Expressions • Craig Kellman

(ABOVE) Sonya Expressions • Craig Kellman
(OPPOSITE) Sonya Color • Craig Kellman

SONYA

Madagascar 3 has many examples of characters in opposition: Alex and Vitaly, Alex and Dubois, Stefano and Vitaly. Sonya is a contrast for King Julien, the Lemur from Madagascar, who discovers her in a boxcar. When they first meet, Sonya emerges from the shadows with drool dripping from her muzzle. She belches. Julien gazes upon her massive glory and instantly falls in love.

Sonya is the only featured character that doesn't talk. One of the circus animals, she is a large black bear with few anthropomorphic features. "We wanted her to contrast with Julien's narcissism," says head of story Rob Koo. "By having her be an animal, she acted like a mirror. But having one character be more animal-like and still be in the *Madagascar* universe is tricky."

Originally, Sonya was a cute bear with a round head, almost a horizontal oval. As her role evolved into something more animalistic, character designer Craig Kellman changed her face to make her look beastly. "We made her head straighter on the sides

and top, and it now blends into her shoulders," say production designer Kendal Cronkhite. "We made her eyes dull with big pupils and pushed them together. Her button nose got broader and thicker. We gave her lips fleshiness, dropped them to expose her gums, and made her teeth pointy. And we roughed up her fur."

To design the sequence in which Sonya and Julien meet, the previsualization team used new software, with which they could arrange digital lights and insert rudimentary effects in a 3D scene at an early stage in scene planning. "The scene starts in a dark, scary environment like a horror film," says head of layout Nol Meyer. "As we reveal the bear, everything brightens and we go into a love scene. With the previs software we used, Kendal [Cronkhite] and Mahesh [Ramasubramanian] could get a rough idea of the lighting and EFX [environmental effects] for any particular sequence in order to plan and design accordingly."

"Sonya created the opportunity for Julien to have a monologue."

—**Rob Koo,** head of story

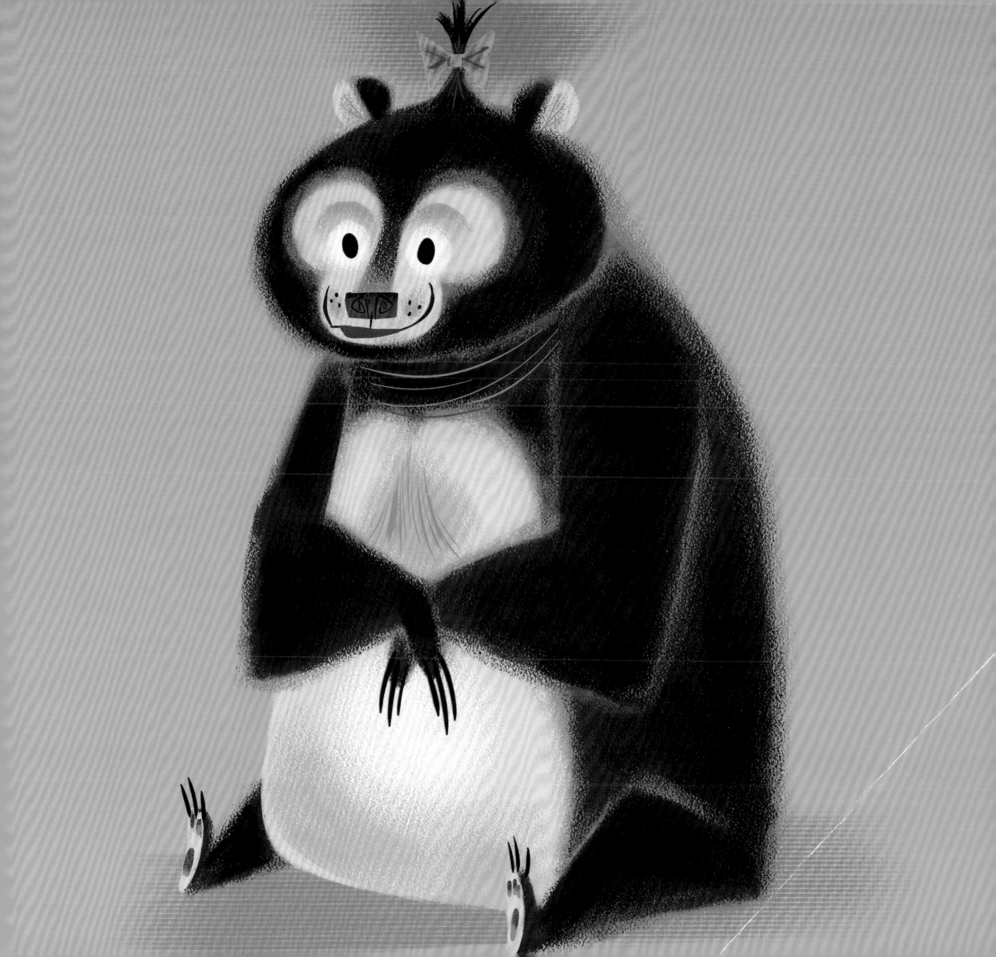

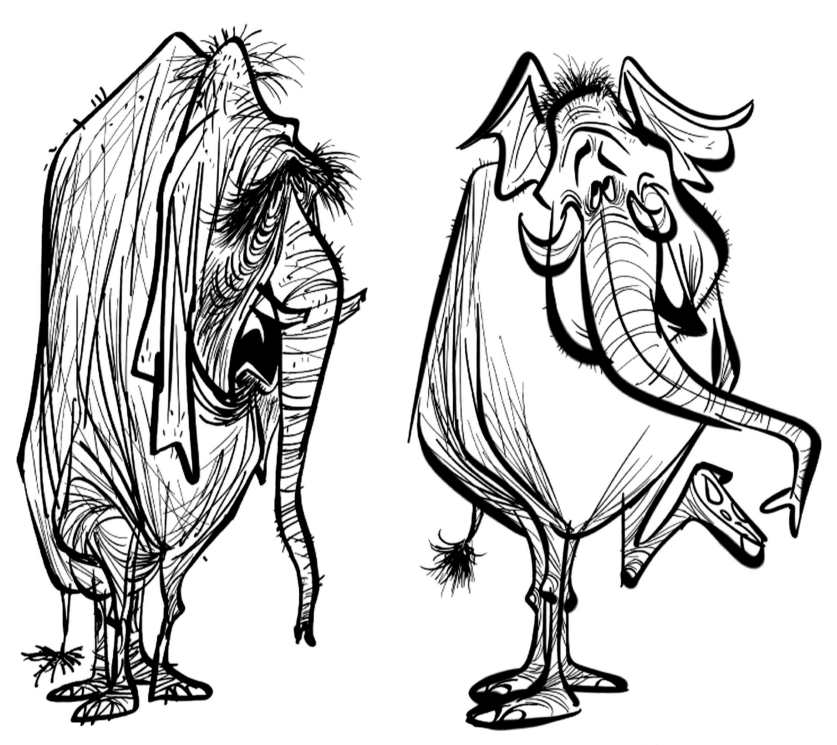

(ABOVE) Elephant Expressions • Craig Kellman
(OPPOSITE, LEFT) Horse Triplets Color • Craig Kellman
(OPPOSITE, RIGHT) Circus Dog Costume Exploration • Craig Kellman

DOGS, HORSES, AND ELEPHANTS

very circus needs dog, horse, and elephant acts. The six circus dogs—little terriers teetering on their hind legs while wearing top hats and chiffon dresses—look innocent, but they are hooligans who carry switchblades and chains. The Andalusian horse triplets, Ernstina, Esmerelda, and Esperanza, are more straightforward—enchanting beings who prance around in their headdresses. The two elephants are elderly and frail but do aerial acts by the end.

"All the animals are based on real circus animals," says production designer Kendal Cronkhite. "To turn them into *Madagascar*-style animals, they are designed with the same philosophy as all our other characters—straight lines juxtaposed against C-curved lines. When you translate straights against curves into 3D, you get lots of points and edges, which is vital to the design of the *Madagascar* world."

> **"The characters' non-anatomically correct proportions help make them believable. They don't look realistic, so you don't expect them to be realistic."**
>
> —Kendal Cronkhite,
> production designer

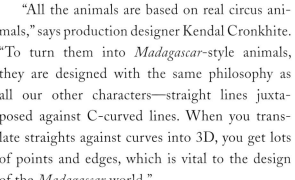

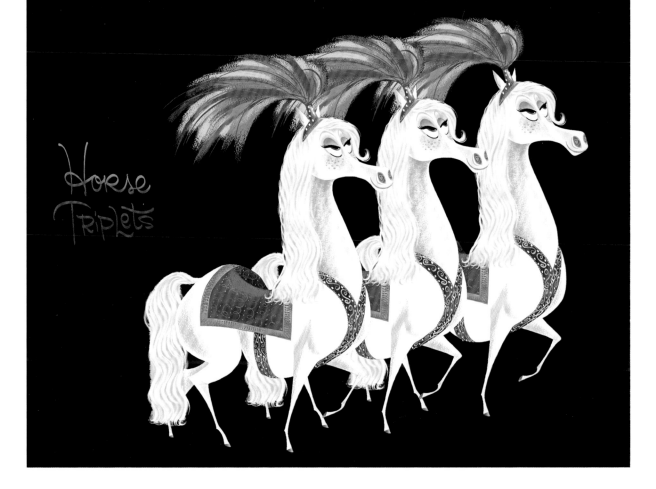

Horse Triplets

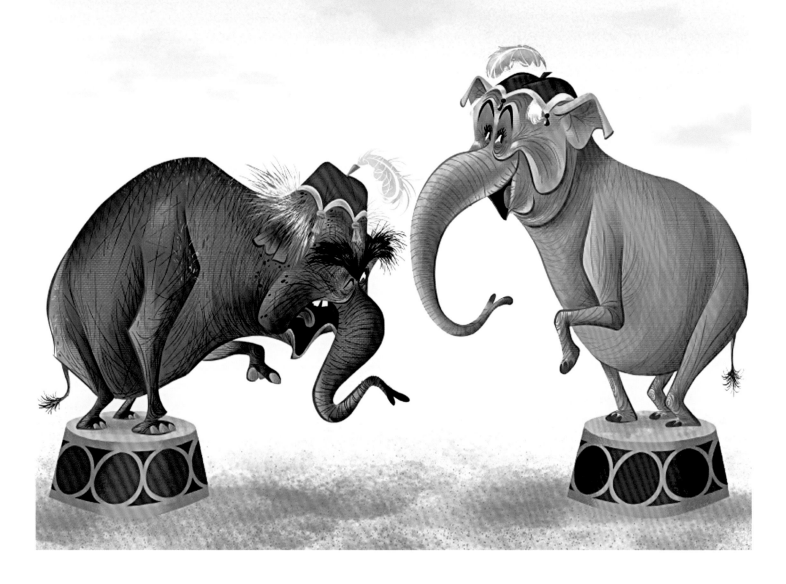

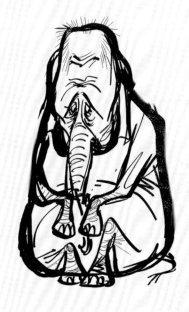
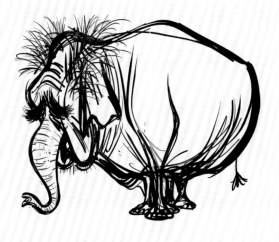

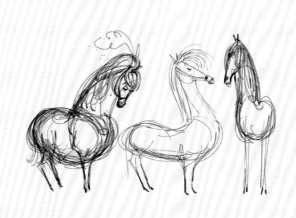

HUMAN CHARACTERS

Peppered throughout the film are human characters who step out of the background and play key roles. Two who carry important story points are the circus master and the promoter.

After the Zoosters slip onto the circus train, the Penguins hatch a plan to buy the circus with their winnings from the casino. The Chimps dress up as the King of Versailles again and arrange to meet the circus master and his clowns in the French countryside.

"The circus master is one of our background characters who we promoted to a hero character," says production designer Kendal Cronkhite. "He's heavyset with a waxed moustache and goatee, and like an old world ringmaster, he wears a brocade velvet vest. Like all our background characters, he has pushed proportions—a big, long head on a square body with little hands and feet."

"We were inspired by traditional European circuses when we designed our clowns," says Cronkhite. "We have the smart clown with a white face and peaked hat; a bumbling one with a big red nose; and a clown with whiteface, arched eyebrows, and red hair that sticks out. We also have background clowns. I wanted a variety of European clowns with the tent-shaped shirts, short pants, white socks with little shoes, and ruffled collars. We don't see them much, but they are in the scene when the Zoosters buy the circus."

In that scene, the king dumps a pile of gold and silver on an improvised circus-crate table. The circus master happily trades the circus deed for this treasure, and then he and one clown after another, and another, and another, and still another climb into a too-small car and drive away laughing uncontrollably.

In Rome, Dubois hops on a parked scooter to chase after Sonya and Julien. The scooter is one of many parked along a street. When she pulls away, a long tail of scooters goes tumbling behind her, quickly catching the eye of the local *polizia*. When the designers created Monaco's ACONs, they

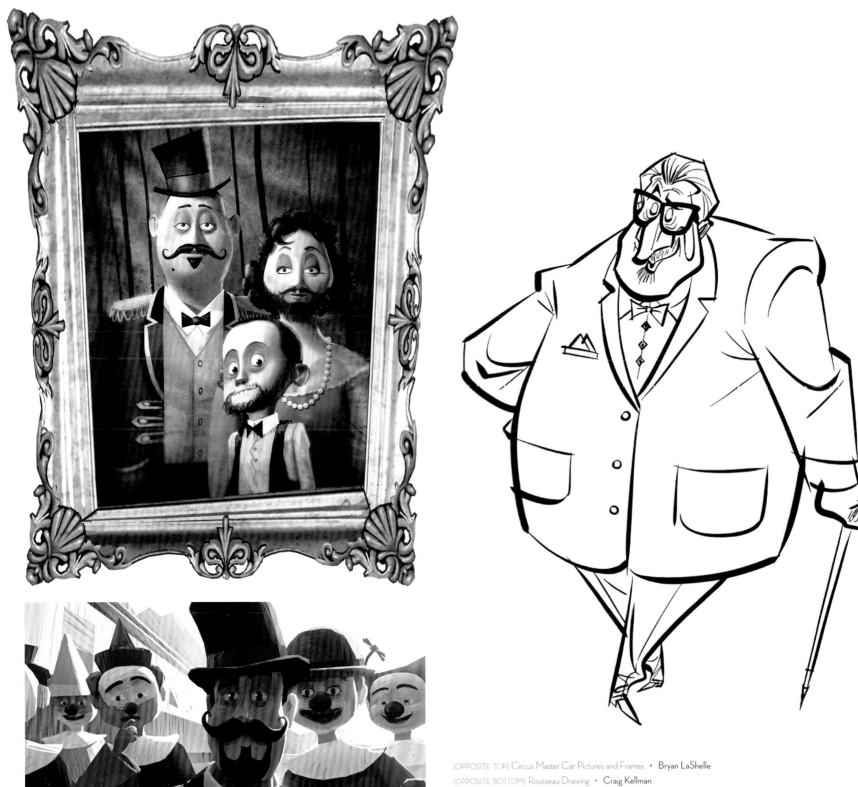

(OPPOSITE, TOP) Circus Master Car Pictures and Frames • Bryan LaShelle
(OPPOSITE, BOTTOM) Rousseau Drawing • Craig Kellman
(TOP LEFT) Ringmaster and Clowns • Erwin Madrid
(LEFT) Circus Master Car Pictures and Frames • Bryan LaShelle
(ABOVE) Rousseau Drawing • Craig Kellman

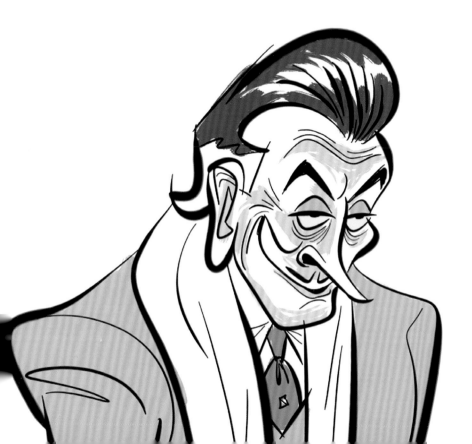

started with six, and then reduced the force to four. To create the Italian police, they put the two ACONs who had been left on the cutting room floor in new uniforms and reassigned them to Rome. One is tall and skinny, the other a rectangle. "We changed the color of their uniforms, their hair, their sunglasses, and the shape of their hats to make them a little different," says Cronkhite.

Finally, in London, the Zoosters meet the promoter they hope will take their reinvented circus to New York. They spot him easily in the British audience. "He was originally supposed to be the man who owned the casino," says Cronkhite. "So when he got cut, we had this great design that we turned into the promoter. We decided to make him the most ridiculous American character ever. He's a big, bulky character that wears an elaborate white cowboy costume. He has a forty-gallon hat and he carries a bald eagle. We wanted to make him as funny visually as possible."

(OPPOSITE) *Rousseau Color* • Craig Kellman
(TOP ROW) *Lord and Lady Rondelet Exploration* • Craig Kellman
(LEFT) *Rousseau Exploration* • Craig Kellman

CROWDS

The artists working on *Madagascar 3* decided to create crowd characters in the same graphic style as the main human characters, which was an incredible challenge considering how many extras populate the film's urban environments.

With this intention, modelers set a goal of making every crowd person look different from the next, a concept that is easier to accomplish in 2D illustration than in 3D animation. Working with Craig Kellman's character designs under Kendal Cronkhite's guidance, the modeling team was able to create six male, six female, and three child body types, along with a variety of interchangeable heads they could mix and match to create a cohesive crowd of unique characters.

"We wanted to give our crowds the same playfulness as our main characters," says head of character animation Rex Grignon. "Europe gave us the opportunity to see people different from ourselves and have fun with that."

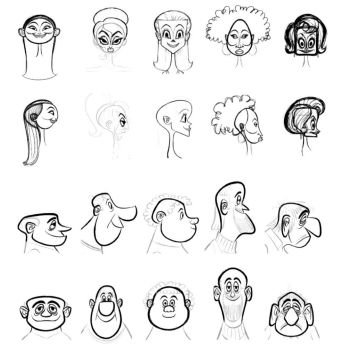

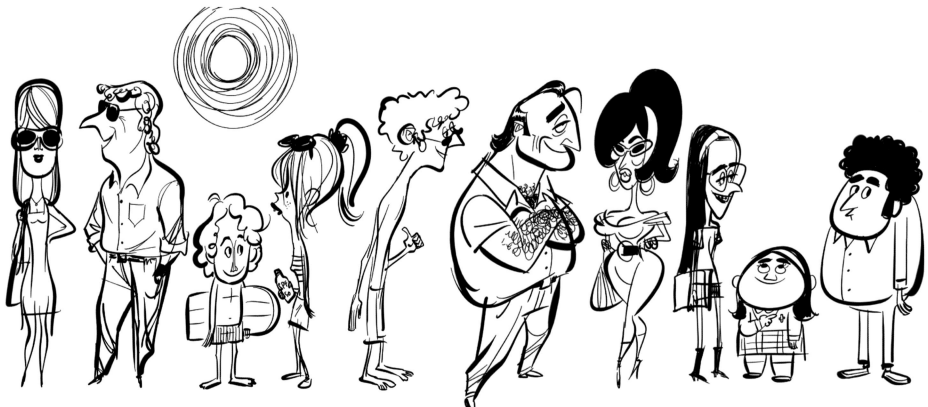

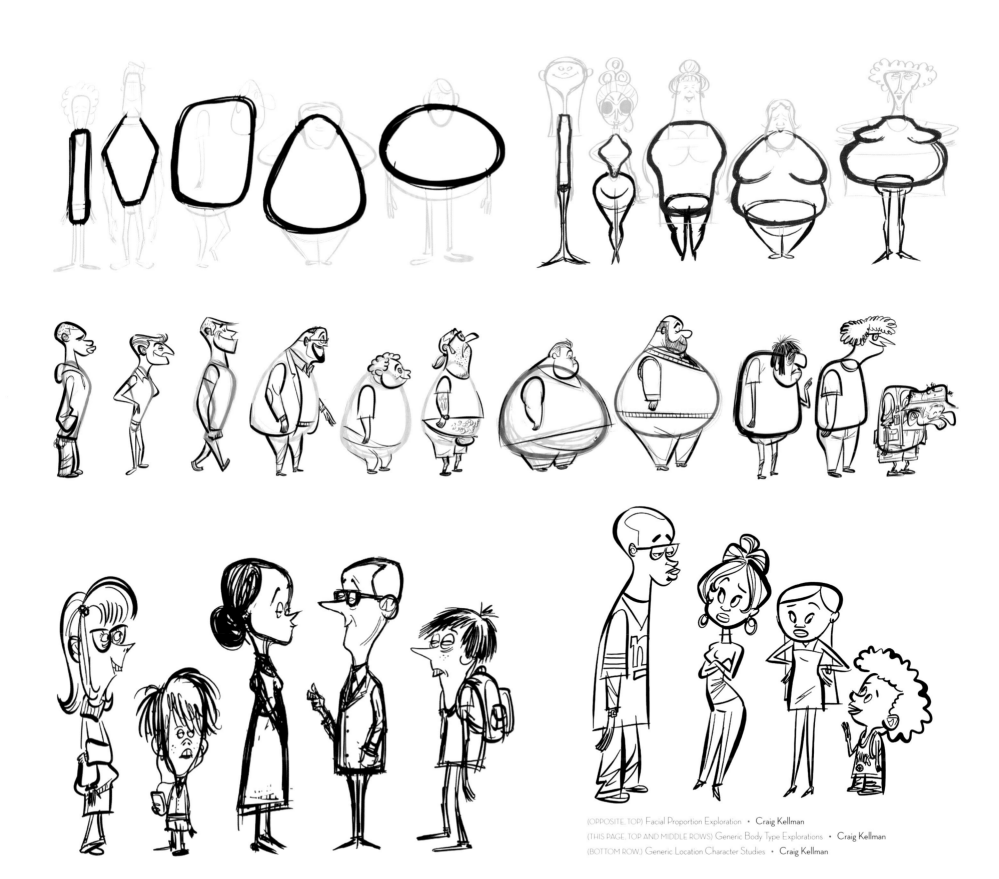

(OPPOSITE, TOP) Facial Proportion Exploration • Craig Kellman

(THIS PAGE, TOP AND MIDDLE ROWS) Generic Body Type Explorations • Craig Kellman

(BOTTOM ROW) Generic Location Character Studies • Craig Kellman

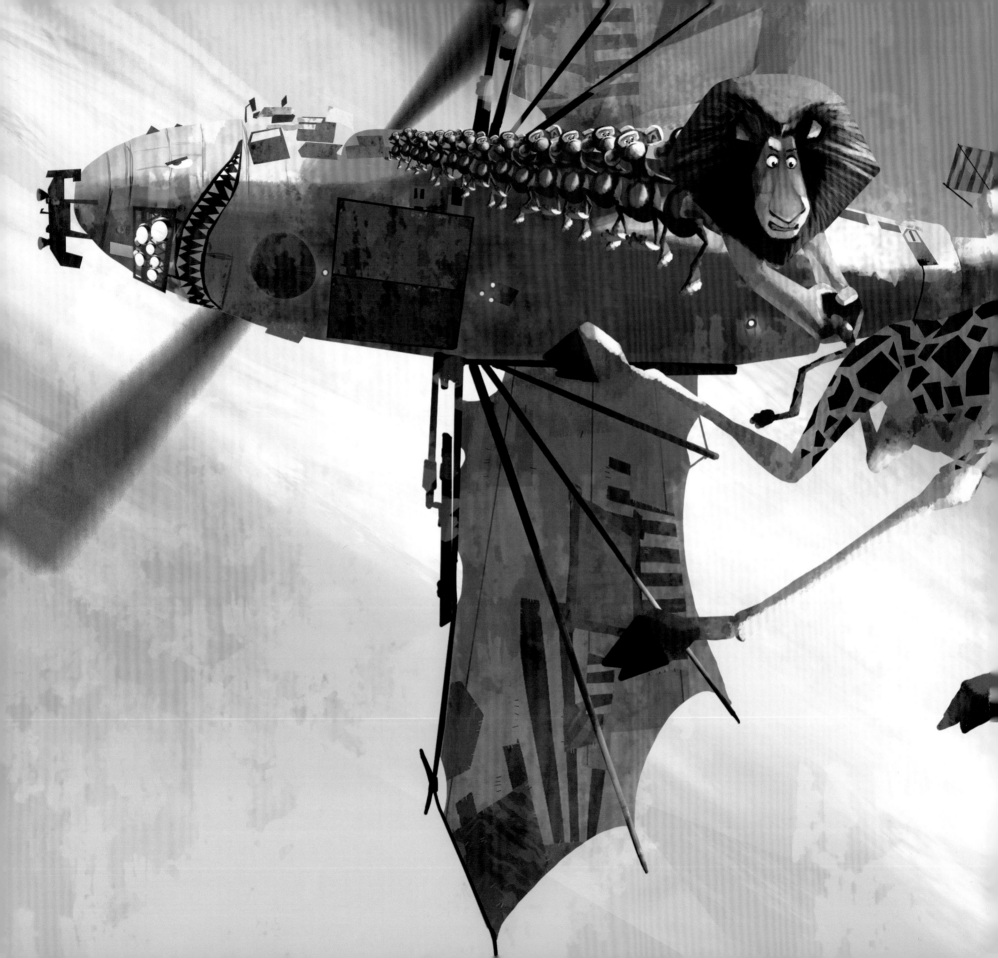

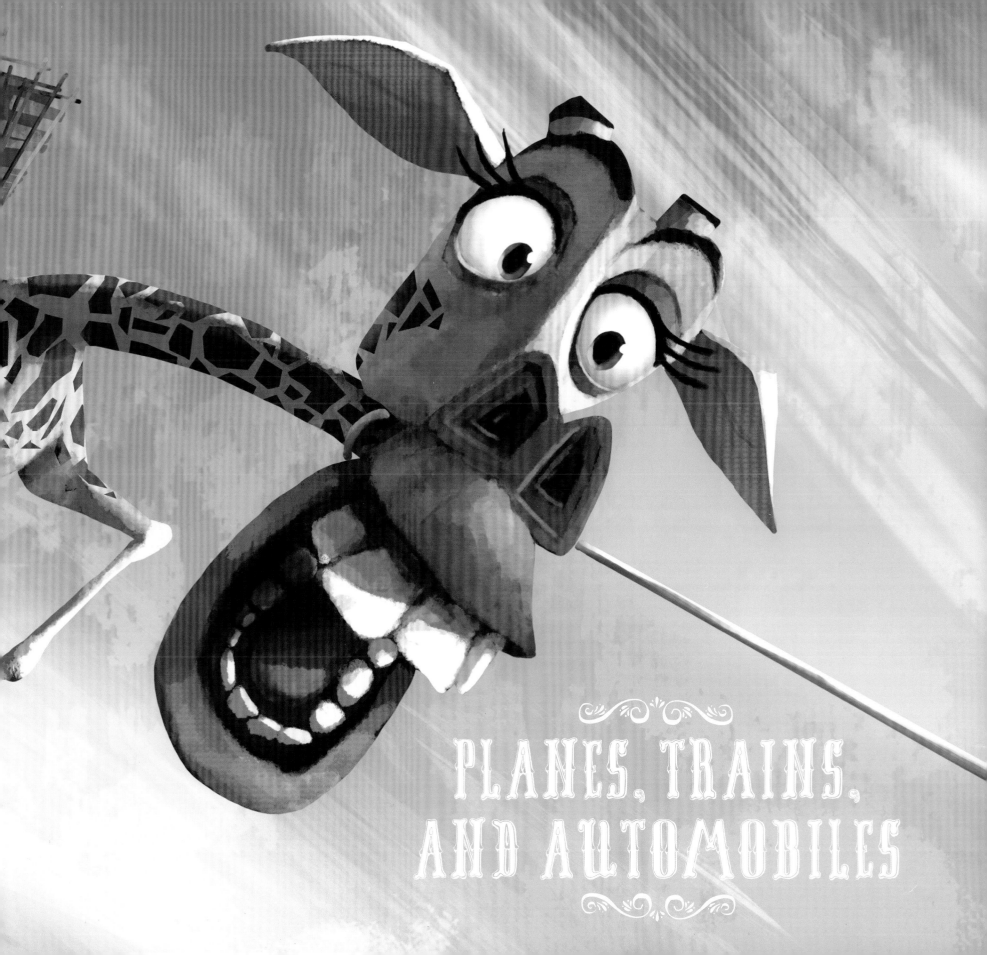

PLANES, TRAINS, AND AUTOMOBILES

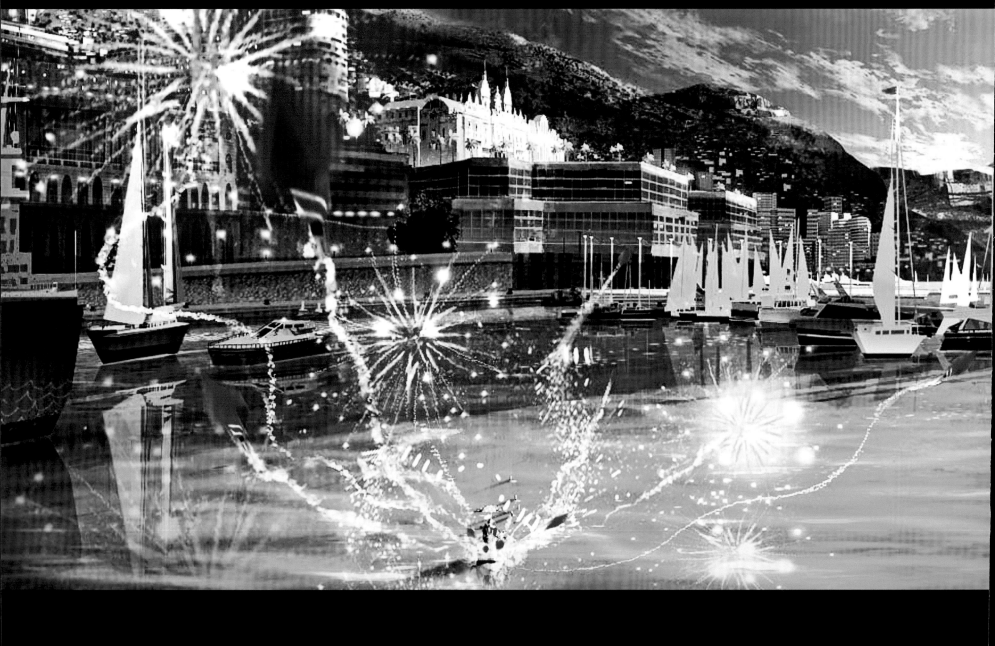

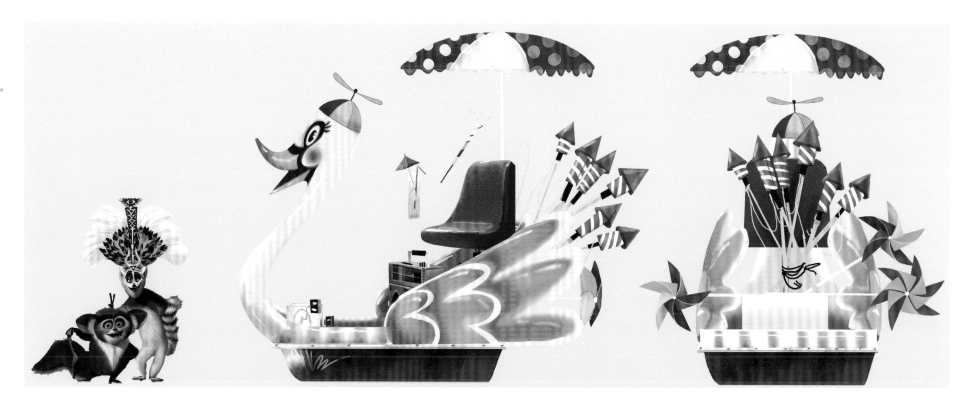

JULIEN'S BOAT

The sun comes up over a Mediterranean Sea as placid as glass when, one by one, the Zoosters rise up out of the water in snorkeling gear. They're in stealth mode. They talk quietly. But a quiet entrance is not in King Julien's repertoire.

Originally, the designers had floated Julien to Monaco in an inflatable ducky boat, but the directors wanted something more over the top. "So Lindsey Olivares came up with the silliest design," says production designer Kendal Cronkhite. "The boat is a swan with a multicolored surface. It wears a beanie with a propeller on top and has rockets in the back."

Julien sits on the swan's head and sips a drink while Mort sits on the floor cranking the foot pedals with his arms. Maurice blasts out the loudest, most ridiculous music you could imagine and lights the fireworks. "When the Zoosters arrive in Monte Carlo, Alex tells everyone to be quiet, but King Julien thinks he's telling everyone to do 'the clandestine,' like it's a dance," says director Conrad Vernon. "So we had him light huge fireworks, to be the punch line for the joke. We started with just a few, but when Jeffrey [Katzenberg, DreamWorks CEO] saw it, he said, 'We're wearing 3D glasses. Shouldn't it be crazy?'"

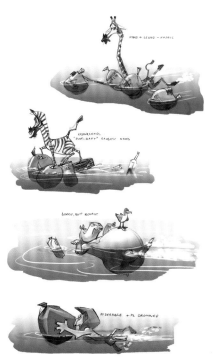

(PREVIOUS SPREAD) Melman Gets Saved • Goro Fujita
(OPPOSITE) Casino Fireworks • Ken Pak
(TOP) Swan Paddle Boat • Lindsey Olivares
(ABOVE) Trash Floats • James Wilson

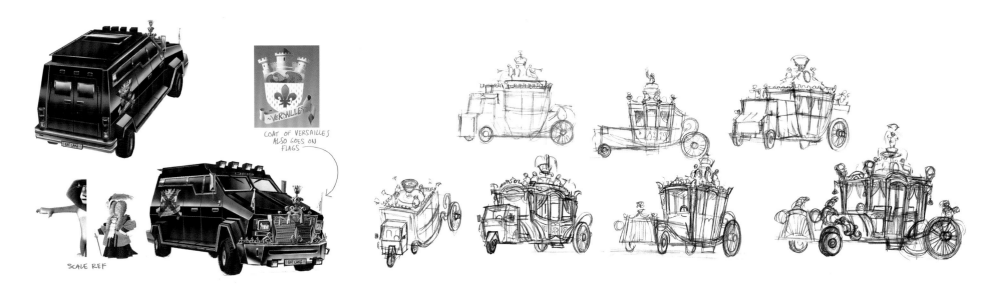

COAT OF VERSAILLES ALSO GOES ON FLAGS

SCALE REF

THE LARV, SCOOTERS, AND OTHER VEHICLES

When you have an urban environment, you must fill it with vehicles, and *Madagascar 3* has thirty-six different types, including Dubois' scooter, her animal control officers' scooters, delivery vans, and various cars. The cars are variations of one model, which is based on a generic European design, but with a different palette of colors to complement each location. For the scooter, the designers referenced European scooters and painted them with Dubois' iconic red. These vehicles are exaggerated, but fairly normal. The Penguins' Luxury Assault Recreational Vehicle (LARV), which they cobbled together from a variety of sources, is not.

"We started with a horse-drawn carriage," says production designer Kendal Cronkhite. "But that seemed more connected to the King of Versailles than the Penguins who rigged it. So we went with the kind of high-security vehicle used to deliver money to banks because that suited the Penguins well. Skipper rides in a kid's car seat and has a plastic steering wheel with a horn. It doesn't do anything. He uses it like a kid would."

Inside, the clever birds added a nuclear reactor and fitted the LARV with an aquarium that, at the press of a button, can spew an oily mess full of flipping and flopping fish onto the street. When the oil spill happens, screens inside show graphic imagery of fish moving through the car.

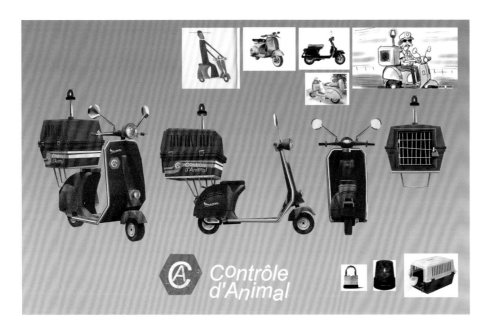

(OPPOSITE, LEFT) LARV Design and Versailles Coat of Arms • Alex Puvilland
(OPPOSITE, RIGHT) King of Versailles Carriage Concept • Alex Puvilland
(LEFT) ACON Scooters • Goro Fujita
(BELOW) Skipper's Seat Prop Page • Alex Puvilland
(BOTTOM) LARV in Atrium • Erwin Madrid

THE MONKEY PLANE

Once again, as in *Madagascar: Escape 2 Africa*, the Penguins' monkey-powered superplane lifts the Zoosters out of danger only to land them in a new adventure. This time, the Zoosters climb up a monkey-chain ladder to get aboard the ship, ending the harrowing car and scooter chase in Monte Carlo and putting Dubois' pursuit to an end for the time being. The monkeys fire on her with an onboard Gatling gun, which shoots banana bullets. She dodges them and hooks onto Melman with a noose, which Alex slices with his claw. Relieved, the Zoosters believe they're on their way home, but a gear soon drops off, a wing flies away, and the superplane nose-dives into a train yard, never to fly again.

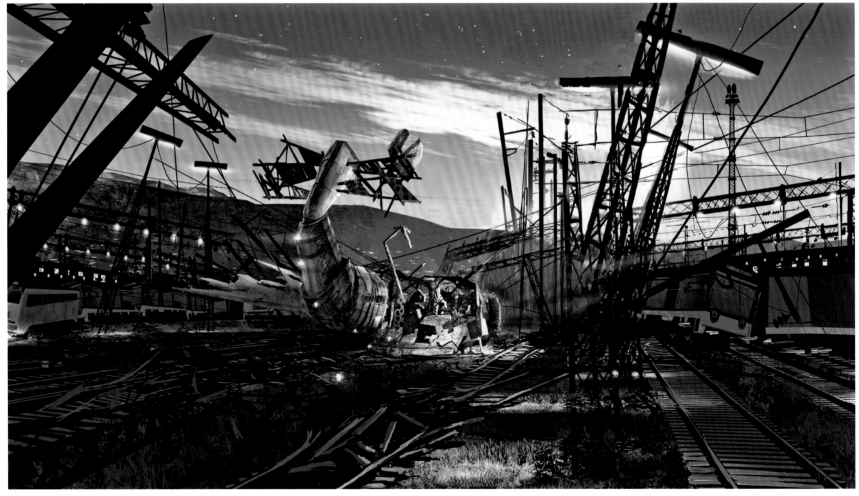

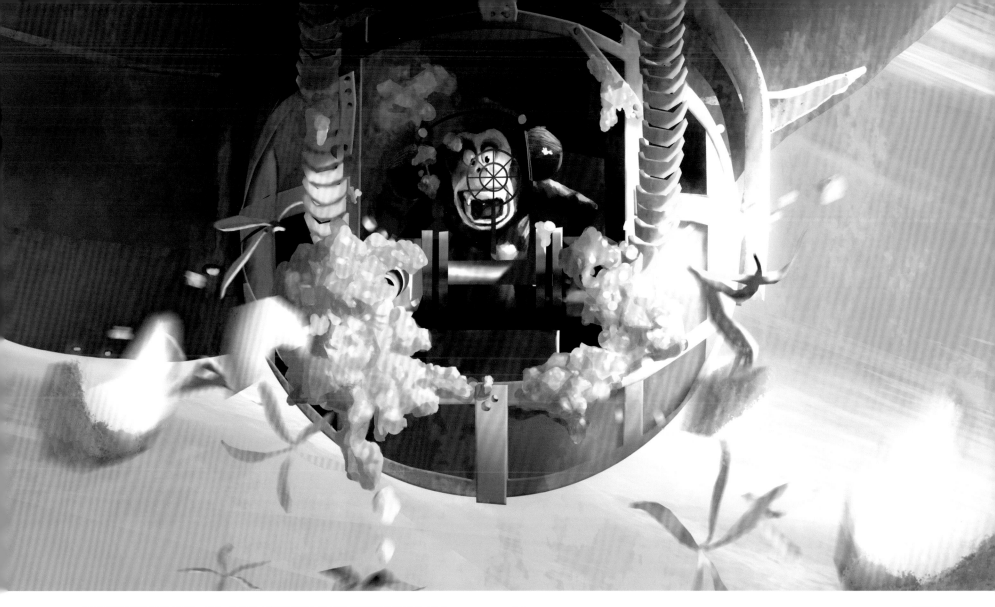

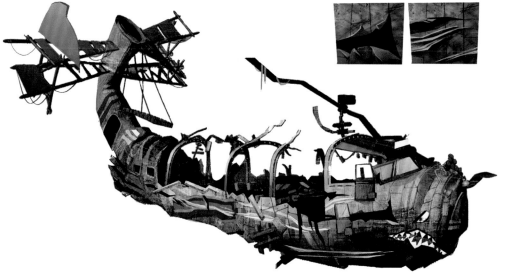

(OPPOSITE, TOP) Alex's Blimp • Kendal Cronkhite
(OPPOSITE, BOTTOM) Plane Crash • Ken Pak
(TOP) Banana Gun • Goro Fujita
(ABOVE) Banana Peels Drop • Goro Fujita
(RIGHT) Plane Destroyed • Stevie Lewis

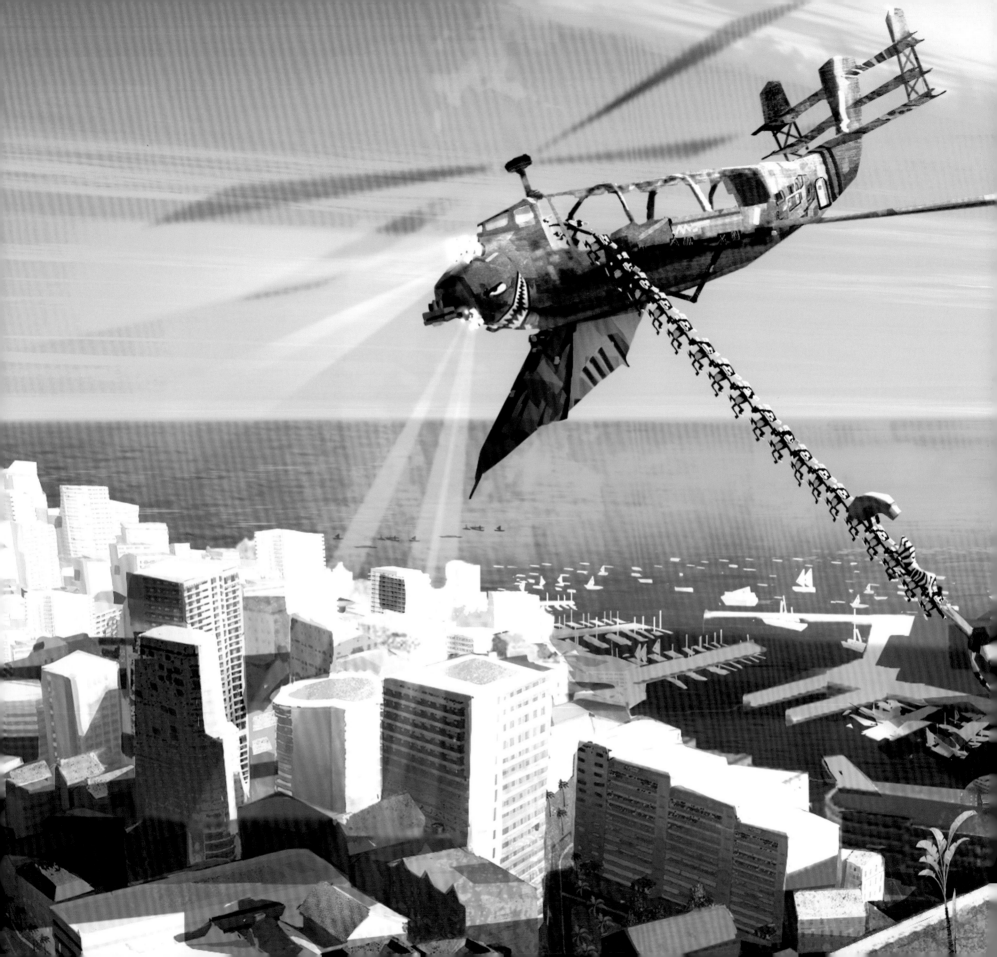

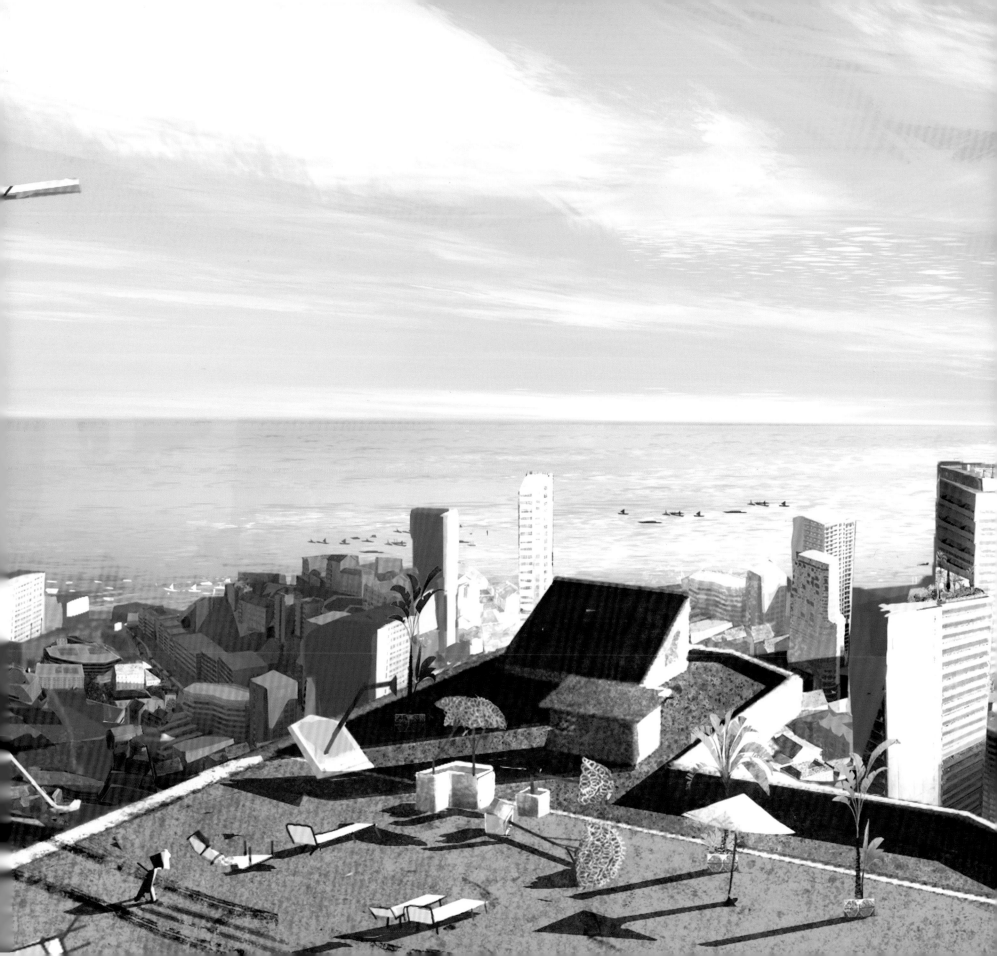

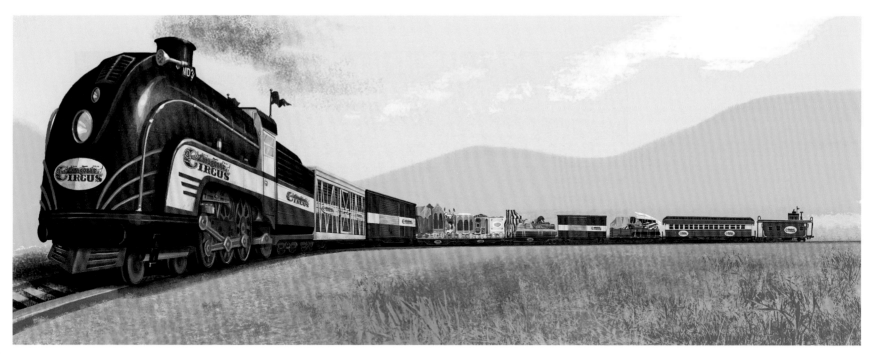

(PREVIOUS SPREAD) Monkey Plane Drag • Ken Pak
(ABOVE) Circus Train Vis Dev • Shannon Jefferies
(BELOW) Zaragoza Circus Logo • Vy Trinh

THE CIRCUS TRAIN

Once Alex convinces Vitaly to let the Zoosters on board the circus train, it becomes their mode of transportation and their refuge. They ride it to Rome and jump on board again in time to escape the furious mob that attended the bad circus. It takes them into the Alps and on to London. "The moment we put these animals on a train traveling through Europe, the story just took off," says head of story Rob Koo.

The train has as many as sixteen cars arranged as needed for specific shots: a boxcar, four flatcars, four stock cars, the circus master's car, a generic passenger car, Vitaly's car, Sonya's car, the engine, a coal car, and a caboose. Originally, the story called for an old train and a new train, but that idea changed.

"We decided to focus more on the acts and how the characters change in the story than how the train changes," says art director Shannon Jefferies.

When they aren't setting up, taking down, or performing in the circus, the Zoosters are often on board the train, which is one of the film's prime locations. Julien falls in love with Sonya in her bear car, which she has decorated with giant claw marks and littered with fish bones and fish heads. Alex learns about Vitaly's past by discovering the framed posters, photos, and reviews in the circus master's car. "We wanted it to feel otherworldly to the Zoosters," art director Shannon Jefferies says. "To be a rich, Victorian, textural space with colors in the reds and blues of the circus, and with lots of gold leaf details—like something they've never seen before."

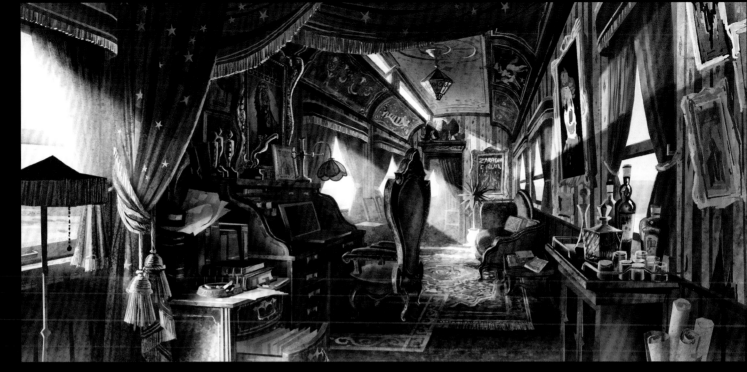

(TOP) Circus Master's Car Interior • Alex Puvilland

(ABOVE) Sequence 1150 "Stowaways" Color Keys • Goro Fujita

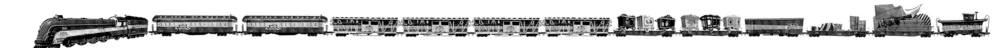

(TOP) Full Circus Train • Bryan LaShelle
(ABOVE) Circus Wagons • Bryan LaShelle
(RIGHT) Train Vis Dev • Shannon Jefferies
(OPPOSITE, TOP) Boxcar • Bryan LaShelle
(OPPOSITE, MIDDLE) Passenger Car • Bryan LaShelle
(OPPOSITE, BOTTOM) Train Caboose • Bryan LaShelle

Vitaly gathers his courage and practices his act in the caboose. And, at the opposite end, the Penguins run the engine room and drive the train.

Designed to a human scale, the train feels a bit small for the big animals. At times, the designers had to increase the size of a chair just enough to allow an animal to sit in it. "When we needed to fit several characters in a car, we sometimes stretched it horizontally," Jefferies says. "We could only get a couple feet, though, because we based the train on a rail system, and it was rigged to ride on the rails, so we couldn't move the wheels."

The train is an old-fashioned steam engine. "I looked at trains and circuses from the 1930s and '40s," says Jefferies. "Those designs and color palettes. I wanted to play with steam engines."

"The art department did a fantastic job creating a sleek-looking train," says director Conrad Vernon. "It's a little Steampunk-ish, but bright red, blue, yellow. Each car has an interesting design with great paintings on the side."

An opportunity to feature the train rolled into view when the directors realized they needed a transition between the scenes in which Alex and the Zoosters buy the circus and when Julien meets Sonya for the first time inside her train car.

"The train doesn't speak, but it definitely has a personality in its design, and we tried to give it a voice," Vernon says. "We panned down the side of the train to show off how it looks, and then we show the Penguins in the engine car. They throw coal into the burner, and steam puffs out. All four of them hop around checking gauges and spinning wheels. They pull chains. And as the train starts chugging along, the sounds of all these things happening turn the sequence into a rhythmic musical number."

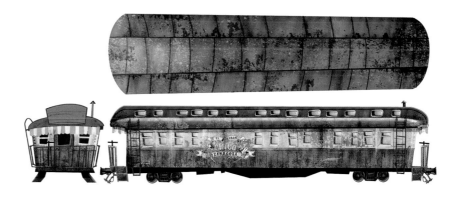

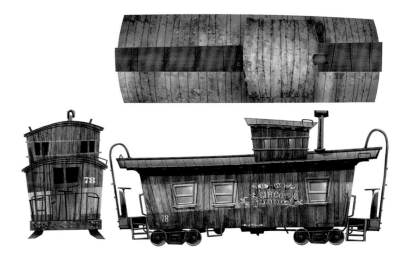

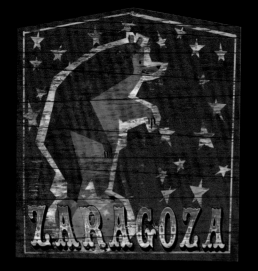

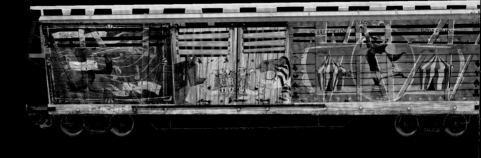

"In the last two movies, the Zoosters went to places where the human world doesn't exist. In this movie, they come into contact with the whole of Europe. That changes things."

—Mark Swift, producer

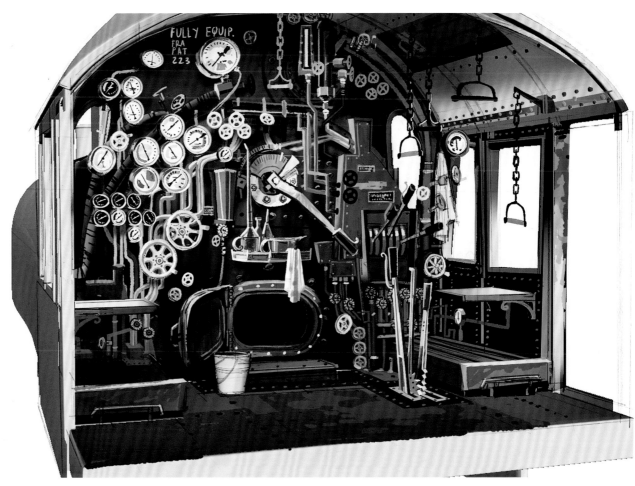

(OPPOSITE) Circus Master Bear Car Murals/Ceiling Panels/Train Car Murals • Bryan LaShelle

(LEFT, TOP TO BOTTOM) Entering Circus Master Car • Bryan LaShelle ⚡ Alex and Posters • Bryan LaShelle ⚡ Trophies • Ruben Perez ⚡ Stefano • Bryan LaShelle ⚡ Stefano and Clippings • Ruben Perez ⚡ The Amazing Vitaly • Ruben Perez ⚡ Alex and Stefano • Ruben Perez

(ABOVE) Train Engine Interior Design • Alex Puvilland

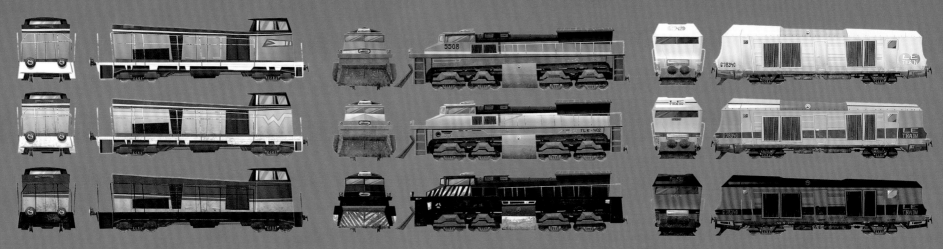

(ABOVE) Generic Trains Color · Travis Koller

(ABOVE) Circus Master Car Rugs · Bryan LaShelle

(ABOVE) Circus Master Car Prop Page · Bryan LaShelle

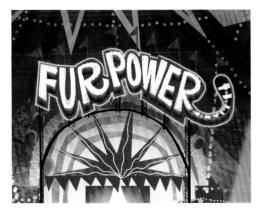

(ABOVE) Fur Power Logo • Lindsey Olivares
(BELOW) New Circus Train • Bryan LaShelle

"The train is an incredibly rich environment. The surfacing textures are beautiful. And I'm excited about what effects did with the smoke."

—Shannon Jefferies, art director

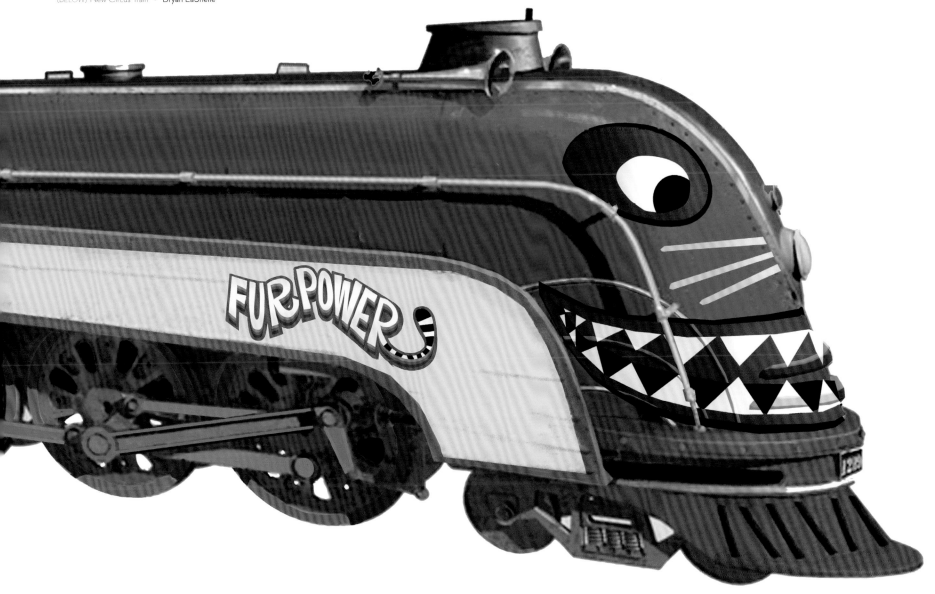

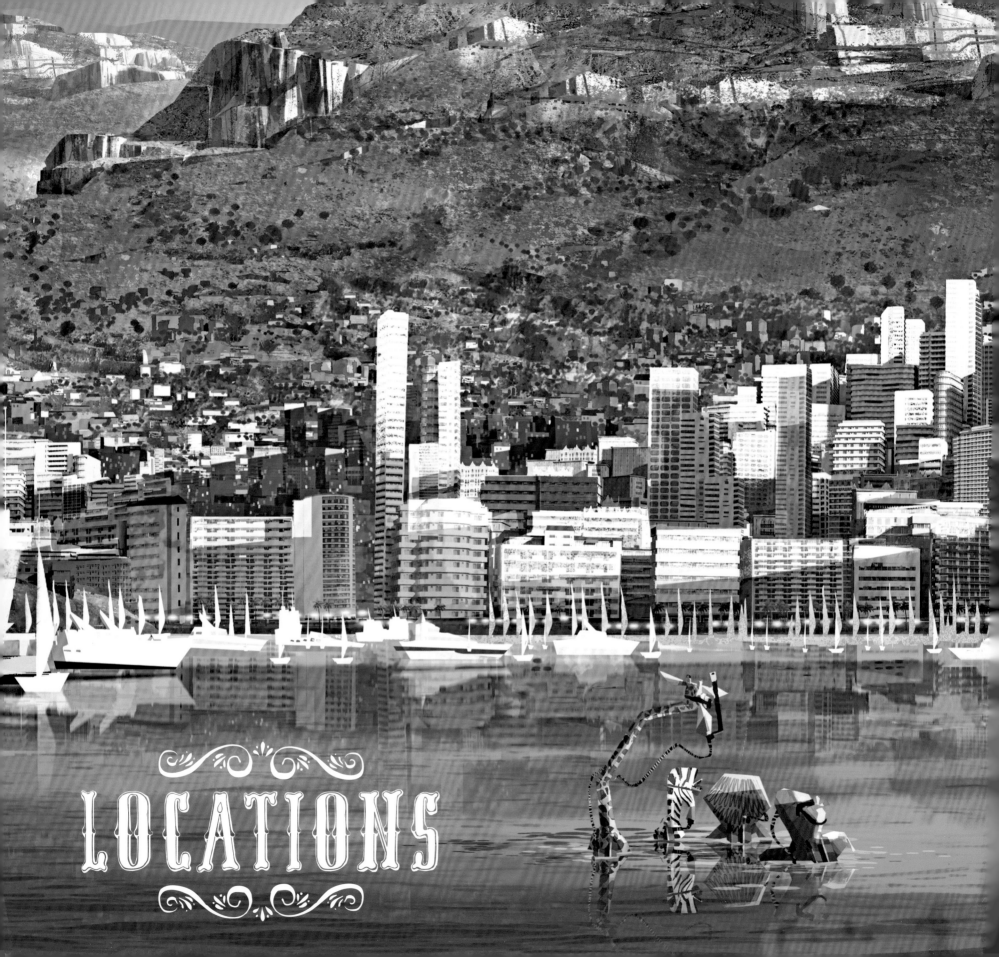

LOCATIONS

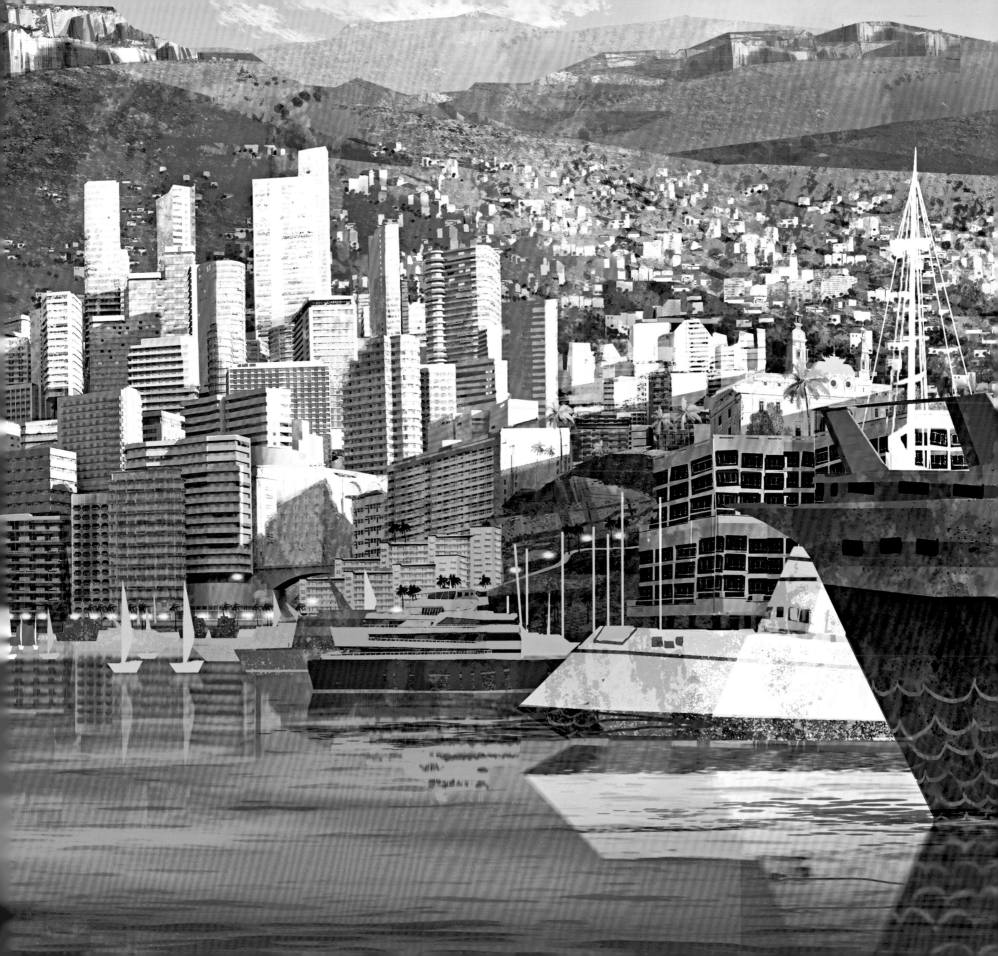

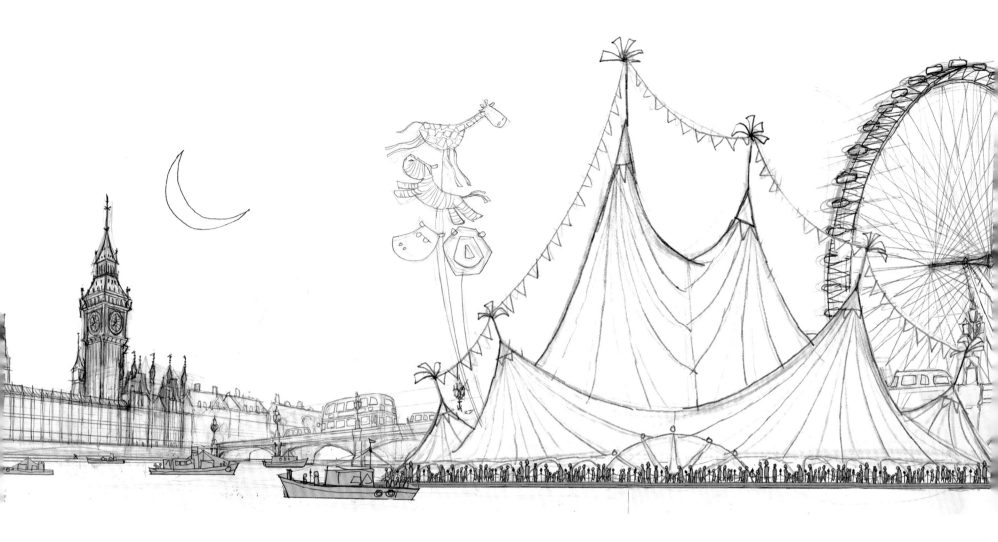

URBAN JUNGLES

Madagascar 3 is a travelogue. The Zoosters start in Africa, immediately go to Monaco, travel through Europe, and eventually return to New York, where their adventure began two films ago. Their lengthy journey took the visual design for the film on an exciting ride, as well.

"Our key visual challenges in the film were the cities, the circus, and the villain," says production designer Kendal Cronkhite. "We used the characters as a basis for establishing the world and moved forward into it. Whatever rules the characters go by, the world goes by. Also, in this film, because they're traveling, we wanted to push the differences between the environments to heighten that sense of travel. So each location has a specific point of view."

The film begins on a bright, hopeful note in the glamorous city of Monte Carlo, where the Zoosters and Lemurs reunite with the Penguins and Chimps. "We went with a '60s groovy, glitzy, retro point of view and a very Mediterranean color palette for Monte Carlo," Cronkhite says.

"Its visual language is horizontal, and the buildings have a clean '60s design. The shadows are blue and filled with light."

After they escape Monaco, the Zoosters buy a circus in a train yard in France and travel with the circus animals on an old train to Rome. "The thought of putting a circus tent in the middle of the Roman Colosseum was hard to resist," says director Eric Darnell. "And because Rome is so different from Monte Carlo, it was a great opportunity for the artists."

Rome is more textural than Monaco, and the palette is warmer, more terra-cotta. "We really wanted to push the age," Cronkhite says. "There are lots of angles and unevenness. The colors are burnt sienna, ochre. The shadows are dark, umber to black."

From Rome, the circus travels to London, but on the way the Zoosters stop the train in the Alps, where Alex inspires the circus animals and his friends to create a new kind of circus. "In the Alps, we used ultramarine blues against the greens of the

"What's really great about this movie is the breadth of it. The art team had their hands full, but they did a fantastic job. The film is beautiful because of all the exotic locations."

—Conrad Vernon, director

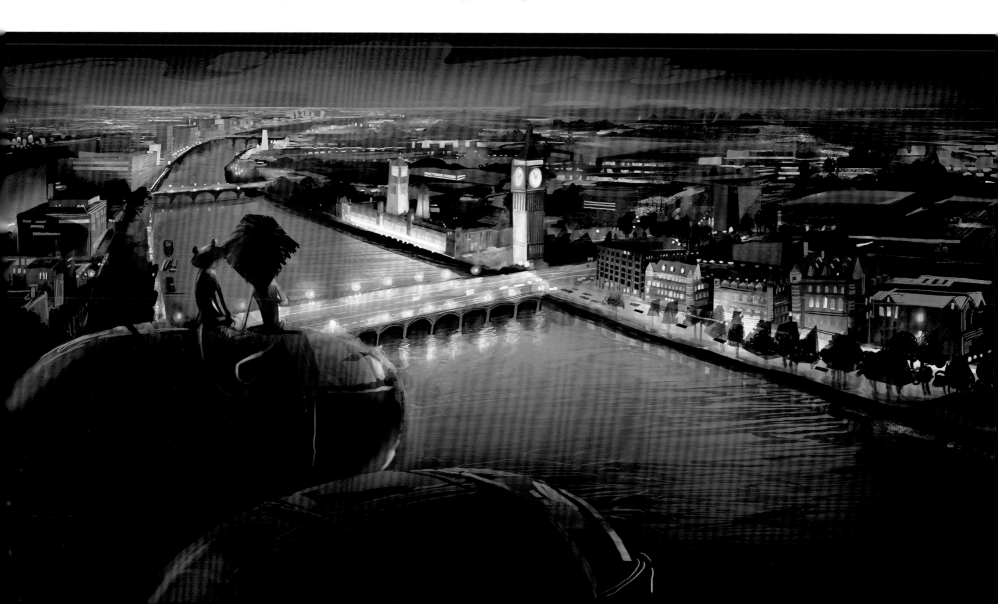

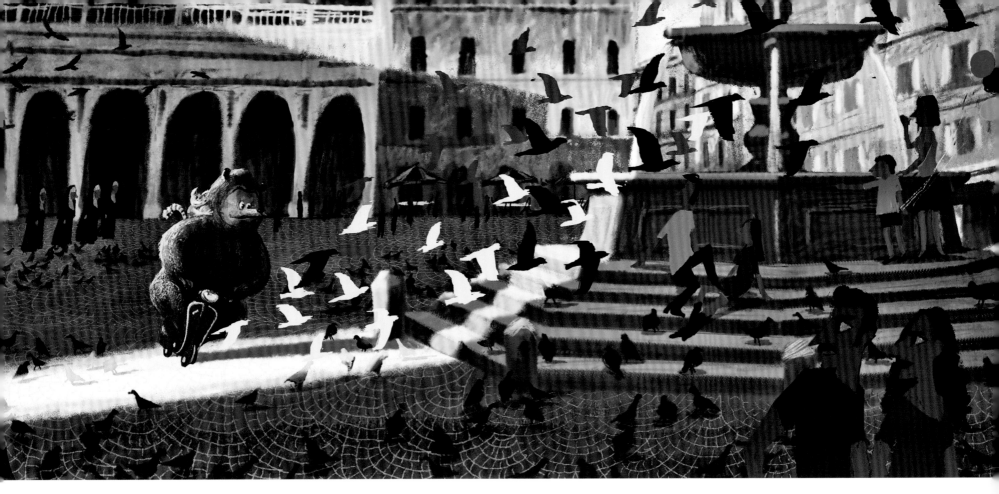

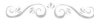

> " The idea is that this is a believable world. So, whatever design rules the characters go by, the world goes by. "

—Kendal Cronkhite, production designer

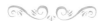

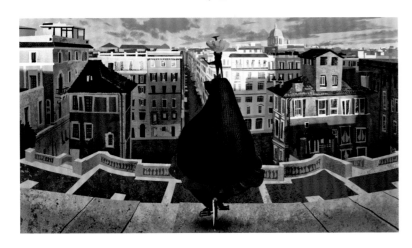

valleys," Cronkhite says. "The characters are exposing their fears and taking risks here in the story. We wanted to create an open-to-the-sky and exposed-to-the-elements feeling for them."

London, by contrast, is all business. "We think of London as a pin-striped suit," Cronkhite says. "It has a conservative, rectilinear look."

After London, the Zoosters finally make it back to New York, where they discover that the city hasn't changed a bit since they ran away from the zoo. "We wanted to show how much the Zoosters have changed since they left, and how little New York City (their home) has changed," Cronkhite says.

Within these locations, two visual keys act as indicators for the film's mood, strengthening the emotional registers of the narrative. One key is the circus, which is sad, desaturated, and shabby until the Alex inspires all the animals to follow their passions and create a new kind of circus. The reinvented circus is bright, exciting, kinetic, and multicolored.

The second visual key is Dubois. "When she first comes into the Monaco chase, we use a low camera angle and cut shadows from the buildings across her, so it's light, dark, light, dark, which creates a lot of visual chaos," Cronkhite says.

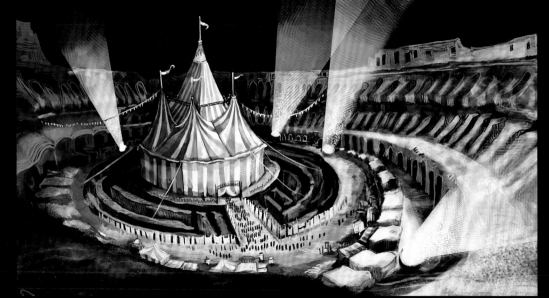

(OPPOSITE, TOP) Rome Birds Vis Dev • Yoriko Ito
(OPPOSITE, BOTTOM) Steps of Rome • Stevie Lewis
(LEFT) Circus Colosseum Wide Vis Dev • Lindsey Olivares
(BELOW) Tent Colosseum Color Vis Dev • Lindsey Olivares
(BOTTOM) Tunnel Exit • Ken Pak

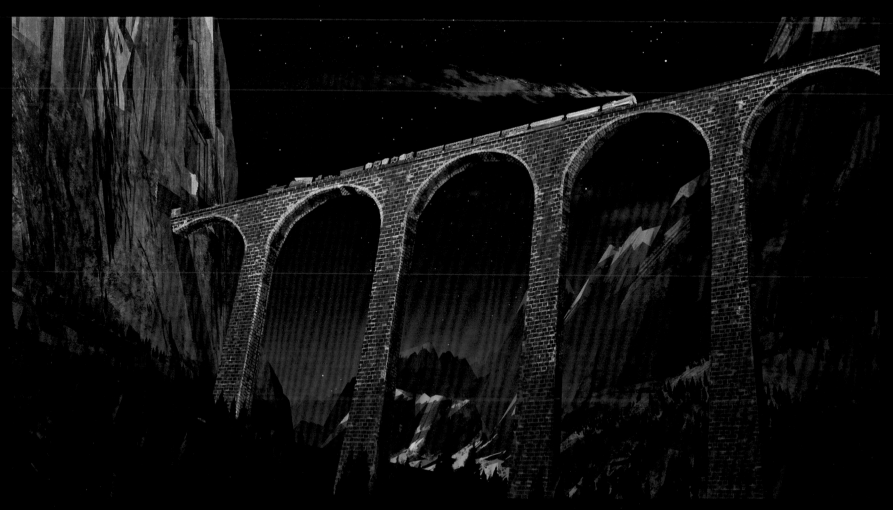

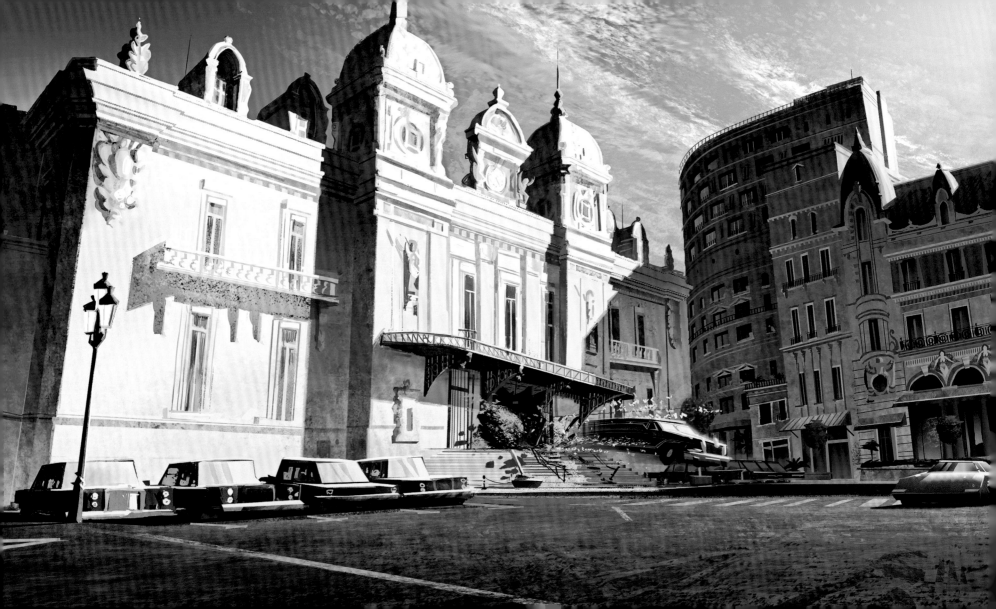

Japanese illustrator Tadahiro Uesugi's style influenced the lighting. "He uses blown-out lights, light-filled shadows, and black shadows," Cronkhite says. "And he uses a saturated line to distinguish between light and shadow. We might have a blown-out white building with a bright blue shadow, and where the light and shadow meet is an orange line. It's an effect our lighting team can get now, and it even works with our characters, so it really ties the two together."

Cronkhite also derived inspiration from the work of Miroslav Sasek, whose books had influenced the set designs for *Madagascar*'s New York. With Sasek's style in mind, artists for the first film had created a "whack" factor for New York's buildings, giving them disproportionate windows with one side longer than the other. For *Madagascar 3*, they took things even further, making them a degree more abstract. "When artists like Sasek sketch buildings, they don't draw in every window," Cronkhite says. "They indicate them. So we have that loss of detail, especially as our buildings recede in space. It draws your eye where you want it to be."

(OPPOSITE) Busting Out Casino · Ruben Perez
(TOP) Hospital · Lindsey Olivares
(ABOVE) Downtown Monte Carlo Building · Lindsey Olivares

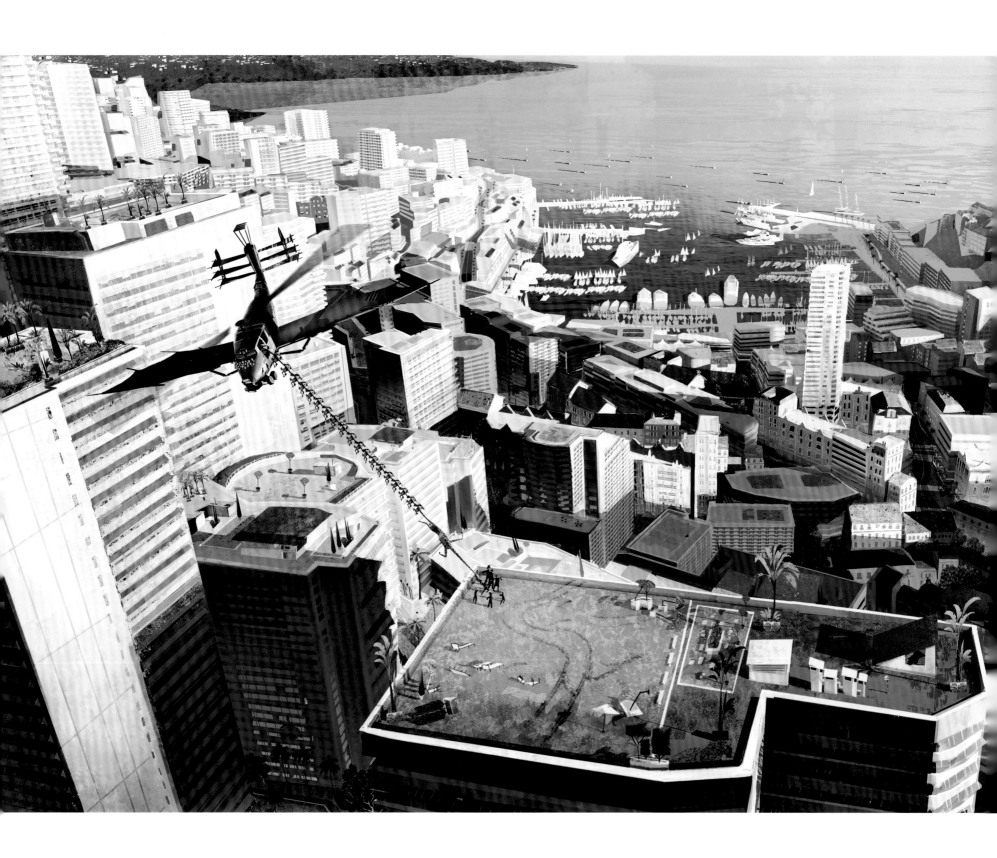

MONTE CARLO

To gather reference material for the sequences set in Monte Carlo, Monaco, production designer Kendal Cronkhite traveled to the sparkling Mediterranean gambling mecca and brought back hundreds of photographs. "When I looked at the photos," says art director Shannon Jefferies, "the images looked like stacks of money and casino chips. Everything in Monte Carlo felt horizontal. So I put together a folder of images that showed horizontal patterns we could use to represent Monte Carlo: the buildings, the rocks, the way we approached the water, everything. Even the trees on the hills have areas of growth that take on horizontal patterns. We wanted to treat everything with this textural language. It's very clean, 1960s groovy."

All told, artists designed the casino, several interiors, and forty types of building exteriors, with three to four versions of each of the latter, from most detailed to least detailed. Set dressers carefully placed those models in the landscape so that the models farthest from the camera were the ones with the least amount of detail. In the far background, artists substituted matte paintings.

Procedural systems helped "grow" the buildings, but it took an artist's touch to make the landscape look as if it had come together over time. "The idea was to exaggerate everything," says visual effects supervisor Mahesh Ramasubramanian. "But you had to see the buildings standing together to decide how to push them. If one building is tall,

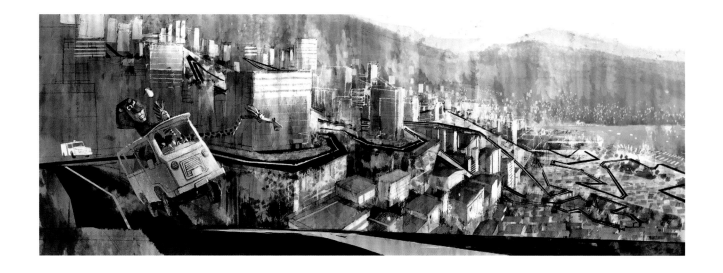

(ABOVE) Rooftop • Ken Pak
(RIGHT) Monte Carlo Concept Vis Dev • Ken Pak

we might make it thinner and taller. If it's next to a building that is short, we make it shorter and wider. We have to look at them together, at entire blocks of Monte Carlo. We handcrafted a lot of the world."

Once the set dressers in final layout placed the buildings for individual shots, lighting artists painted the city with the final brush. "We wanted to have that beautiful Mediterranean quality of light in Monte Carlo," Jefferies says, "so we honed in on the aquamarine, gold, and creamy colors."

The designers discovered that they could create the beautiful bright Mediterranean light that Cronkhite experienced in Monte Carlo and still incorporate Tadahiro Uesugi's illustrative lighting style. "We went brighter than we have ever gone on our films," Cronkhite says. "We let the light take away the color and go white in the brights and then gradate to a beautiful saturated line where light and shadow meet as we got near the shadow side of the building."

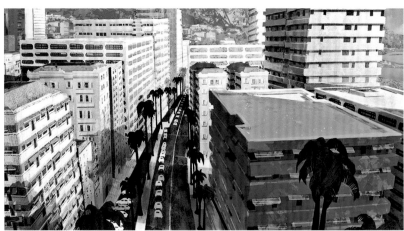

(THIS PAGE) Monte Carlo Lighting Vis Dev • Gaku Nakatani
(OPPOSITE, TOP LEFT) Brasserie Exterior • Lindsey Olivares
(OPPOSITE, TOP MIDDLE) Casino Carpet Prop Page • Lindsey Olivares
(OPPOSITE, TOP RIGHT) Casino Skylight Interior • Lindsey Olivares
(OPPOSITE, BOTTOM) Casino Interior • Erwin Madrid

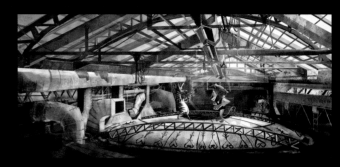
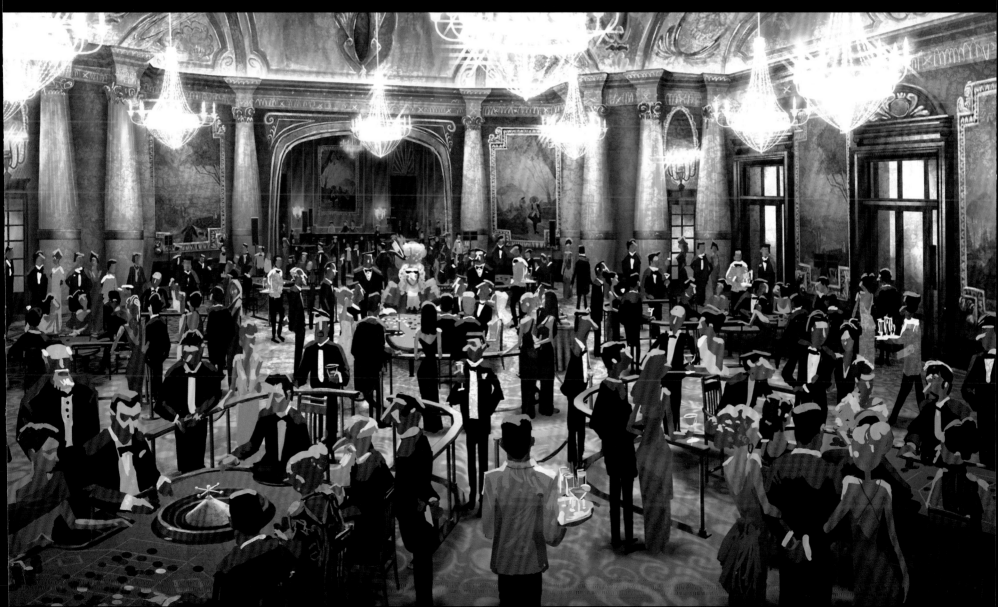

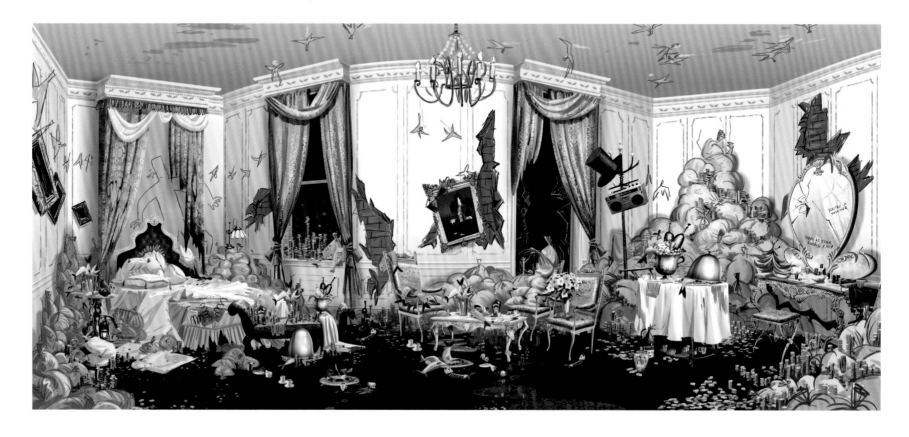

Slashes of light illuminate building interiors such as Dubois' office and the casino, and spots of light filter between boxcars in the train yard outside Monaco where the Zoosters discover the circus train. "There are lots of shots where characters travel through buildings," says lighting CG supervisor Gaku Nakatani. "And there are many shadows. But we found new ways to add contrast and details in the shadows."

Just as the Zoosters adventure in *Madagascar 3* began in Monaco, so, too, did the artists journey into shape, texture, and light. "We achieved an organic, hand-drawn feeling and a beautiful sense of light and shadow," Cronkhite says. "We carried that quality through the film."

(TOP) Hotel Room Exploded View • Ruben Perez
(ABOVE) Penguins Pillow Fight • Travis Koller / Ruben Perez
(OPPOSITE) King of Versailles Hotel • Ken Pak

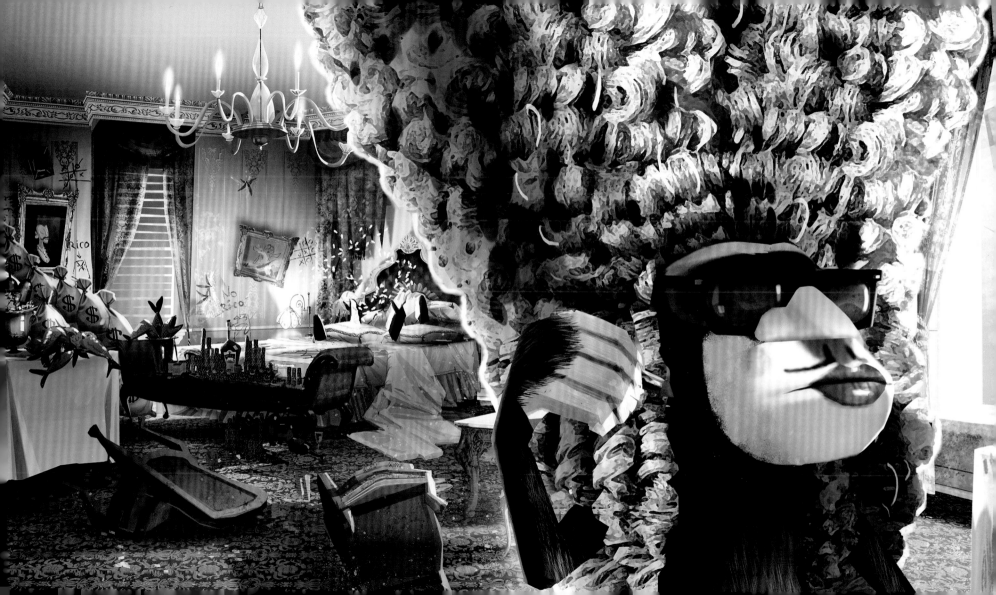

DUBOIS' OFFICE

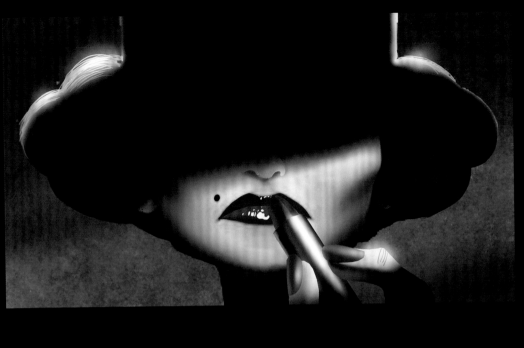

(THIS PAGE) Dubois Office Concepts • Alex Puvilland
(OPPOSITE) Dubois Office Color Keys • Travis Koller

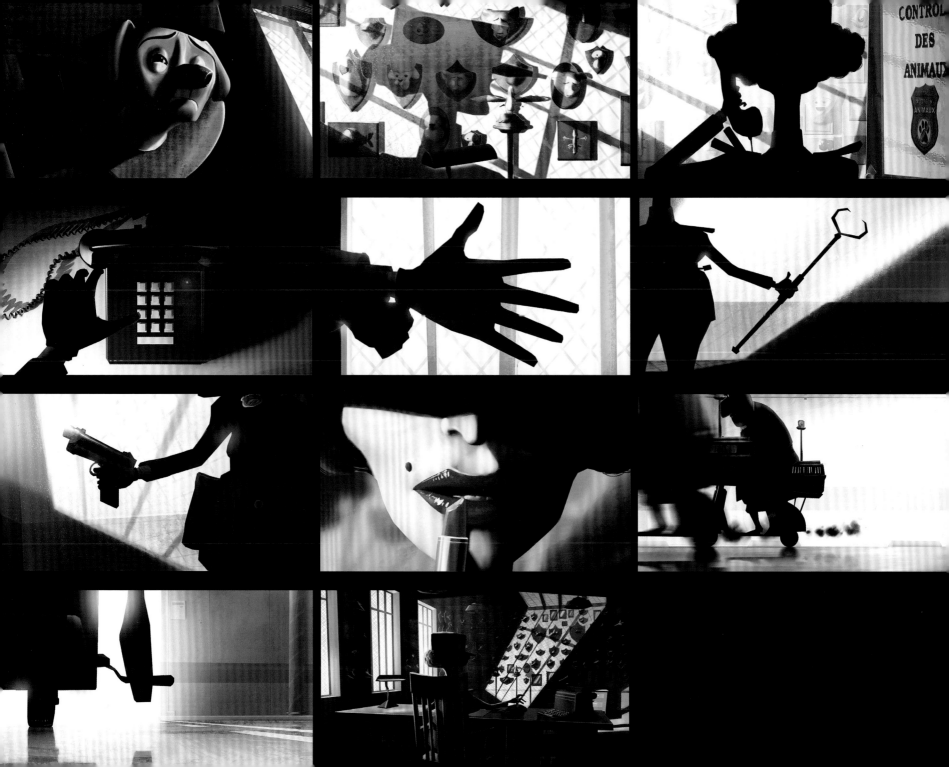

(ABOVE) Old Circus Colosseum · Lindsey Olivares
(BELOW) Colosseum Sunset · Erwin Madrid

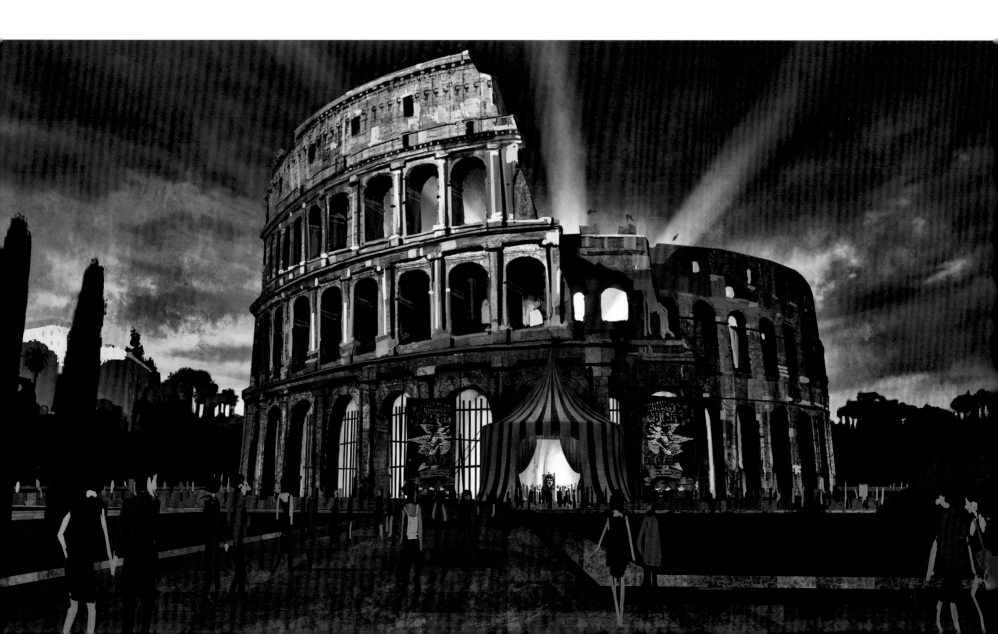

ROME

Rome is where the Zoosters witness their first circus performance. "We wanted the city to look hopeful," says art director Shannon Jefferies. "Rome is very sunny with a lot of warm tones, less horizontal than Monte Carlo, more askew. It's older, warmer, and more textural. The clouds are less organized and more random."

"The color palette and lighting of Monte Carlo feels very Mediterranean," production designer Kendal Cronkhite says. "Rome, on the other hand, features a sunset with exaggerated oranges and siennas that heighten the romance of Italy."

The circus animals set up the tent in the Colosseum. It's ragtag, but with an old Gypsy charm. Then the circus starts. The colors fade. There is a single spotlight. It's dusty. The circus animals' performances are horrible. The horses fight with each other. The dogs attack a member of the audience. The rubber ball the elephant stands on deflates.

Meanwhile, Dubois has picked up the Zoosters' scent in the train yard where the plane crashed and hops a train heading for Rome. She has seen a circus

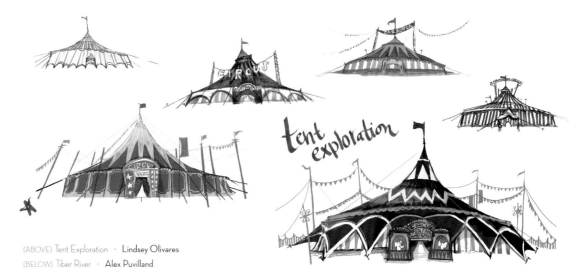

(ABOVE) Tent Exploration • Lindsey Olivares
(BELOW) Tiber River • Alex Puvilland

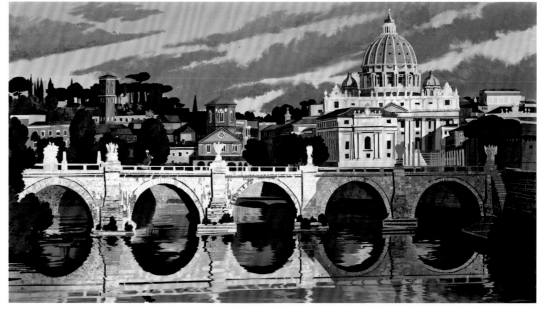

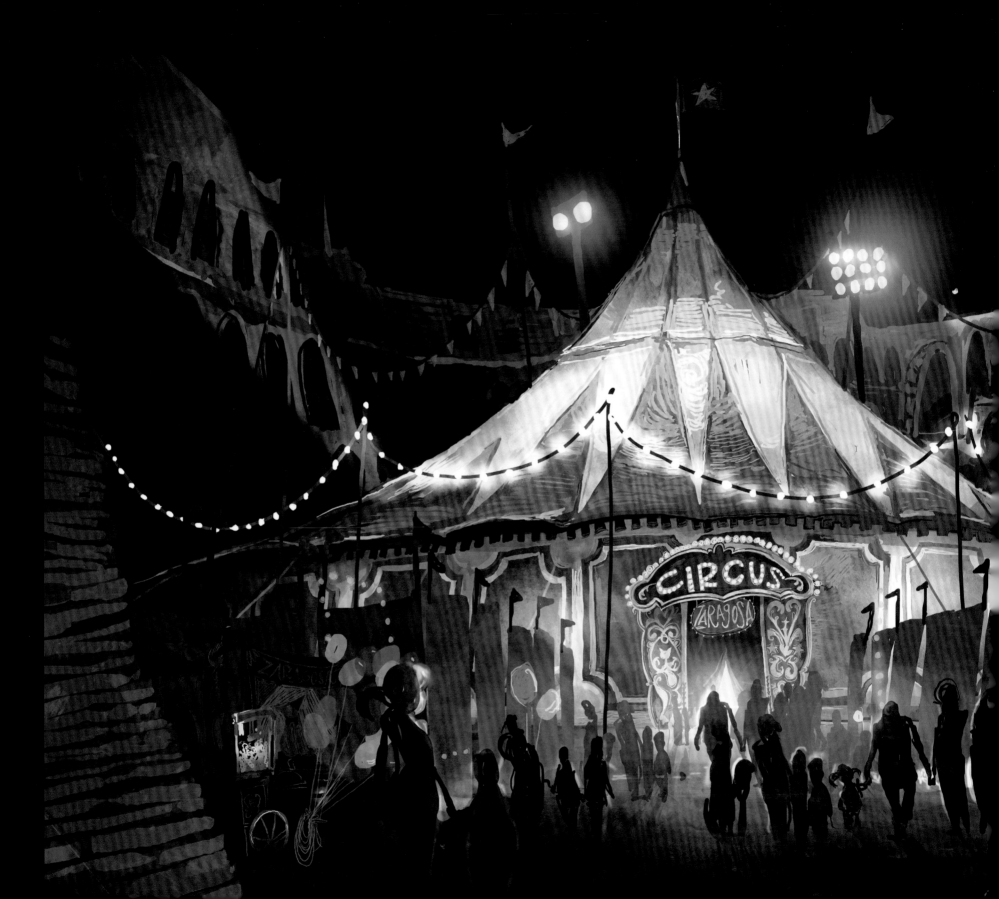

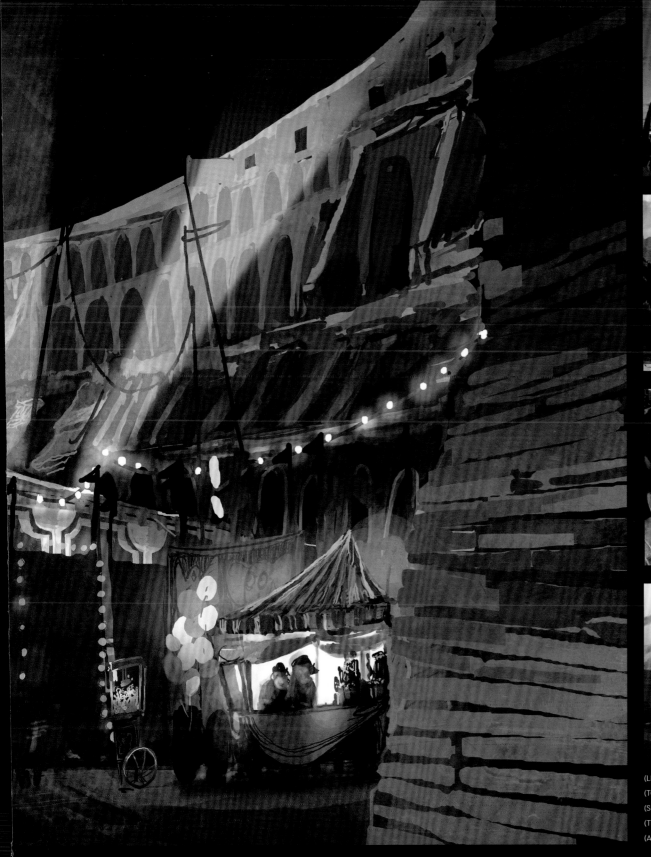

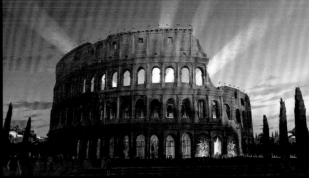

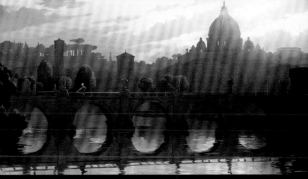

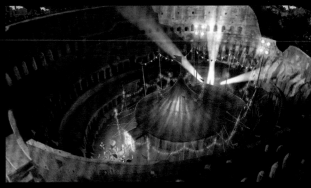

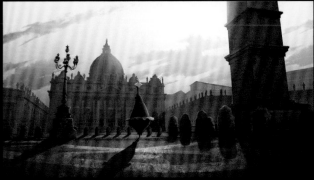

(LEFT) Old Circus Colosseum • Lindsey Olivares
(TOP) Colosseum Sunset • Erwin Madrid
(SECOND FROM TOP) Tiber River • Erwin Madrid
(THIRD FROM TOP) Colosseum Aerial • Erwin Madrid
(ABOVE) St. Peter's Square • Erwin Madrid

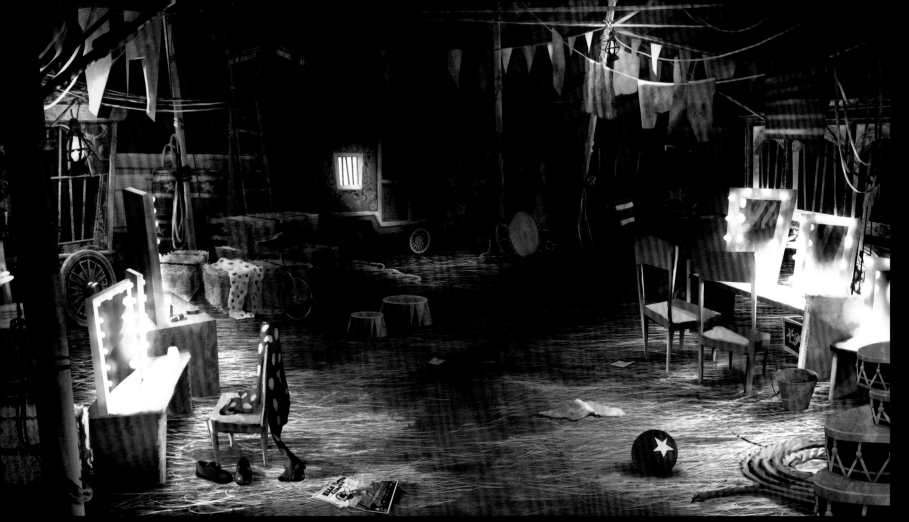

(TOP) Backstage • Goro Fujita

(ABOVE) Stefano Spotlight • Goro Fujita

(RIGHT) Stefano's Horn • Goro Fujita

OPPOSITE, TOP) Circus Entrance Exploration • Lindsey Olivares

OPPOSITE, BOTTOM) Circus Posters • Bryan LaShelle

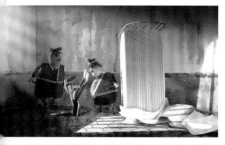

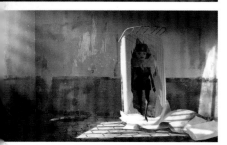

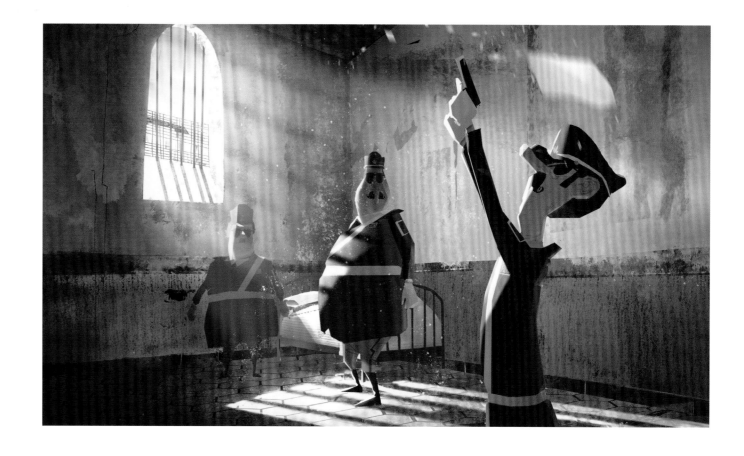

poster and realizes where the animals are hiding. In Rome, when Julien and Sonya race past her on their new Ducati, toppling a few monuments on the way, she gives chase on a stolen scooter. The police catch Dubois and put her in jail, but a clever escape plan puts her back on the Zoosters' trail.

"We assigned the color red to Dubois," says art director Shannon Jefferies. "So although Rome is usually burnt sienna and ochre, when we have a sunset and Dubois in the scene, we really push that red." When Dubois shows up at the train station, though, the environment is desaturated, almost black and white, with long, hard shadows and bright, washed-out lighting.

"We played with a more interesting color palette and more lighting situations for this film than the other two Madagascar films."

—Shannon Jefferies, art director

(LEFT) Jailbreak Color Keys • Lindsey Olivares / Ken Pak
(ABOVE) Ceiling on Captain • Ken Pak
(OPPOSITE, TOP) Film Noir Train Station Exploration and Dubois Arrival • Lindsey Olivares
(OPPOSITE, BOTTOM) Dubois Arrival • Lindsey Olivares

THE TRAIN STATION

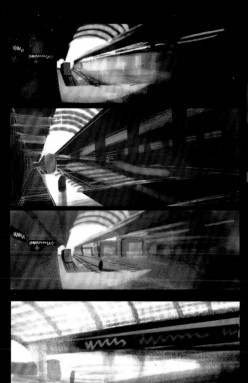
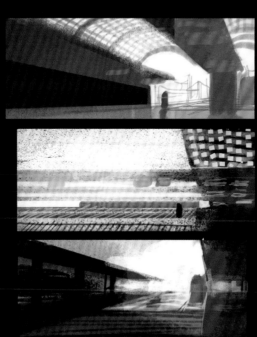
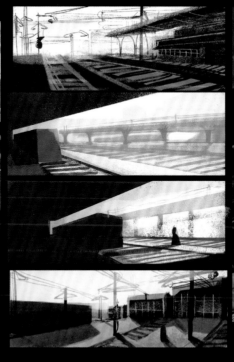
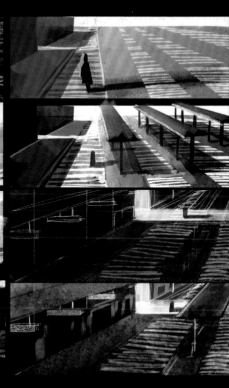
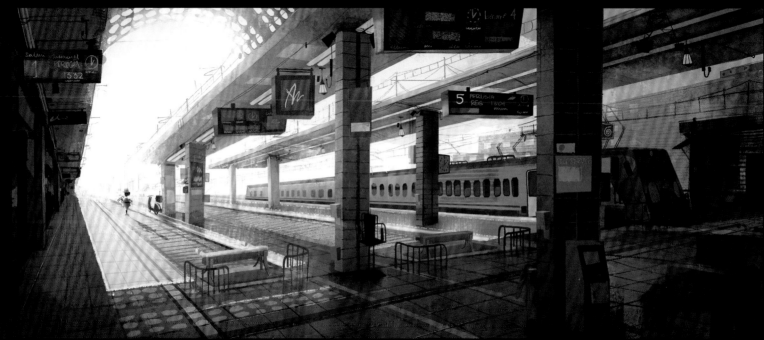

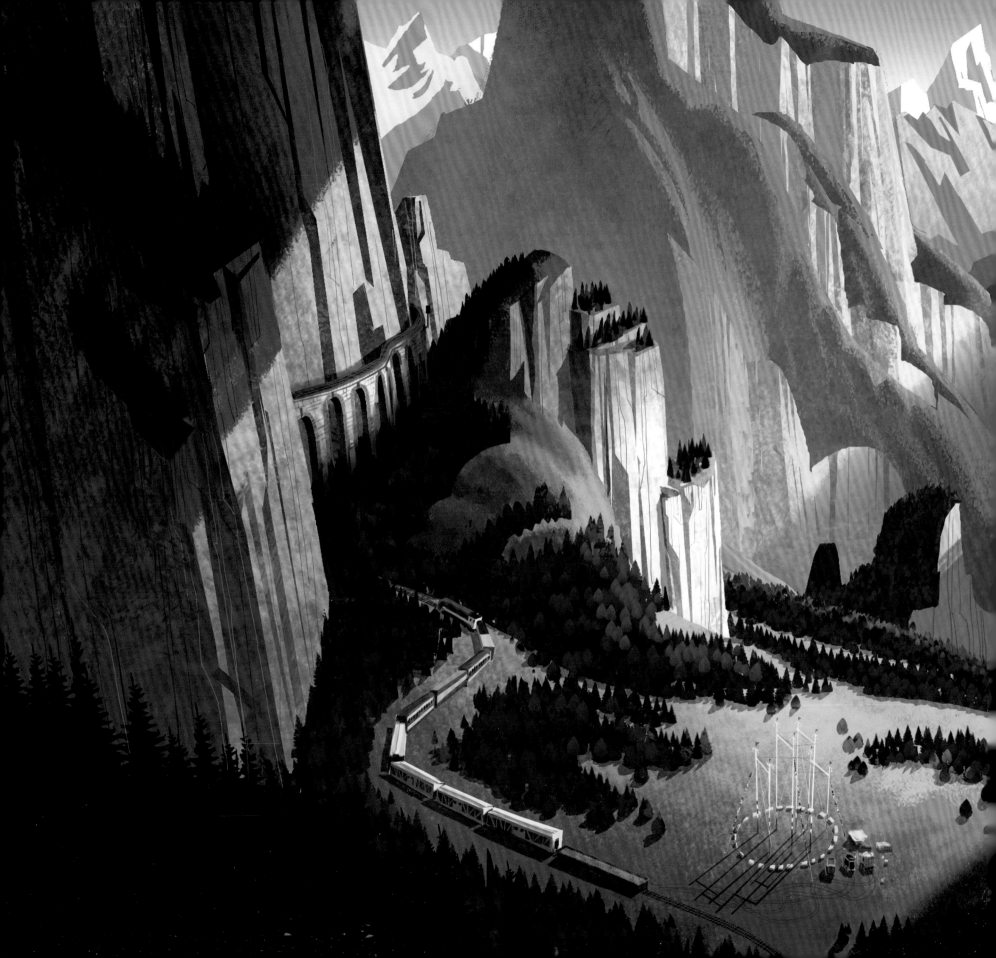

THE ALPS

After the debacle in the Colosseum, the animals board the circus train and leave for London. On the way, Stefano tells Alex how amazing the now "stinky, poopy" circus used to be. Then he tells Alex he has a *stupido* idea: Alex could teach the circus animals to do a new circus "Americano style." Alex doesn't think the idea is *stupido* at all.

The next morning, the train stops somewhere in the Alps, and Alex announces that he wants to change the show to create something more authentic. "Circus is not about the acts," he says. "It's inside every one of us." This is a turning point in the film. Director Eric Darnell explains, "Vitaly says to Alex, 'You can't change the circus. There's a long tradition.' Alex says, 'That's what everybody thought until those French Canadians came along drunk on maple syrup and cheap pharmaceuticals and reinvented the whole circus concept. And you know how they did it? They got rid of the animals.'

(LEFT) Rehearsal Color · Alex Puvilland
(ABOVE) Perform · Shannon Jefferies

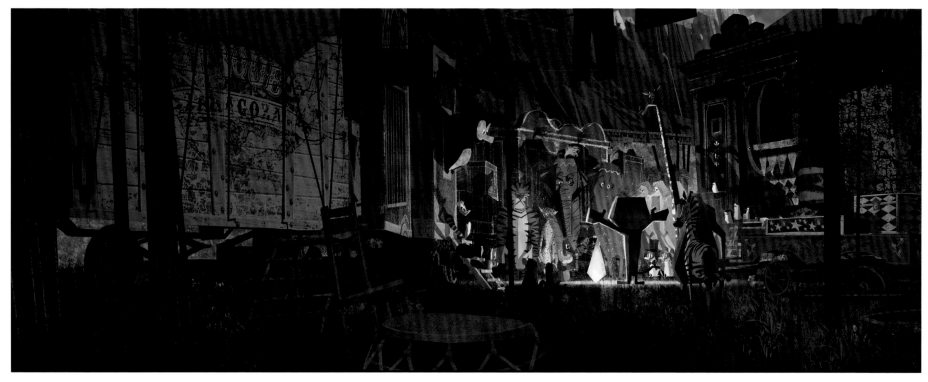

(ABOVE) Alps Campfire • Ken Pak

(ABOVE) Alps Chase Contrast • Kendal Cronkhite

"Our idea was to build on color as we move through the film, to introduce new colors. From that, we started to hone in on how that can specifically show we're traveling."

—Shannon Jefferies, art director

(ABOVE) Clouds • Alex Puvilland

The animals gasp at the thought of kicking animals out of the circus. But Alex declares that they are going to do those French Canadians one better. They are getting rid of the people. It will be an all-animal circus. The circus animals love this idea."

The newly inspired animals invent their new circus acts right there, in the mountain valley. They practice morning, noon, and night. Soon a new circus evolves.

"This is a time when the characters take risks," says art director Shannon Jefferies. "They realize they need to expose their weaknesses to build a better circus. They open the bones of the circus to the world. We played with that idea when we designed the Alps environment. We wanted to do an open-air design that was fresh and clean. We used greens and blues again, but the colors were crisper than in Monte Carlo, more saturated. Also, it's their first time in a rural area, and we wanted to play with that contrast. It's a very up moment. We used the mountain peaks, even the evergreen trees, to create an upward feeling. Everything is up and hopeful."

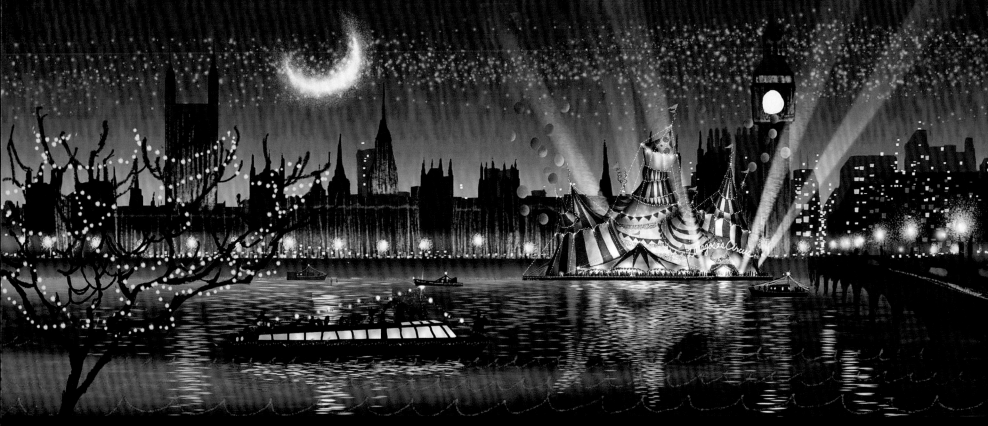

(ABOVE) London Circus • Erwin Madrid

(ABOVE) Bridge, Fire Escape, Roof Chase Vis Dev • Yoriko Ito

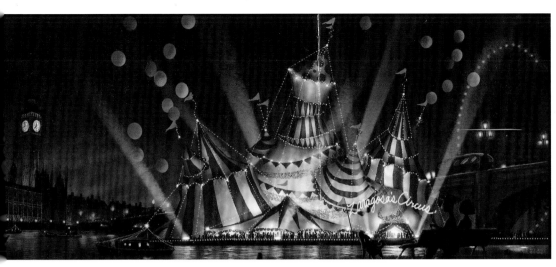

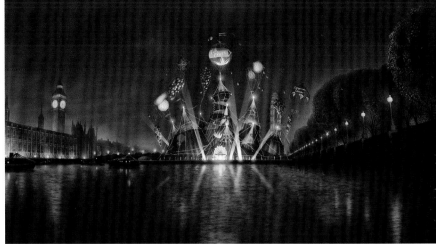

LONDON

Reinvigorated after their stay in the Alps, the Zoosters, Lemurs, and circus animals take their reinvented, exciting new circus to London where, they hope, a promoter from America will bankroll their return to New York. In London, they blow people away. The animals do amazing human acts that are stylized and theatrical.

In contrast to the horizontal lines and the creams, golds, and bright Mediterranean blues of Monte Carlo; the more jumbled lines and warm colors of Rome; and the crisp mountain greens and blues of the Alps; London is somber and formal. "When you look at the architecture in London, you see a lot of verticals," says art director Shannon Jefferies. "It reminded us of pin-striped suits. So that became our shape direction for London, and our colors were gray and blue."

The conservative London buildings provide a perfect contrast for the wild new circus that comes to town and floats on the Thames. "As an audience, when you watch a film, you take away a point of view and feeling, whether you're conscious of it or not," says production designer Kendal Cronkhite. "The more we plan a visual approach that supports the story, the more powerful the story and film become. When we come to London, we want people to see a beautiful circus tent on the Thames with all the lights and balloons around it, lit from within, with the Parliament buildings behind. We want people to see that and say, 'Wow. Look at the circus they reinvented. It's beautiful.' The way we imagined London supports that point of view."

> **"The circus usually puts its shows on at night. So we tried to get creative with sunsets and night skies."**
>
> —Shannon Jefferies, art director

(TOP LEFT) London Circus · Erwin Madrid
(TOP RIGHT) London Cirque Vis Dev · Yoriko Ito
(ABOVE) London Bobby · Ken Pak

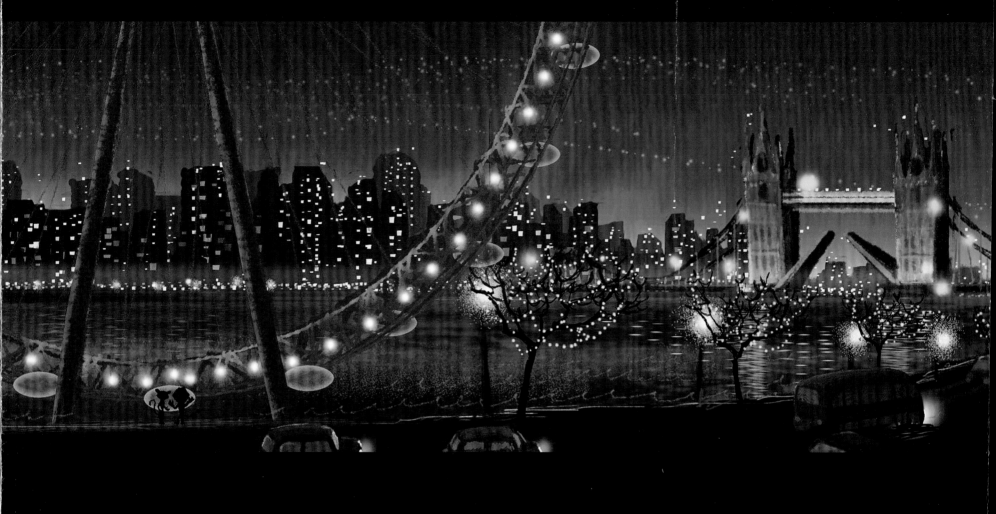

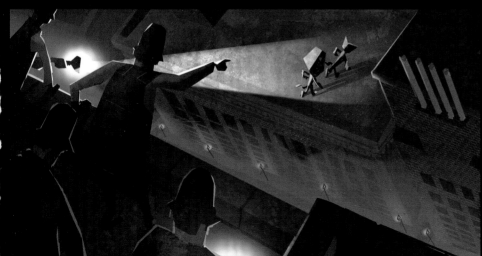

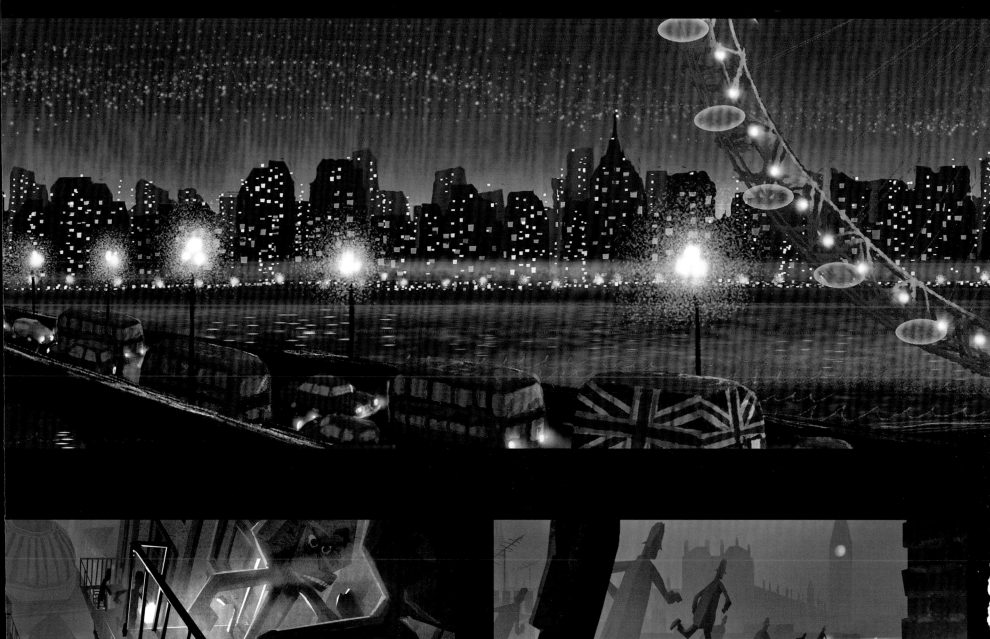

THE NEW CIRCUS

Together, the Zoosters and circus animals create a sparkling new circus. Vitaly opens the circus by soaring through a flaming hoop. Melman and Gloria do an amazing dance on an incredible high wire. Multiple parallel lines of bright, neon-colored wires stretch across the arena at various levels. Between them, from the top of the tent to the bottom, are dozens of candy-colored neon hoops: Trapeze Americano. Melman and Gloria dance on the elastic, luminous wires while Gia and Alex fly from one glowing hoop to another. And Stefano and Marty shoot out of multiple cannons. "Earlier in the story, Marty thinks it is crazy for anybody to shoot themselves out of a cannon. But he is forced to do just that when he must perform a heroic rescue," says director Eric Darnell. "And as he flies through the air, he realizes this is what he's been looking for his whole life. Forget running with the herd. He wants to fly with the birds."

The environment for this extravaganza needed to be as over-the-top as the acts. "We used an incredibly bold palette for the new circus," says art director

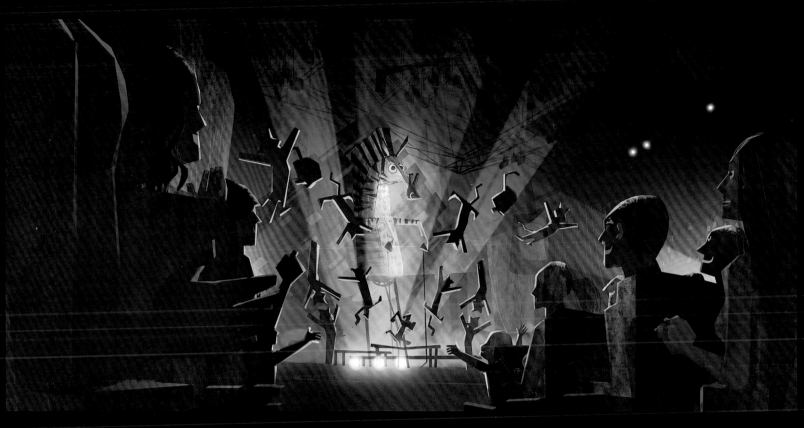

(OPPOSITE) Stage Transformation • Ruben Perez
(TOP) Flying Gloria Concept • Ken Pak
(ABOVE) Flying Gloria Concept • Ken Pak

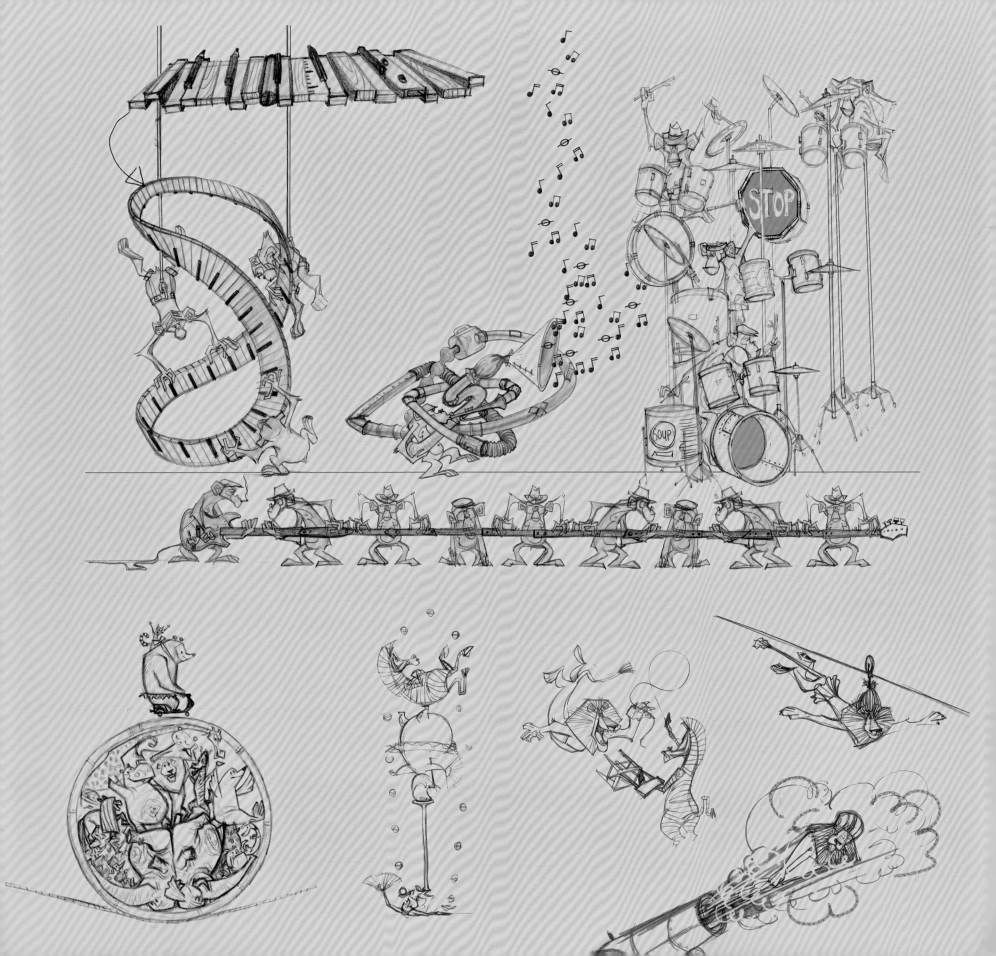

Shannon Jefferies. "That idea has been with us since the beginning. The design is a little bit surreal and fantastic, but also more whimsical."

"The new circus represents an amalgam of all the animals' personalities working together," says director Conrad Vernon. "They reinvent the show, and in doing so, reinvent themselves. Before, the circus had no personality. The animals were doing what the humans told them to do. But, Alex tells them, the circus isn't the acts they do. He points to his heart and tells them, 'It's in here.' So we didn't ground the circus in reality. We created a visual spectacle. But also we played with surrealism to get inside the animals' heads. To show what it feels like to be performing. The circus represents the animals' internal emotion. We want the audience to feel a certain magic when they see it."

(OPPOSITE, TOP AND BOTTOM RIGHT) New Circus Exploration · Kendal Cronkhite
(OPPOSITE, BOTTOM LEFT) New Circus Exploration · Geefwee Boedoe
(TOP RIGHT) Circus Star Shape · Ruben Perez
(ABOVE) New Circus Color Keys · Lindsey Olivares

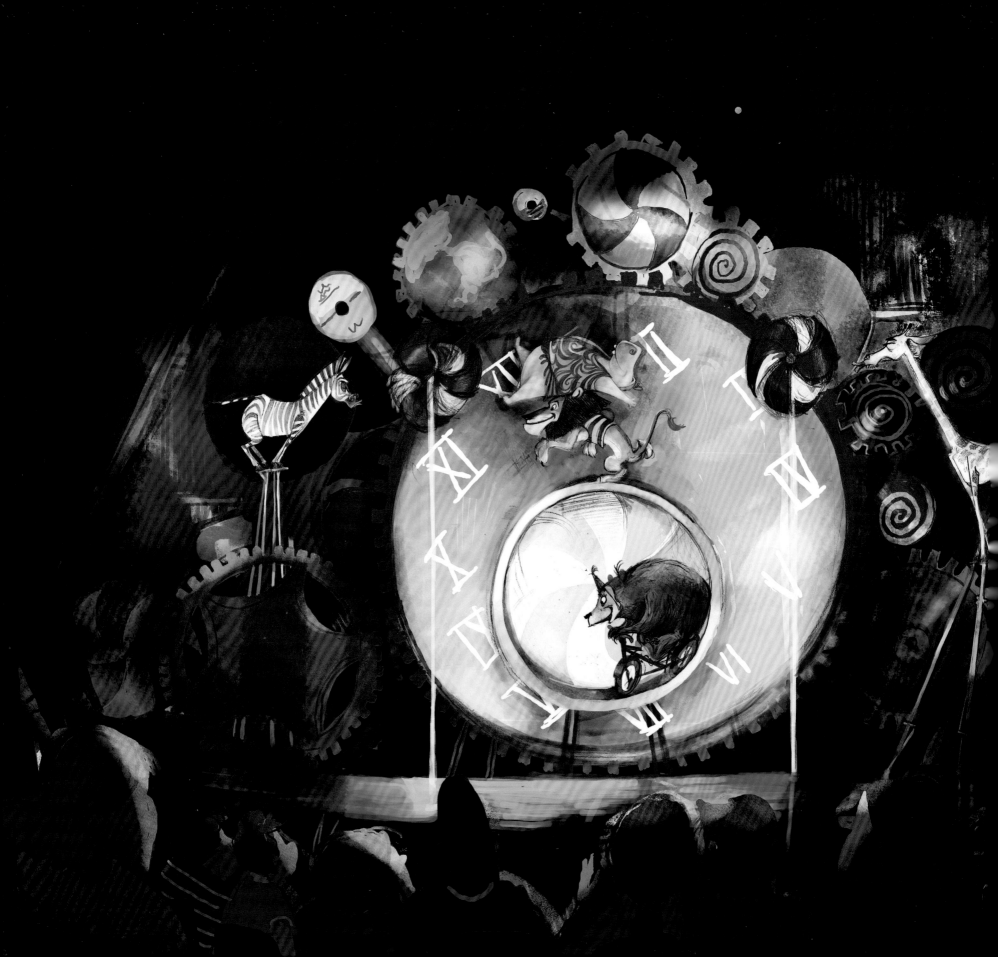

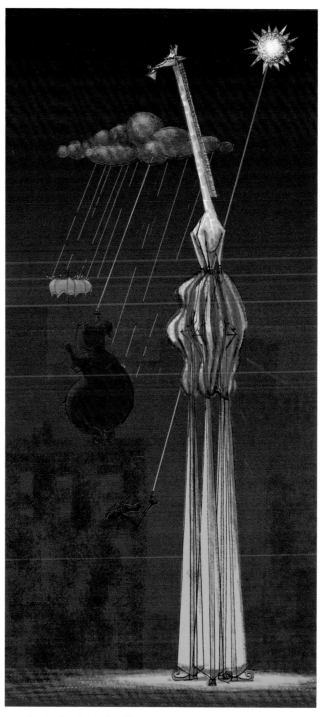

(LEFT) Spin Me Round • **Lindsey Olivares**
(ABOVE) Melman on Stilts • **Kendal Cronkhite**

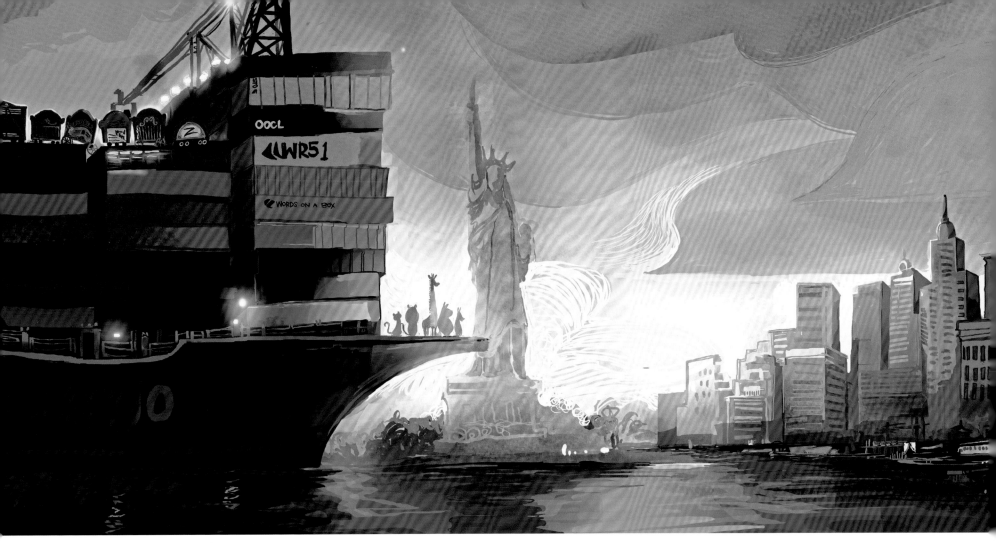

(ABOVE) Purple Ship Homecoming · **Lindsey Olivares**
(BELOW) Ship Exploration · **Lindsey Olivares**

NEW YORK

The arrival in New York is the culmination of the Zoosters' adventure. All through Europe, their persistent goal was to go home.

For their journey through Europe, the artists developed a visual language to make each location spectacular and different from what the Zoosters had known in New York. "And then because of the way the story goes, we treat New York as if nothing has changed," says production designer Kendal Cronkhite. "It's exactly the same as it was in *Madagascar*. It's fall. We used the same set pieces. We wanted to drive home how much the Zoosters have changed since they left."

(ABOVE) New York Circus • Ken Pak

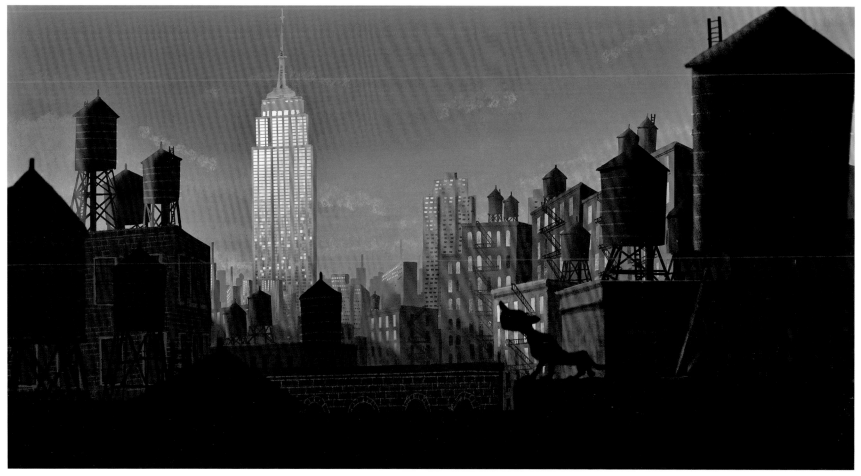

(ABOVE) Water Tower • Yoriko Ito

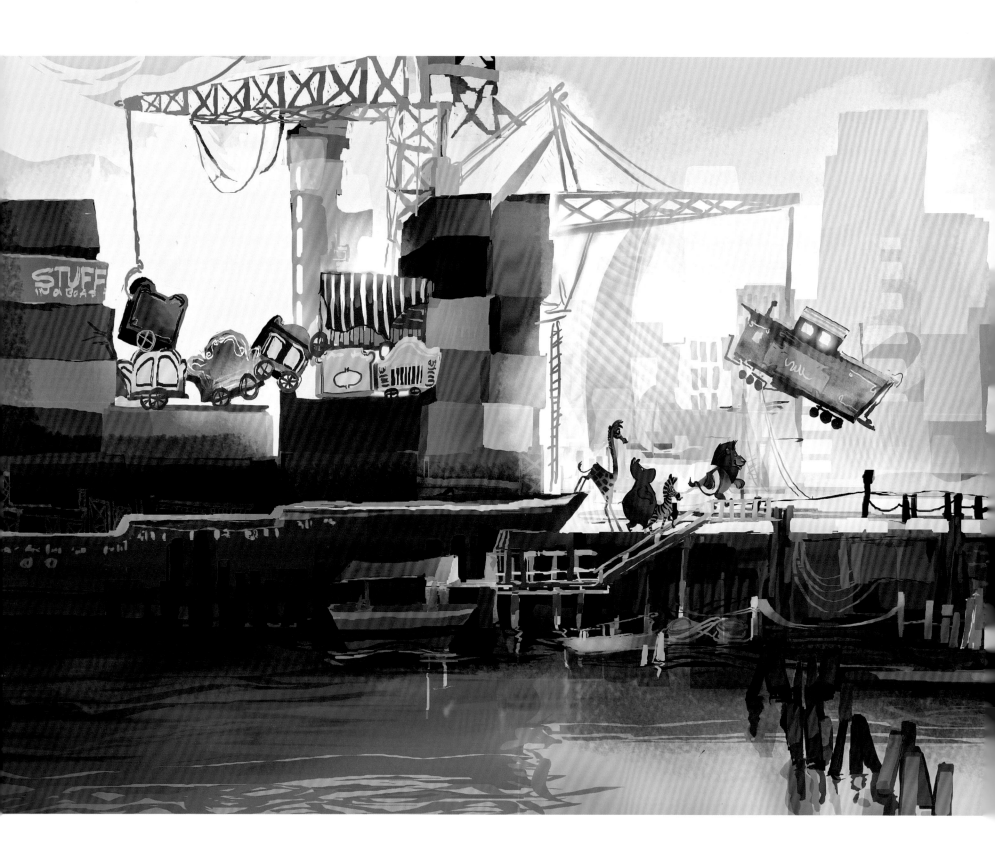

"I love that the characters have outgrown New York."

—Rex Grignon, head of character animation

(ABOVE) New York Dock • Lindsey Olivares
(RIGHT) Ship Exploration • Lindsey Olivares

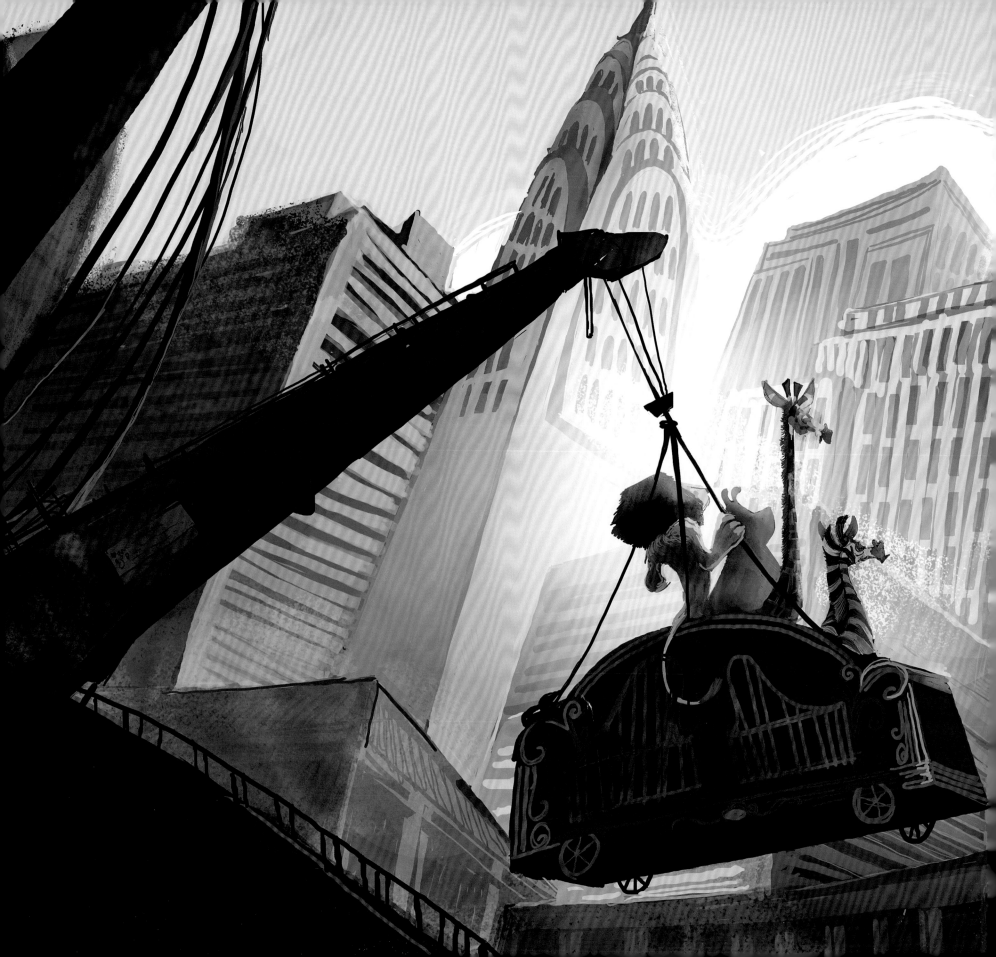

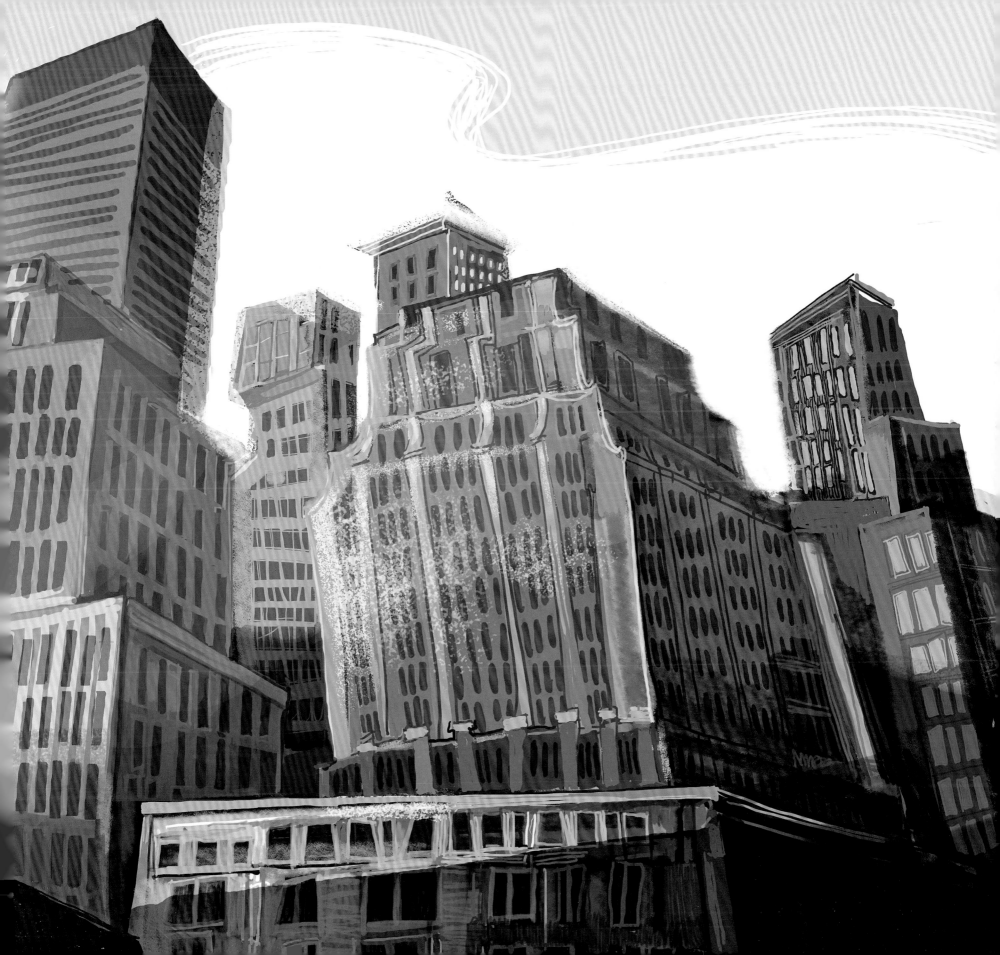

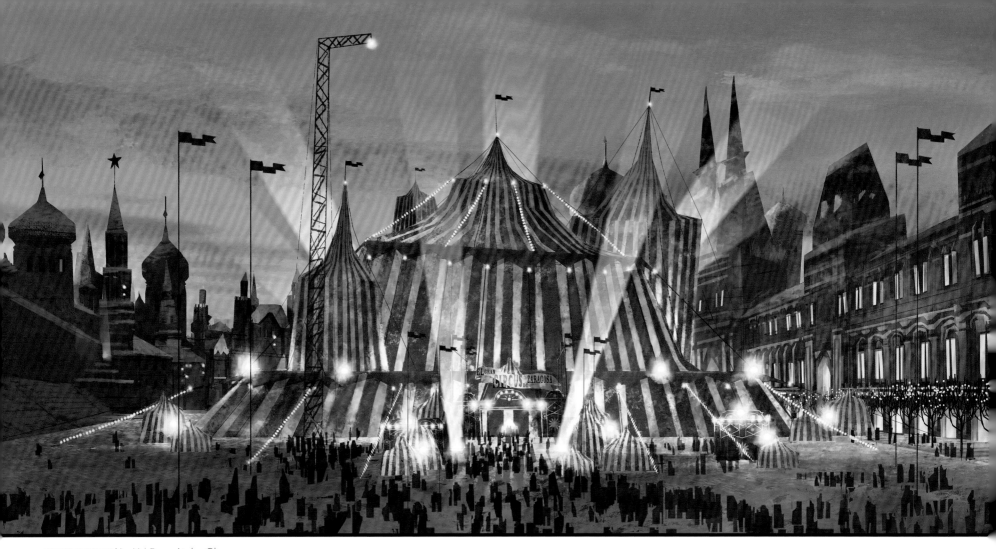

(PREVIOUS SPREAD) New York Pier · Lindsey Olivares
(ABOVE) Red Square Moscow · Ken Pak
(BELOW) Color Variations · Stevie Lewis
(OPPOSITE, TOP) Minister's Office · Travis Koller
(OPPOSITE, MIDDLE) Paris Circus · Stevie Lewis
(OPPOSITE, BOTTOM) Moscow · Sam Michlap

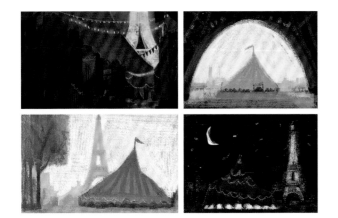

MISSED ENGAGEMENTS

Madagascar 3 was always envisioned as a travelogue, and until the story settled into its groove, the artists imagined many locations the Zoosters could visit with the circus. Besides traveling to Rome and London, Cronkhite visited Paris to gather reference for a planned chase through the *arrondissements*. Paris moved to the wayside and other environments dropped off the map. But for a time, the circus traveled widely—to Greece, to Russia.

"We have a beautiful image, an early concept of the new circus in Red Square," says director Eric Darnell, "and wonderful artwork for other locations that didn't make it into the film. We started with many ideas, but once we had the nuances of the story worked out, the extra locations became superfluous. We already had so much scope as we traveled from Monte Carlo to Rome and through France to London. We didn't need more locations to tell our story."

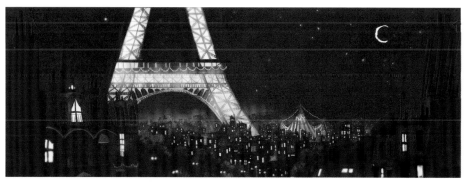

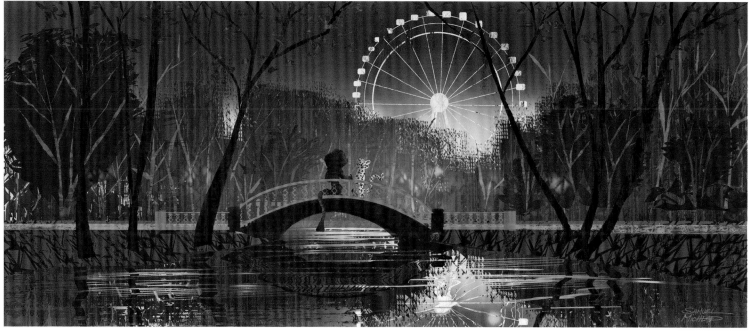

(ABOVE) Greece Circus • Ken Pak

BUILDING A SEQUENCE

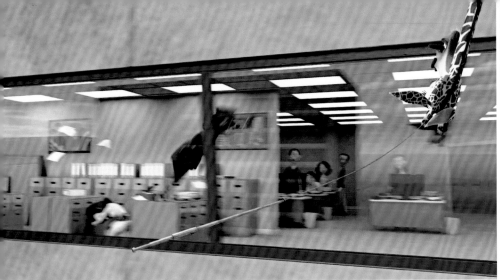

SEQUENCES 600 AND 700
"MONTE CARLO CHASE" AND "ROOFTOP RESCUE"

Hundreds of people—story and layout artists, modelers, riggers, surfacers, painters, animators, lighting artists, effects artists, colorists, compositors, and others—create incredible artwork and then bring it to life. They give characters flesh and bones, clothes and fur. They build cities, color walls, cause the sun to rise, and turn lights on at night. They put cars on roads, boats in water, trains on tracks, and move them all through the landscape.

Sequences 600 and 700, "Monte Carlo Chase" and "Rooftop Rescue," were the first to go into production. Together they form one long chase scene that involves all the main characters in the film except the circus animals. The sequences take place in Monte Carlo on streets filled with vehicles and pedestrians. The villain Dubois and her henchmen, the animal control officers (ACONs), ride scooters as they chase the Zoosters, Lemurs, Penguins, and Chimps in a Luxury Assault Recreational Vehicle (LARV) through the streets and over rooftops.

These sequences, which happen early in the film, establish the character of the villain and the visual language for environments used throughout the film. "There's a moment when Dubois looks into the LARV and sees a zebra driving," says head of story Rob Koo. "It drives her crazy."

"We know immediately how bad she is and how skilled," adds head of layout Nol Meyer. "She can dodge banana bullets. She's willing to put her life in danger. She's completely focused."

The action takes place in a unique environment specifically designed to complement the characters' graphic style. "To keep the audience in suspended disbelief, the buildings, mountains, roads—even effects like banana bullets—must have the same look as the characters," says visual effects supervisor Mahesh Ramasubramanian. "Maintaining consistency is really important."

New tools helped the artists build and light a stylized Monaco and create crowds of people with the same pushed proportions as the main characters. "We didn't want a CG look," says lighting CG supervisor Gaku Nakatani. "We wanted to create an illustration."

(PREVIOUS SPREAD) Early Monte Carlo Chase Vis Dev • Ken Pak
(ABOVE LEFT) Office Run • Travis Koller
(ABOVE RIGHT) Banana Drop • Previs/RLO: James Bennett, David Bianchi, John Braunreuther, Todd Jansen; FLO: Pam Hu, Tyler Ham, Heather Wang, Brian Newlin; Animation: Scott LaFleur; CFX: Kris Campbell; FX: Stephen Cooney, David Wilson; Crowds: Scott Raymond, Kevin Vassey, Geoffery Jarrett; Matte Painting: Michael Collery; Lighting: Michel Kinfoussia
(OPPOSITE) Monte Carlo Chase Color Keys • Alex Puvilland

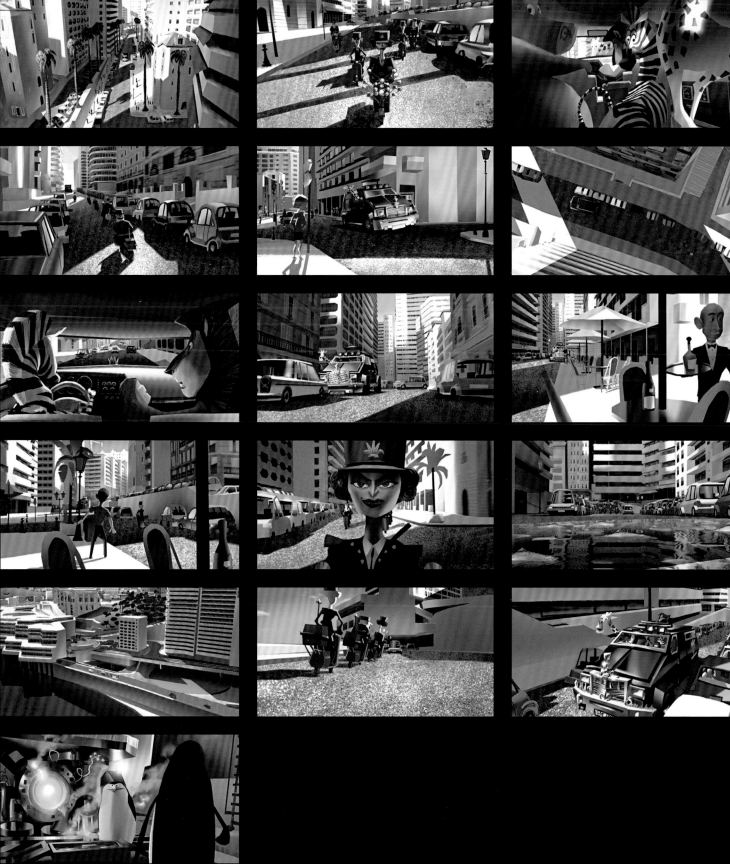

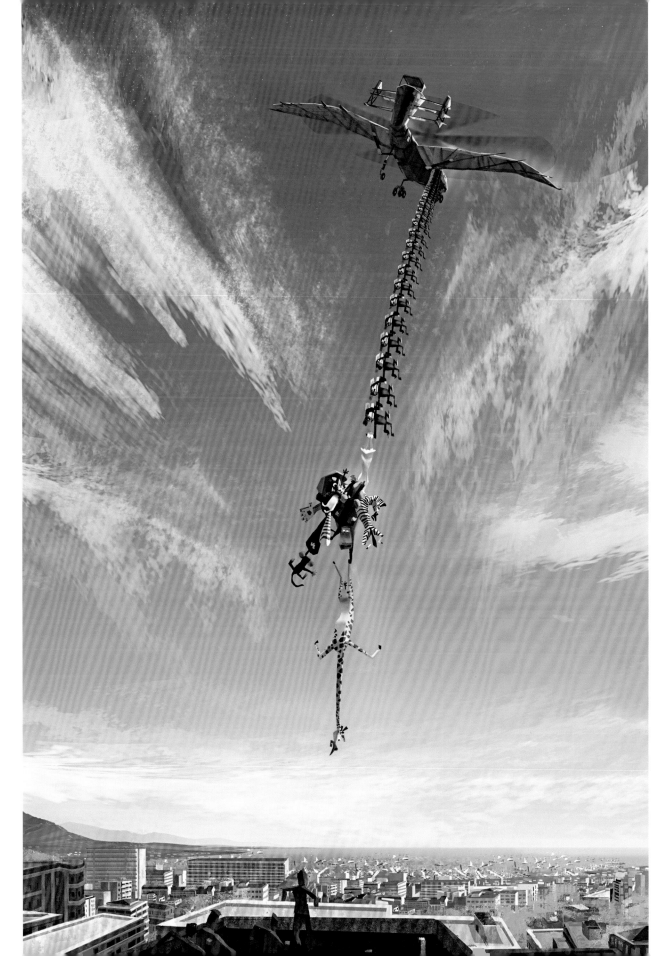

(OPPOSITE, TOP) Monte Carlo Signs • Bryan LaShelle
(OPPOSITE, BOTTOM) Dubois Attacks • Ken Pak
(LEFT) Monte Carlo Roof Chase • Ken Pak

60's Modern High Rise

French

60's Modern
(Stylized: think Mondrian)

Mediterranean

Waiter

Large Block

French

Modern

Modern

French

Waiter

Smaller Block

VISUAL DEVELOPMENT

Production designer Kendal Cronkhite has overseen the conceptualization and realization of *Madagascar*'s unique visual style—from characters to environments and from design through production—since the beginning.

Cronkhite joined DreamWorks Animation in 1996 to work on *Antz*. Ten years ago, she became production designer for *Madagascar*. "*Madagascar 3* is the third *Madagascar* film for me, and every time we do one I think, 'Oh, if I could go back and do something more.' Each film has given me that chance. For *Madagascar: Escape 2 Africa*, we were able to design characters and environments that we didn't have in the Madagascar jungle. For this film, we were able to reinvent what 'urban' means within the *Madagascar* style. We've added a beautiful graphic quality to this film that we haven't had before."

Art director Shannon Jefferies works closely with Kendal Cronkhite. They're often in the same meetings and do rounds together, having developed a close working methodology right from the start while working on *Madagascar*. In fact, the two artists knew each other while students at the Art Center College of Design in Pasadena.

"When I moved to San Francisco, Kendal asked if I wanted to work on *Antz*," Jefferies says. She became an illustrator for *Antz* and *Shrek 2* and then joined *Madagascar* as an art director.

"Early on for each film, we have a small crew of three to five artists and a set designer in the art department for visual development," she says. "When we get into production design, the crew grows to around twenty artists. On *Madagascar 3*, we had two set designers because we had so many sets."

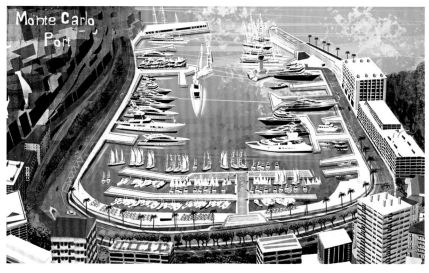

(TOP) Casino Interior • Lindsey Olivares
(ABOVE) Monte Carlo Port • Travis Koller

The sets for the Monaco chase sequence were particularly complex. "First, we had to decide what Monaco would look like in the *Madagascar* world," Cronkhite says. "We were all over that city, down in the streets with the chase, flying above the entire city, flying off the streets into rooftops, following Dubois through buildings. So how do you do that? We can't go to the prop store and order two of those and three of that."

"We had so much to design," Jefferies says. "We had to design all the buildings in Monaco. To get as much variety as we could from a limited number of buildings, we designed storefronts we could take off or plug in. We also designed all the street signs, cars, parks, and trees. Lighting became another challenge. Lighting is very difficult when you're covering a lot of ground."

STORY

The role of the story team is to work with the script to outline the movie's plot, identify each character's key arcs, and translate those story and character concepts into storyboards. "Story is a process of discovery," says head of story Rob Koo, "and for sequences 600 and 700, we had a good opportunity to see what crazy things we could do."

Koo joined PDI/DreamWorks as storyboard artist for *Antz* and then moved onto *Shrek*, for

which he won an Annie Award, before signing on to the *Madagascar* trilogy. He became head of story on *Madagascar: Escape 2 Africa* and held that role for *Madagascar 3*, supervising as many as thirteen artists during planning and production.

The biggest challenge in the Monaco chase sequence for the story artists was its enormity. "Our job is to work with the directors and producers to translate the script into a medium closer to a

(BELOW, RIGHT, AND FOLLOWING SPREAD) Sequence 600
Storyboards • Rob Koo and Xavier Riffault

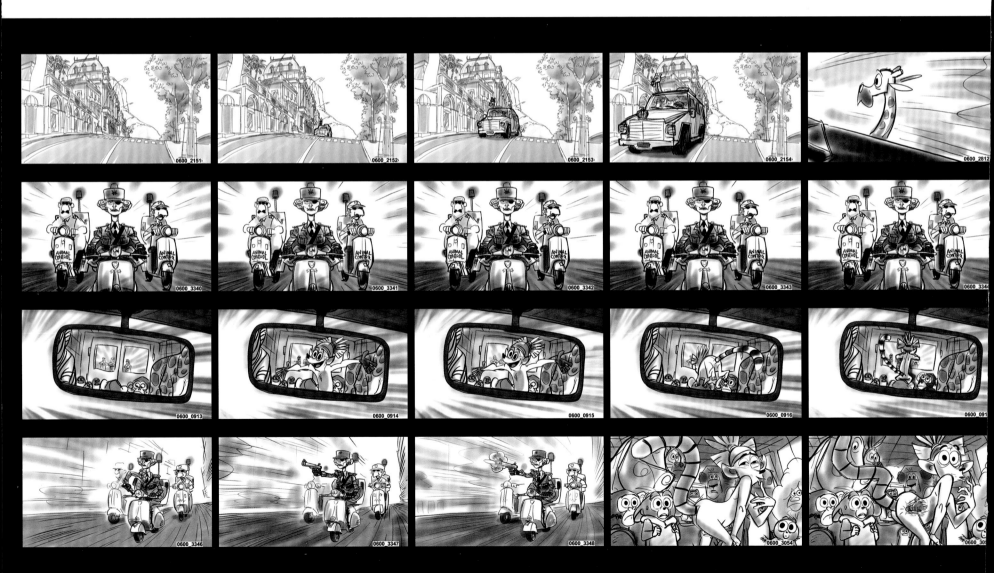

film experience," he says. "One page in a script that says the characters chase through Monte Carlo can easily become three hundred drawings. We did a lot of brainstorming for the Monaco chase to think of the gags. Because we wanted it based in Monte Carlo, Kendal [Cronkhite], the directors, and I flew there and walked the path the chase would take. Then we drew the storyboards to be close to the actual experience."

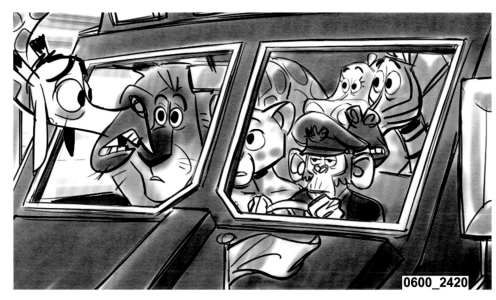

0600_2420

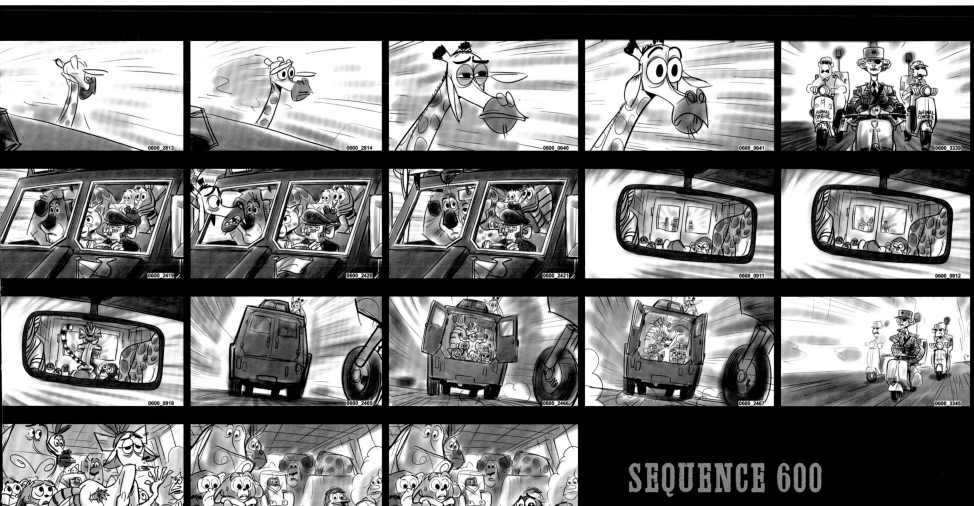

SEQUENCE 600

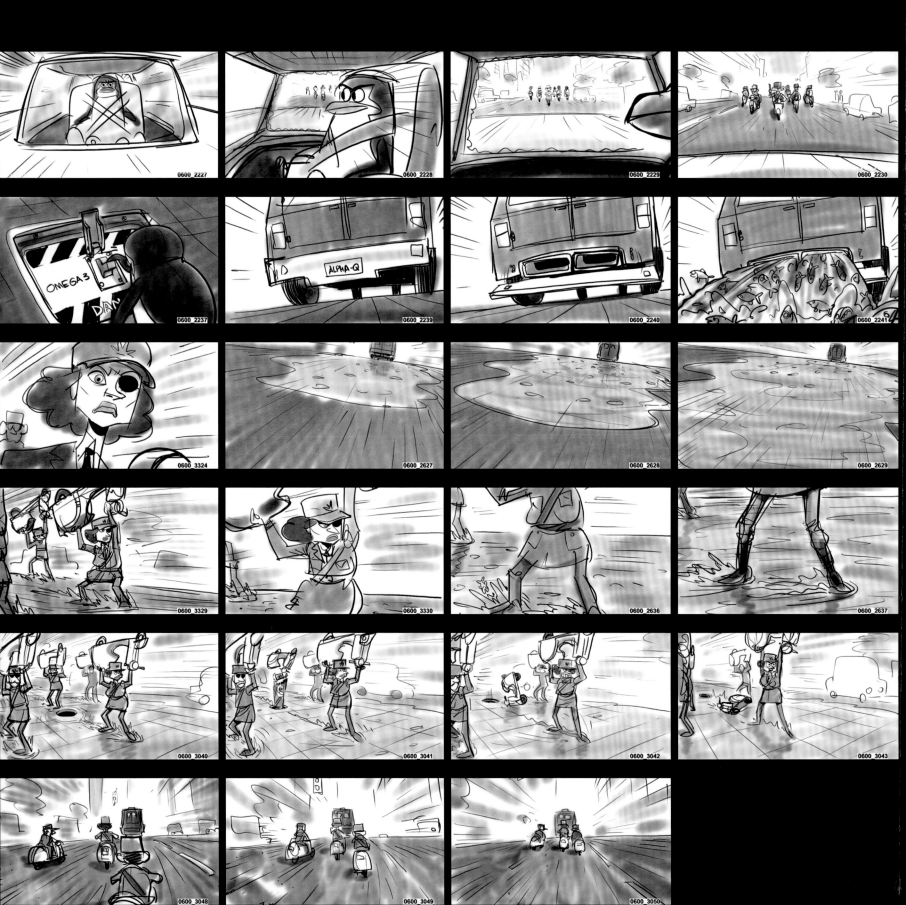

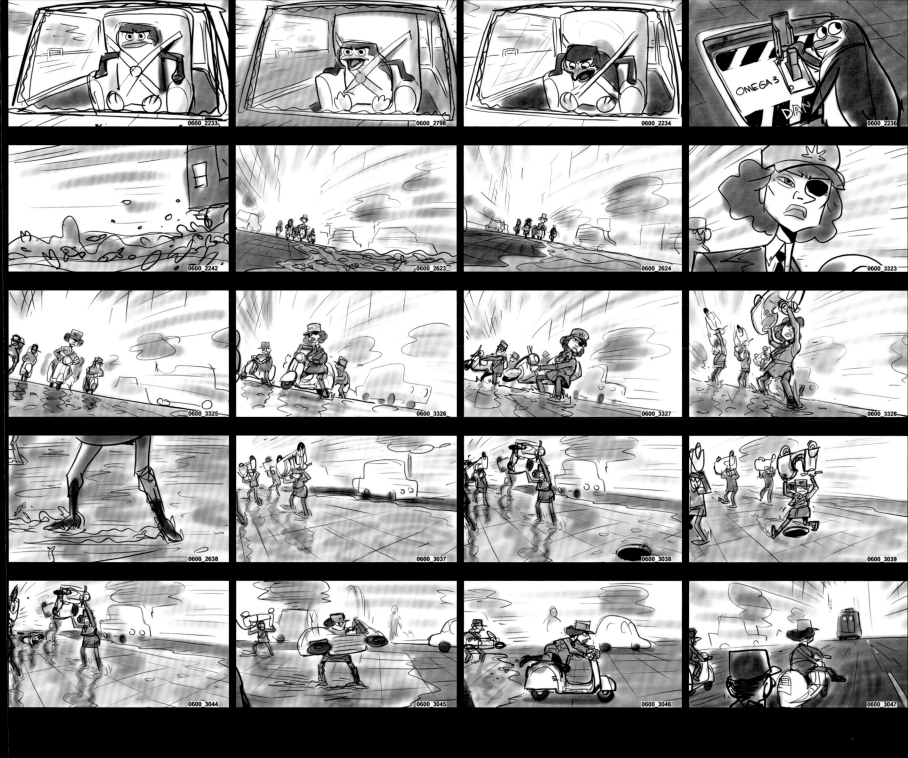

"I think of storyboarding as a form of translation from the writing to the visual."

—Rob Koo, head of story

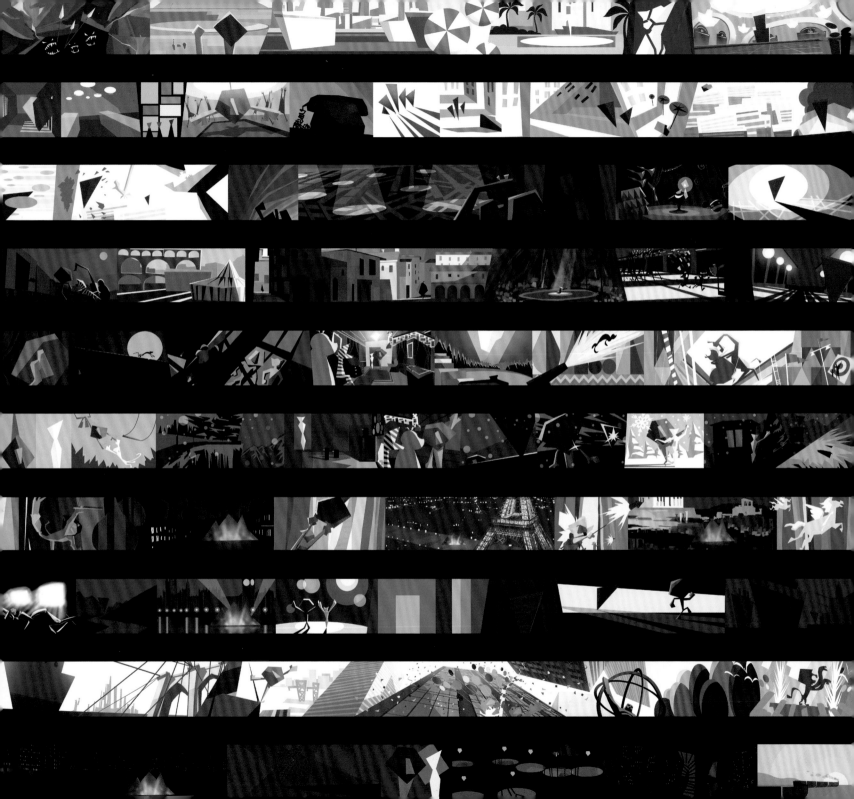

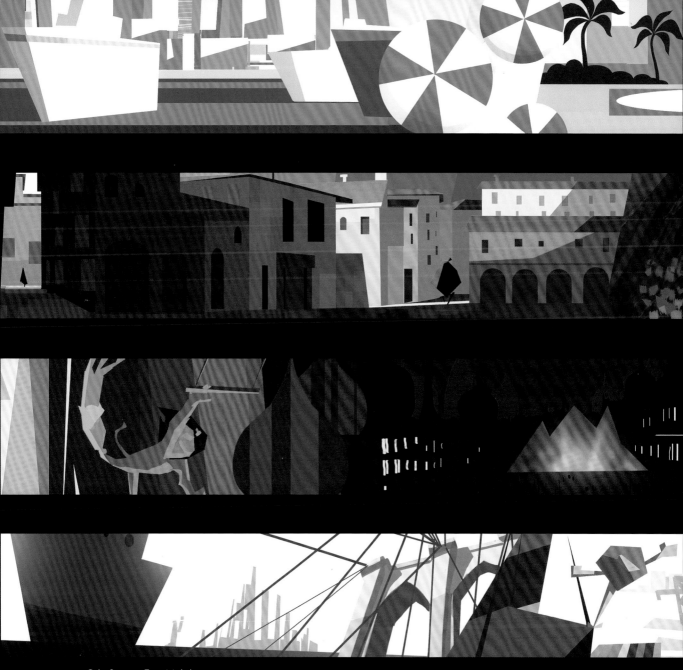

(OPPOSITE AND ABOVE) Color Script Erwin Madrid

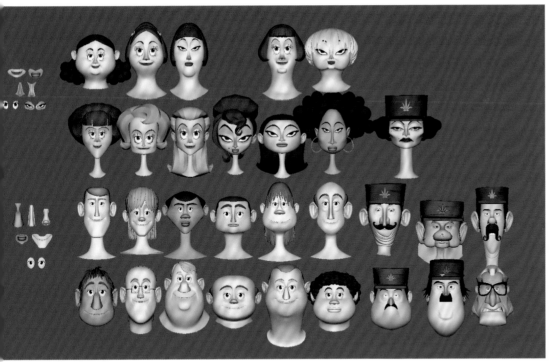

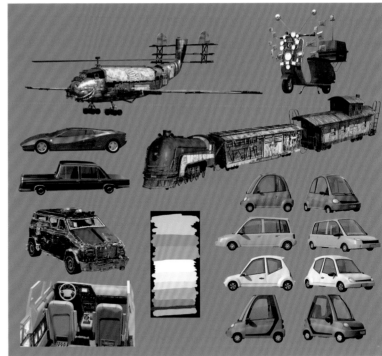

MODELING AND SURFACING

Modelers, led by head of modeling Josh West, build everything seen on screen for an animated film. The characters, the buildings, the street signs, a rope, a bit of trash on the ground come together using pieces of geometry—curves, triangles, and more complex polygons—to create the outside shell of the three-dimensional objects. When finished, the objects look as if the modelers built them with gray clay. Surfacers add texture and color and define the object's material properties, thus turning the gray clay into a wooly Persian rug, a spotted leopard, a shiny chrome bumper, and so forth.

To construct and populate Monaco, modelers built 131 buildings with 3 levels of diminishing detail, 171 twisting streets, 373 props, 82 plants, 36 vehicles, and 4 versions of the LARV. For the citizenry, the artists produced a cast of human extras with the same pushed-proportion style as the animals. Modelers dressed the characters with 131 pieces of clothing, 17 pairs of shoes, 28 hair styles, and 62 accessories.

Surfacing artists led by Aaron Florez enhanced the look of the film with graphic textures using algorithmic shaders to mix watercolor elements into digital concrete, wood, and stone and to create a new, painterly style for the characters' skin, clothing, and vehicles.

RIGGING

nimators move digital models by using control points added to each model by riggers (character technical directors). Head of rigging Rob Vogt and his team place these points strategically on the geometry that makes up each figure, so animators can move the characters in specific and expressive ways. The cartoon-y squash-and-stretch animation style devised for *Madagascar* caused the studio to revise its rigging setup for the first film. "We have advanced rigs now to do the broad stuff we're used to seeing," says head of

character animation Rex Grignon. "What's new in this film is what we chose to do with the characters. We take them places they haven't been before, both physically and emotionally."

The Zoosters, the circus animals, and the various humans in the chase sequence have the most intricate rigs, but even the fish that the Penguins dump from the LARV to stop Dubois and the ACONs are rigged characters. "In this case, we used a simple rig to bounce the fish around automatically," says visual effects supervisor Mahesh Ramasubramanian.

(BELOW) Alex, Melman and Dubois Emo Rigging • Rigging: Thomas Bittner, Justin Fischer, Stephan Osterburg, Morgan Evans, Drago Avdalovic, Keira Yang

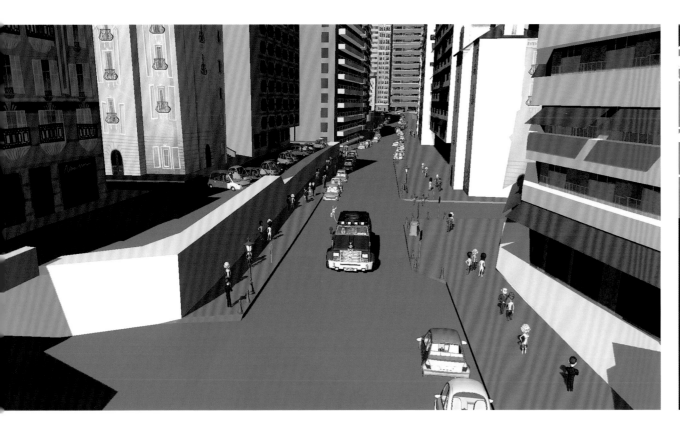

PREVIS AND ROUGH LAYOUT

Layout artists are cinematographers. Traditionally, while referencing storyboards, they move simplified characters through three-dimensional space seen from a selected camera view to create rough layouts for shots of short, predetermined lengths. Today, though, the department starts with previsualization. The previs artists create multiple camera views for large, continuous action sequences that can show depth of field and, for the first time, light and shadow. Once the directors and editors select a camera view and determine the timing for cuts, the artists break the sequences into shots.

"Storyboard artists can't take time to draw every frame from three camera views," says head of layout Nol Meyer. "But once we have characters and vehicles blocked in, we can set up as many camera views as the directors and editors want, from a close-up of Dubois closing in on the Zoosters in the LARV during the chase through Monaco to a long shot."

(TOP, LEFT) Monte Carlo Street
 Previs: James Bennett
 Set Designer: Carlos Zaragoza
(TOP, MIDDLE) Monte Carlo Fairmont Tunnel
 Previs: Mike Leonard
 Set Designer: Carlos Zaragoza
(TOP, RIGHT) LARV Rollover
 Previs: David Bianchi
 Set Designer: Carlos Zaragoza
(RIGHT) Marty and Gloria on the Monkey Chain
 Previs: James Bennett
 Set Designer: Carlos Zaragoza
(FAR RIGHT) Dubois Close Up
 Previs: James Bennett
 Set Designer: Carlos Zaragoza

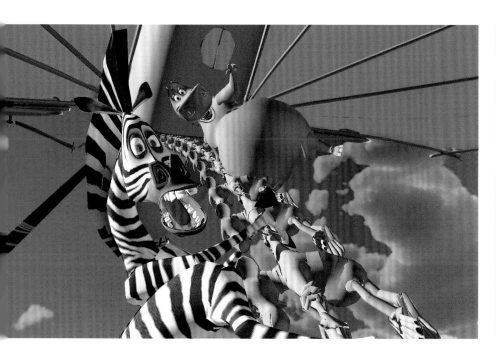

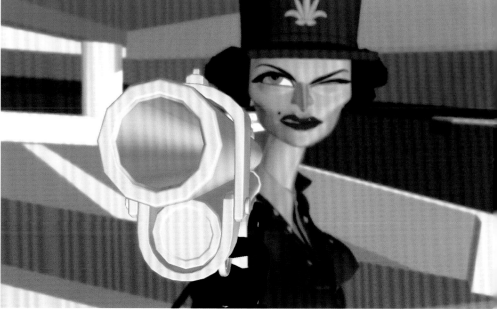

STEREO 3D

The previs artists worked with stereo 3D in mind from the beginning, using depth to "accent the madness" says head of layout Nol Meyer. "The way the *Madagascar* characters interacted with the world was already stereo friendly," Meyer continues. "And, in Monte Carlo, we had a wonderful set with people on the street, traffic, cars parked along the road, and streetlights. That visual richness helps an audience feel immersed in a world. By taking the camera around a building and up to the top, rather than cutting to a wide shot, [we allow] the audience [to] really enjoy the space."

FINAL LAYOUT

The final layout artists replaced the simplified versions of the Zoosters, Dubois, and the ACONs used by rough layout artists to design the sequences with the fully rigged characters the animators performed with in each shot. In sequence 600, for example, "They put Dubois on her scooter, put the scooter on the street, and gave her a dart gun," says head of layout Nol Meyer. "They only put in the elements she interacts with." Separately, the final layout artists also dressed the sets for the entire chase.

A custom system helped the layout artists build the intricate city, but set dressers on the final layout team placed final versions of individual cars, trees, shrubs, planter boxes, rooftop gardens, and café tables as needed. During the chase through Monaco, Dubois crashes through several office buildings. The set dressers even outfitted these interiors with desks, chairs, and typical office supplies. "It made it feel like a real place," says final layout supervisor Brian Newlin.

(BELOW) Office Room 1 • Travis Koller
(BOTTOM LEFT) Croissants & Coffee • Alex Puvilland
(BOTTOM RIGHT) LARV Crash • Final Layout: Linda Bork
(OPPOSITE, TOP) Monte Carlo Street • Final Layout: Pam Hu
(OPPOSITE, BOTTOM) Monte Carlo Rooftop • Final Layout: Debbie Langford

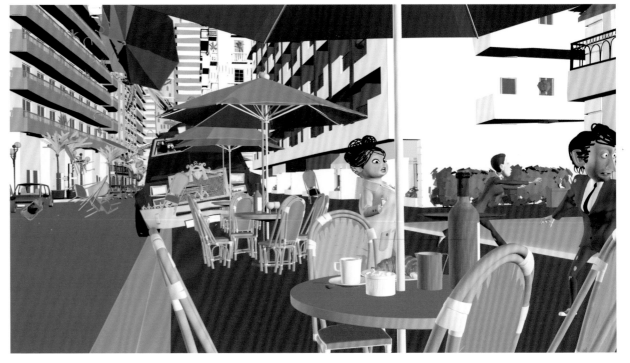

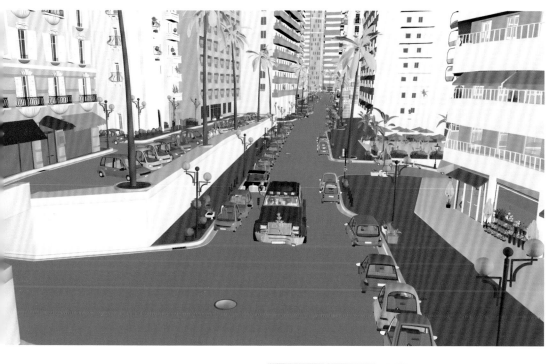

“ **There's so much detail in cities. We tried to find ways of simplifying the detail to keep your attention on what's important and at the same time make you feel like the characters are in a real city.** ”

—Mahesh Ramasubramanian,
visual effects supervisor

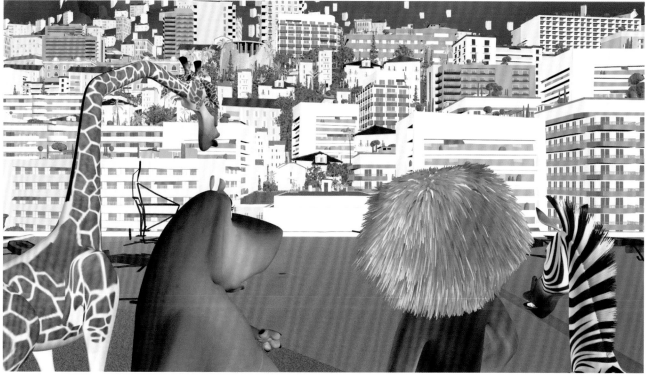

> **"We have new skin shaders that allow light to filter through the skin so the edges of our characters have a real saturated color when the light comes through them."**
>
> —Kendal Cronkhite,
> production designer

CHARACTER EFFECTS

The character effects (CFX) team, led by head of character effects Kris Campbell, was responsible for eliminating the "tube arms" used for crowd characters in other films and creating clothing that fit the *Madagascar* style, even though the characters are different sizes and shapes. Starting with a default body type, the CFX team adjusted the motion and fit for each and then checked that the motion worked no matter how the animators moved the characters. To make sure the clothing folded right from every angle, they rendered each character four times, from the front, back, side, and above.

The main characters in *Madagascar 3* don't wear clothes, but they do have fur, which represented a different type of challenge to the CFX team, especially since the characters' pelts are different from real animal fur. For example, Alex's mane is stiff and thick, rather than soft and fluffy, and it needs to maintain a distinctly graphic shape. Artists positioned guide hairs to form silhouettes, generated thousands of hairs that followed the guides, and then used noise fields to deform the individual hairs.

As the Zoosters race through Monaco and, later, hang from a ladder dangling from a monkey-powered superplane, the character effects team were challenged to develop ways to make their fur blow realistically enough to heighten the danger without ruffling the graphic style.

(TOP) Wind on Fur · CFX: Uma Havaligi

(LEFT) Fur Contact · CFX: Jon Farrell

(ABOVE) Wind on Mane, Fur, and Whiskers · CFX: Rose Ibiama

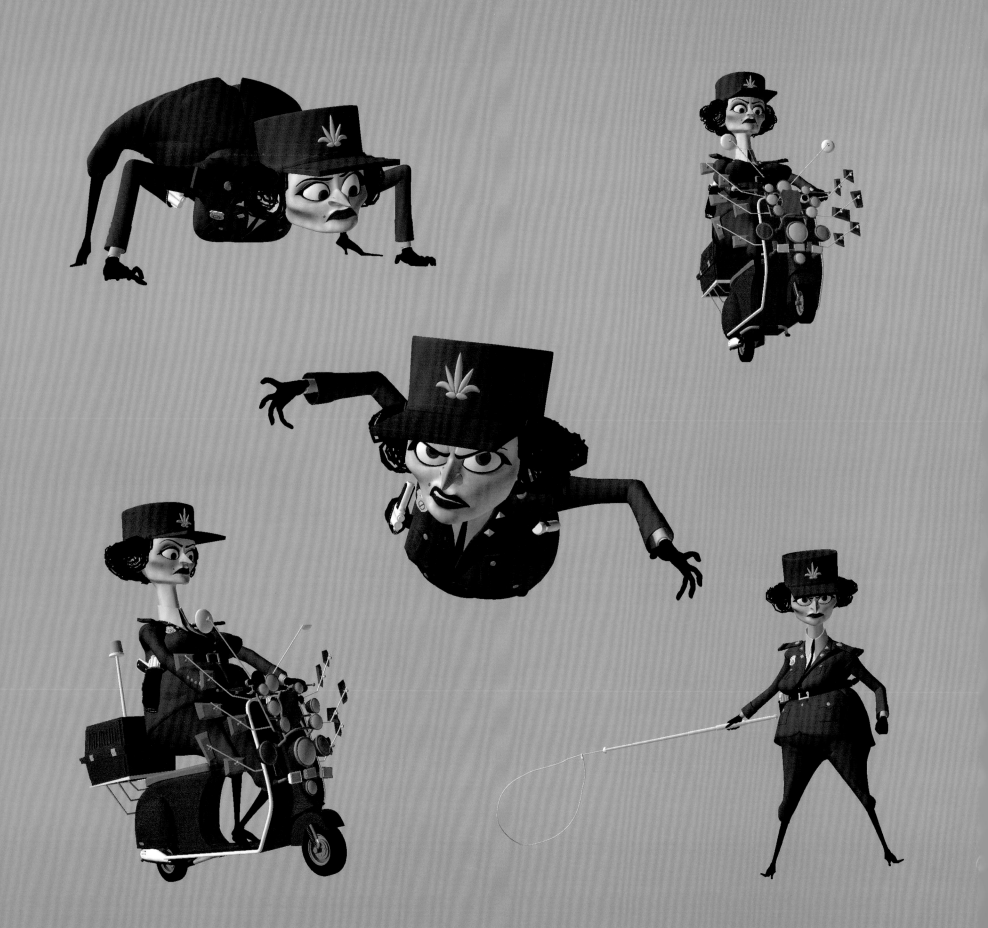

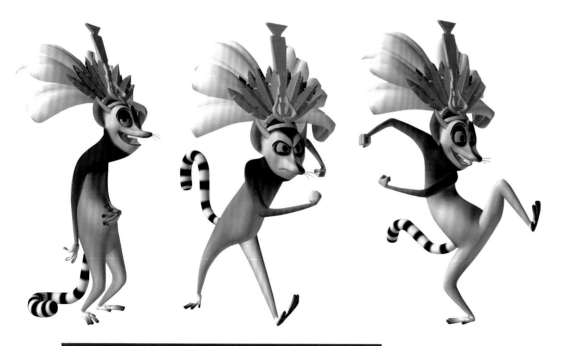

"We concentrated on giving a lot of control to animators so they could make the humans live up to our Zooster animals in style and in the amount they can express themselves."

—Mahesh Ramasubramanian,
visual effects supervisor

ANIMATION

Like most people I work with, I have always loved animation," says Rex Grignon, head of character animation. Grignon joined PDI in 1988 and helped build a character group that created breakthrough commercials starring some of the world's first CG characters. Later he became head of character animation for *Antz*. He then moved onto *Madagascar* and defined the film's wacky cartoon animation style. "I was there when Gloria spoke her first lines," he says.

For *Madagascar 3*, Grignon supervised more than fifty animators. "We breathed life into the characters," he says. "We created the performances, expressions, gestures for all the actors in the film."

The Monaco chase sequence really challenged the animation team to sustain the performances of each character. "Any time you are cutting a fast action sequence, you have to make sure the characters stay in the moment," Grignon says. "Usually animators do three or four seconds of animation a week. When one shot takes a week, it's hard to keep the energy and focus in your brain all that time. A character is in the middle of a harrowing chase in an out-of-control vehicle driven by a crazy Penguin. You have to keep checking to keep that at the forefront."

The prospect of bringing to life crowds of bystanders who participate in the chase also challenged the animation team. "In Monte Carlo, we have a mix of people from wealthy casino clientele to tourists," says Grignon.

To create the necessary sense of diversity, one team of animators placed individually interesting people within a cohesive crowd. Meanwhile, another team planned general groupings. Together, they created a crowd that is full of individuals but doesn't dominate the sequence or detract from the story.

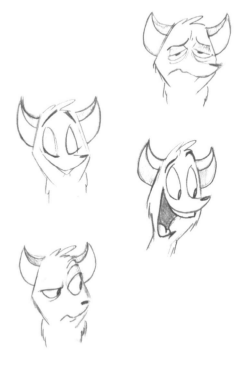

(OPPOSITE) Dubois Poses • Animation: Carlos Puertolas
(TOP LEFT) Julien Poses • Animation: Rani Naamani
(ABOVE) Julien Sketches • Animation: Rani Naamani

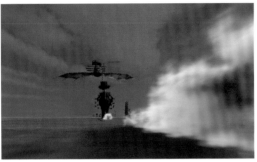

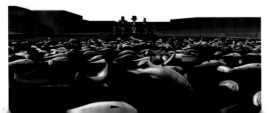

VISUAL EFFECTS

A visual effects supervisor manages technical and creative work, so it was fortuitous that Mahesh Ramasubramanian studied computer graphics at Cornell University under legendary professor Donald Greenberg, who has guided many CG inventions and fostered cross-disciplinary studies. "I knew I wanted to work on making images," Ramasubramanian says. "But, I wasn't sure I could find a role that mixes technology, creativity, and management. When I found DreamWorks, I hit gold."

Ramasubramanian was hired as an effects artist, and his first film was *Shrek*, for which he created mud for Shrek's bath. He became a visual effects supervisor on *Madagascar 3*. Now he manages many computer graphics departments: effects, lighting, modeling, surfacing, matte painting, character effects, crowds, and rigging—in other words, most of the crew, which exceeded 250 people on *Madagascar 3*.

Visual effects include natural elements such as water, dust, smoke, and fire, as well as explosions and other man-made forms of destruction. But in the context of an animated film, it's not just a question of simply reproducing these occurrences as they would appear in the real world. They have to be done in the style of the film they belong to, and they frequently add a certain level of dramatic effect to any scene in which they appear.

"We create comedic effects," says Ramasubramanian. "For example, we exaggerate the exhaust from Dubois' scooter, then have it die quickly. When there is an explosion, it's bigger than you expect. The effects all drive the story forward, and they are stylized in design, texture, and animation.

For Ramasubramanian and the team led by head of effects Scott Peterson, the challenge sequences 600 and 700 presented was the sheer scope of the job. "In the chase, we sometimes had twenty-five characters in a shot," Ramasubramanian says. "So everything was multiplied by twenty-five. We had to model, rig, and surface all the characters, put wind in their hair. And in sequence 700, we have a bird's-eye view of Monaco. We had to build everything you can see—the buildings, the water, the yachts, the mountains in the background, the explosions, the smoke, the banana splats. These two sequences, which involved creating Monaco, were more complex than any we've done before."

(TOP LEFT) Scooter Smoke Shadows and Velocities • FX: Jihyun Yoon
(LEFT) Fish Oil Spill Dynamics • FX: Greg Gladstone

(LEFT) Banana Gun Splat Simulation • FX: Carl Kaphan
(ABOVE) Banana Gun Splat Volume • FX: Carl Kaphan
(BELOW) Banana Gun Final Render • FX: Carl Kaphan

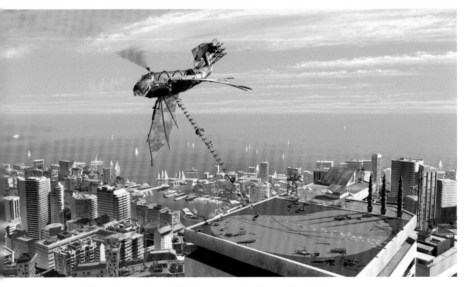

LIGHTING

Lighting artists place lights, turn them on, and adjust the illumination, giving each scene a unique array of light and shadow. Following through on the philosophy that guided her use of color when developing environmental artwork for *Madagascar 3*, production designer Kendal Cronkhite asked the lighting department to use artist Tadahiro Uesugi's hand-drawn illustrations as inspiration for their lighting design. "One thing we focused on was having saturated color bleed into the edge between a blown-out, almost pure white light and shadow," says lighting CG supervisor Gaku Nakatani. "Even the characters have some edge bleed to add richness."

A painterly texture, almost like a silk screen, was surfaced onto the environment to add an organic feel. Lighters worked from general templates to illuminate the environments in each sequence, using specific templates for Monaco and each character and then refining the look.

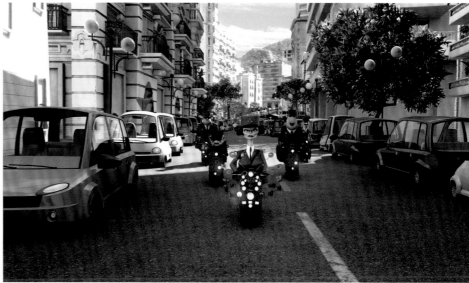

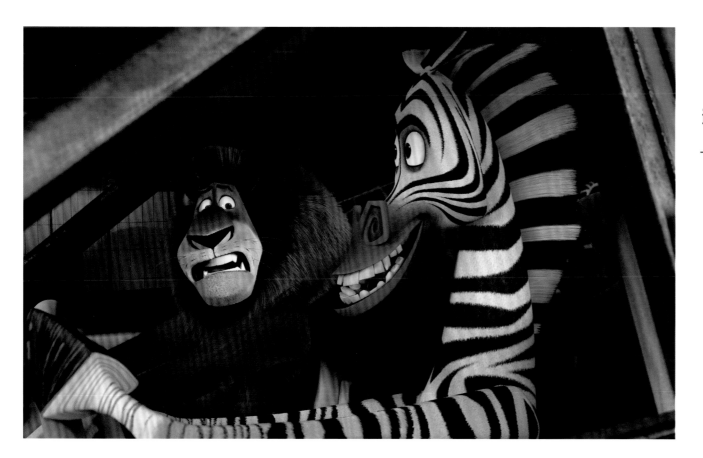

> " **We were trying to have an illustration look to the CG animation.** "
>
> —Gaku Nakatani, lighting CG supervisor

(TOP LEFT) Dubois Lasso • Previs/RLO: James Bennett; Final Layout: Heather Wang; Animation: Carlos Puertolas; CFX: In Soo Lee; Crowds: Scott Raymond; FX: Carl Kaphan; Lighter: Frank Ritlop; Paint Fix: Bill Gumina

(TOP RIGHT) Dubois and ACONs Chase • Rough Layout: James Bennett, David Bianchi, Brendan Carroll, Todd Jansen; Final Layout: Linda Bork, David Murphy; Animation: Kevin Andrus; CFX: Michael Todd; FX: Lana Sun; Crowds: Geoffrey Jarrett; Matte Painting: Michael Collery; Lighting: Stephanie Mulqueen; Paint Fix: Marco Marquez

(LEFT) Marty and Alex Drive • Rough Layout: James Bennett, David Bianchi, Brendan Carroll, Todd Jansen; Final Layout: Linda Bork, David Murphy; Animation: Mariko Hoshi; CFX: David Deuber; Matte Painting: Michael Collery; Lighting: Adam Chin; Paint Fix: Marco Marquez

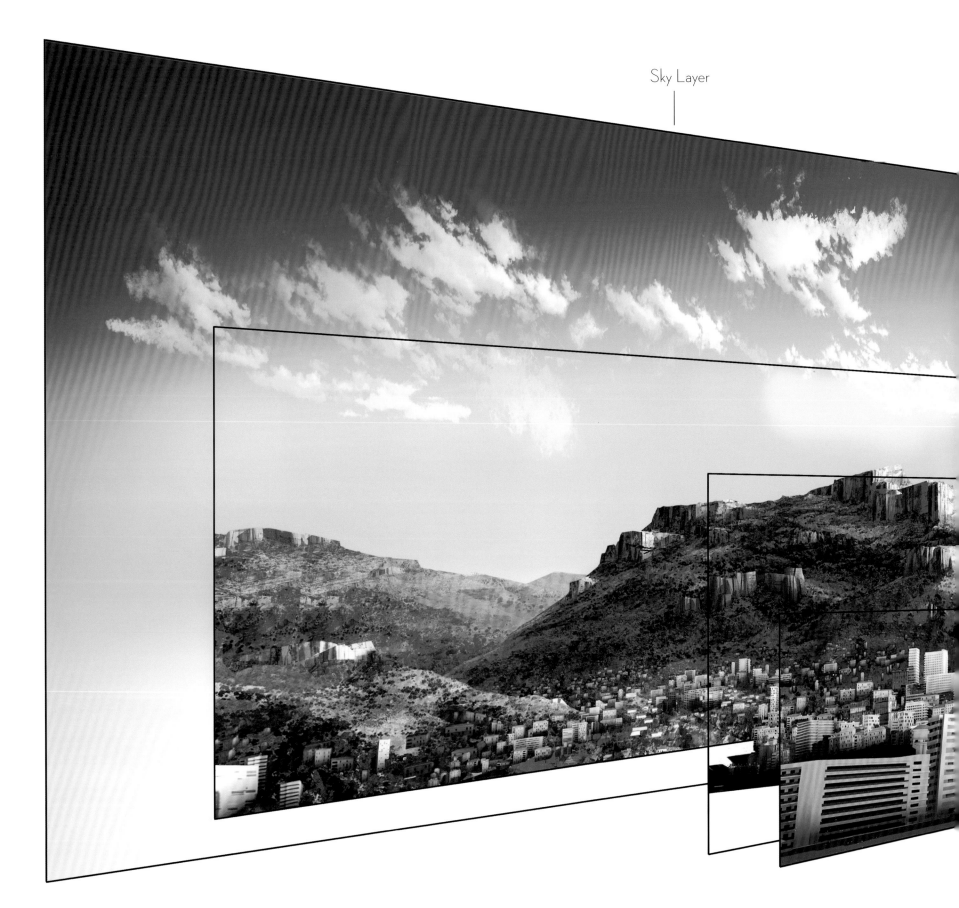

Sky Layer

MATTE PAINTING

T he amount of detail a modeler applies to an object in the frame depends on how far the object is from the camera. At a certain point, in the far, far background, past the least detailed model, the CG environment becomes a matte painting, a technique adapted from live-action filmmaking.

"We use matte painting on every film," says production designer Kendal Cronkhite. "We have from the beginning. We depend on matte painters for so many reasons. For this chase sequence, they created the skies, most of the ocean, and the background hills. Sometimes we put a matte painting in first to establish the lighting and color of a scene. And once a shot was near completion, the matte painters finessed it. They went over the buildings and added details, and they added trees and foliage in Monte Carlo to make it look finished."

Background Hill

Mid Ground City

Foreground City

Rendered Elements

(THIS SPREAD) Monaco Environment • Matte Painting: Josh Caez; Lighting: Brian Kulig

(ABOVE) Monte Carlo Arrival • Art: Ken Pak; Matte Painting: Tony Halawa; Lighting: Brian Kulig

(ABOVE) Monaco Harbor Color Key • Art: Ken Pak

(ABOVE) Monaco Harbor Matte Painting Block-in • Matte Painting: Josh Caez

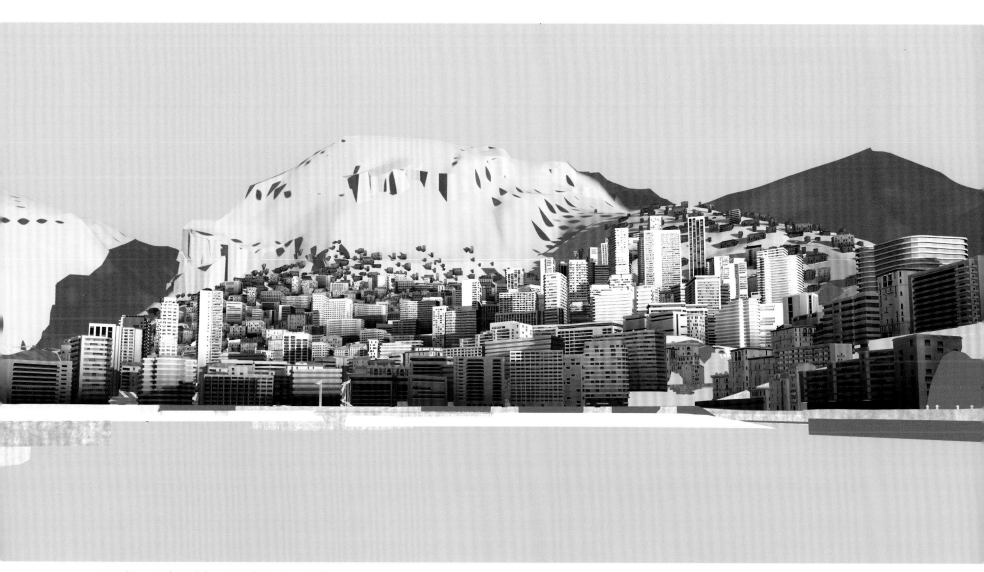

(ABOVE) Monaco Harbor Underlay • **Matte Painting:** Jason Arold

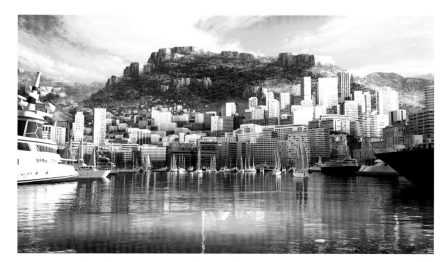

(ABOVE) Monaco Harbor Matte Painting • **Matte Painting:** Josh Caez

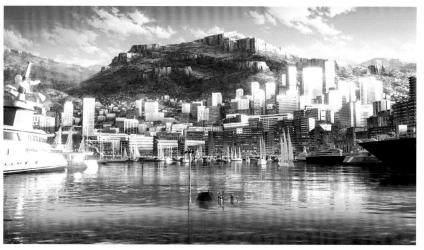

(ABOVE) Monaco Harbor Final Render • **Matte Painting:** Tony Halawa; **Lighting:** Brian Kulig

FINISH

A t the end of the process, compositors took the elements—the LARV, Dubois on her scooter, the monkey-powered superplane, the ACONs, the sets dressed by the final layout artists, the sky painted by the matte painters, and so forth—and combined them into final frames. Painters fixed little problems that occurred along the way—a cloud in the sky that looked too ragged, for example, or a tree branch that blew in the wrong direction. And then, with all the frames linked into a final film, colorists sat with the director, production designer, and others to adjust hues, tones, and atmosphere.

For this sequence, a big challenge was making sure that Monte Carlo looked consistent whether seen from the street level, a rooftop, or a helicopter. The finishing pass also checked that sequence 600 blended beautifully into 700, and that 700 transitioned properly into the next, and that everyone's work made it to the screen in the way they imagined it would.

(ABOVE) Dubois Falling Final Render • Previs/RLO: David Bianchi; Final Layout: Pamela Hu; Animation: Mark Roennigke; CFX: Rose Ibiama; FX: Jason Waltman, Jihyun Yoon; Crowds: Scott Raymond, Geoffrey Jarrett, Tanner Owen; Matte Painting: Nicole Mather; Lighter: Brian Kulig; Paint Fix: Kevin Coyle

"**This is a crazy, complex movie and visually stunning.**"

—**Rob Koo,** head of story

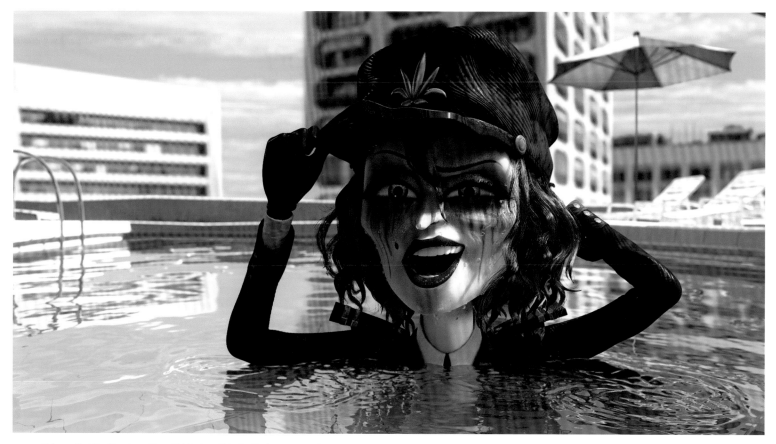

(ABOVE) *Dubois in Pool Final Render* • Previs/RLO: Jason Wesche; Final Layout: Pamela Hu; Animation: Mark Roennigke CFX: In Soo Lee; FX: Alex Patanjo, Lara Sun, Jason Waltman; Matte Painting: Michael Collery; Lighter: Brian Kulig; Paint Fix: Kevin Coyle

" I think Madagascar 3 brings the best of the first two films together. It's wildly funny and action packed, but it has a beautiful heart at its core. "

—Rex Grignon, head of character animation

CONCLUSION

The cartoon-y style of the *Madagascar* films has always pushed the animated art form toward its extremes, but the software tools developed for this film, and the skills of the artists who designed and created the characters and environments, have produced some of the most interesting and beautiful images yet to appear in a CGI feature. The human characters, with their pushed proportions, fit into this world populated by cartoon animals—a world that is as graphic and illustrative as the characters.

"We love these characters, and we hope we have an opportunity to continue the journey," says producer Mireille Soria. "But the Zoosters have always said they wanted to get back to New York, and this concludes that part of their journey."

"A key part of their adventure concludes here," adds producer Mark Swift. "But crazy stuff could happen within the circus."

The movie concludes during magic hour, as the circus train rolls through Connecticut. "It's fall, so we had all the beautiful colors of the East Coast at that time of year," says production designer Kendal Cronkhite. "For the finale, we bring all the visual ideas of the film together: beautiful magic-hour lighting, the fall colors of Connecticut, the strong angles of our villain, the joy of the reinvented circus, and the curved upward shapes of the friendships our characters have made. This story is about home and passion and doing what's right for you, but also the fear and adventure that's involved. Life is taking risks. This is living. We wanted to bring those ideas together for the ending of our film."

Whatever happens with the Zoosters, we can be certain that the extraordinarily talented artists who created these films will have more adventures to come. Their journey certainly continues.

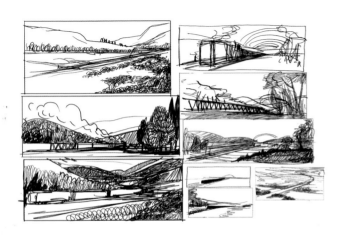

(ABOVE) Connecticut Thumbs Line • Lindsey Olivares
(OPPOSITE) Circus Parade Establishing Key • Alex Puvilland and Ken Pak

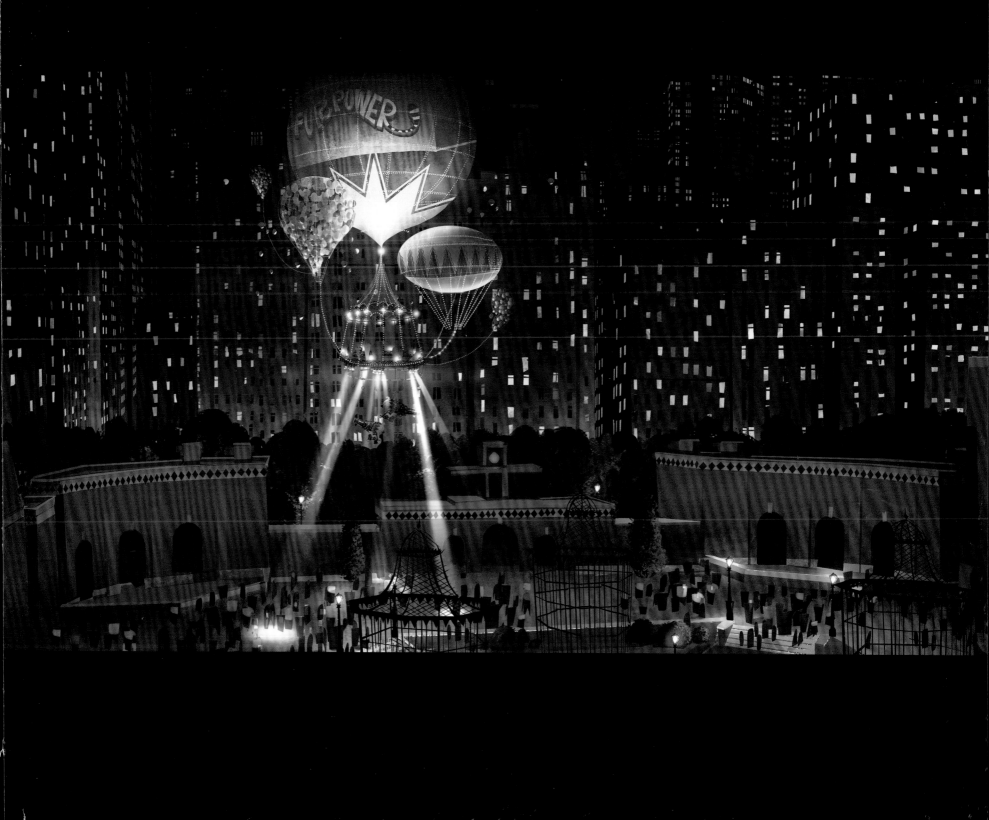

(TOP) The PDI/DreamWorks Animation Redwood City Crew
(MIDDLE) The DreamWorks Animation Glendale Crew
(ABOVE) Rome Circus Vis Dev • Lindsey Olivares

ACKNOWLEDGMENTS

DREAMWORKS ANIMATION would like to thank Kristy Cox, David Hail, Jeff Hare, Karen Hoffman, and Christine Nguyen.

COLOPHON

PUBLISHER: Raoul Goff

ART DIRECTOR: Chrissy Kwasnik

DESIGNER: Jenelle Wagner

ACQUIRING EDITOR: Jake Gerli

PRODUCTION EDITOR: Jan Hughes

PRODUCTION MANAGER: Jane Chinn

INSIGHT EDITIONS would also like to thank Mikayla Butchart, Deborah Kops, Binh Matthews, and Anna Wan.